D0580694

What more reliable way to experience joy

than to contemplate nature?

It never fails, never disappoints.

Anonymous

Charlie + Angelica —

Congratulations !

What an accomplishment —
You should be most proud !

Marsha + Randy Kearney
October 25, 2002

Introduction

To understand how Florida's natural places came to be, it is necessary to look back in time. These fabulous places are the result of several billion years of geological history, weather, and a very short span of human impact.

We may think of Florida as "new" in many ways. For example, it has been dry land for less than 1% of the existence of the earth. Humans are certainly new to Florida. For 99% of the time that human-like creatures have existed, none of them could be found in Florida—not even a monkey.

Compared to humans, however, Florida is "old." Its lands greatly predate human existence. For about 25 million years, Florida got along fine without humans, but humans are abundant now. With their overly large brains and grand pretensions, they have radically changed Florida's natural conditions.

It is hoped that this book will inspire many people to pursue adventures in Florida's wilderness. Such adventures can only bring about an increased appreciation of the wilds that remain. Hopefully, this will produce better caretakers for this diverse, green state.

PREHISTORIC FLORIDA

Florida was a marvel long before recorded history. Believe it or not, the Sunshine State was once closer to Egypt than to Georgia. The current belief among geologists is that Florida was attached to ancient Africa in an area close to the present day nation of Senegal. If not for "continental drift," Moses might have parted the Red Sea to search for the promised land in Florida. According to current theory, the land that makes up most of Florida was once part of a supercontinent referred to as "Gondwanaland," or simply "Gondwana." Gondwana included parts of Africa, Antarctica, Australia, South America, and India.

About 300 million years ago, Gondwana began to collide and merge with another supercontinent called Laurasia, which was the core of modern day North America. This mammoth collision caused the uplift of the Appalachian mountains.

The merging of these enormous land masses created an even larger entity called Pangea or "Pangaea." It endured as a single continent for at least 100 million years before it eventually broke apart, leaving the future Florida attached to North America.

This ancient continental billiards game occurred because the continents are part of very large geologic structures, called tectonic plates, that drift very slowly across the face of the planet. These plates ride and slide on a plastic, easily deformed layer that occurs about 60 to 80 miles beneath the surface.

When it was part of Gondwana, Florida was apparently part of a submerged continental shelf, and was covered by sandstone and shale. After attaching to North America, Florida was separated from the continental land mass by a shallow seaway, called the Georgia Channel, much like the Bahamas Platform is separated from North America by the Florida Straits. During this time, Florida was covered by warm, shallow seas, which deposited thick layers of limestone made of the skeletons of marine animals. About 25 million years ago, the Georgia Channel filled in. Sand and silt cascaded off the continent onto Florida, and Florida became dry land. Today, Florida is a layer cake, with a foundation of African rocks, a core of limestone, and an icing of sand.

Since Florida first rose above water, global warming and alternating ice ages have caused its coastlines to vary greatly. During one major ice age when much of the earth's water was in glaciers rather than oceans, the water levels dropped so much that the coastline of the Gulf of Mexico was about 200 miles farther west than it is now. Alternately, during warmer epochs, the only part of peninsular Florida above the sea was the Central or Lake Wales Ridge. If global warming from "greenhouse gases" causes Florida to be drowned again, it will be a familiar climatic pattern.

THE FIRST FLORIDIANS

Traditionally, anthropologists believed that the original inhabitants of North America entered this continent from northeast Asia between 12,000 and 15,000 years ago. Recent research suggests that they may have arrived much earlier. They apparently came across a land bridge that connected Asia and Alaska during a cold period when seas were lower than at present.

Descendants of these Asian immigrants eventually made their way to Florida. These nomadic ancestors of Native Americans (often called "Paleo-Indians") lived and died for thousands of years leaving only traces of their undoubtedly rugged and adventuresome existence. Paleo-Indians apparently subsisted largely by hunting. Fossils indicate that the now extinct animals they encountered included giant armadillos, primitive camels, giant tortoises, mammoths, and saber-toothed tigers. It is probable that their hunting contributed to the extinction of these creatures.

THE LAST MILLENNIUM

About 800 years ago, Native Americans began to farm Florida, burning off ground cover for agriculture. This had little impact on Florida since the total number of Native Americans was small. Perhaps 100,000 native peoples were living in Florida when the Europeans arrived.

Various warring Europeans arrived five centuries ago and began to clear land for plantations (citrus, cotton, indigo, and sugar) and settlements. The first to arrive were the Spanish and French, later the English. They fought each other over territory and religion, meanwhile inflicting many miseries on the native Floridians. Europeans sold natives into slavery, tried to force their Catholic and Protestant beliefs upon them, killed them for daring to be disobedient, incited tribal wars, and infected them with diseases for which they had no immunity. Yamasee Indians, allies of the British, in the early 1700s massacred most of Florida's Apalachees. They took survivors into captivity in South Carolina.

Two other large Florida tribes exterminated by Europeans included the Timucua and Calusa. Spanish explorers wrote that the Calusa were a tall race—seven feet tall! However, the Spaniards who came were shorter than present Europeans, and possibly the Calusa seemed larger than life merely because they resisted the invasion so fiercely. The Calusa tortured and killed their captives, but so did the Europeans

Many tribes may have contributed to the accumulation of the large shell mounds that can be seen in many Florida parks and preserves, but these are now most often associated with the Calusa. These mounds consist mostly of conch, oyster, and scallop shells, left over not only from dinner, but from the manufacture of weapons and utensils. Anyone who has stepped on a sharp seashell while walking into the sea can easily imagine what sharp knives could be made from a honed and polished shell.

Florida "Crackers" tried to tame the Florida frontier. The Crackers were pioneers who sought better soils in Florida and brought their families to Florida from other states. The Florida frontier was a southern "Old West" complete with smudge pots to ward off mosquitoes. Most of these efforts to tame the frontier made little impact on Florida's wildlife and wild places compared to what followed. The name "Cracker" probably has its origin in the cracking of whips. However, some think it has to do with grinding or cracking of corn, or the cracking of jokes.

The Territory of Florida became a state in 1845. By this time, the few Seminoles left in Florida had been driven into hiding in swamps. Others had been sent to Oklahoma to live on reservations or killed in the Seminole wars. Possibly fewer than 100 Seminoles were left in the state. Florida was admitted to the Union as a slave state. There had been proposals to divide Florida into two states: a slave and a

free state. This was avoided by admitting Iowa as a free state, and leaving Florida a slave-holding state. The idea of Florida as two states probably never stood a chance, as there was slavery state-wide. Yet Florida as two states might have made sense. In fact, the vast area of Florida was at various times administered in colonial eras as two territories, east and west Florida.

Florida became a state just in time to secede from the Union. It sided with the Confederacy. However, except for one small battle at Olustee, and the sacrifice of some of its sons on more northern battlefields, Florida did not play much of a role in the Civil War other than as a food basket for the rebels. (The battle at Olustee is the one depicted at the conclusion of the movie *Glory*, in which the exceptionally brave and valorous Massachusetts Negro regiment was all but annihilated.) The Civil War, in which more Americans died than any other war, passed with virtually no impact on Florida's wilderness.

THE LAST 100 YEARS

Don't it always seem to go
That you don't know what you've got
'til its gone.
Pave paradise, put up a parking lot.
 *– Joni Mitchell**

The Twentieth Century brought a population explosion to Florida. First, roads and railroad lines opened the state to expansion. Later, land booms brought many people to Florida before the Great Depression. During the Depression, government jobs were provided for the unemployed through agencies like the Civilian Conservation Corps. The government agencies specialized in public works, creating many parks and the highway down the Keys following Flagler's pioneering railroad.

World War II brought many military recruits to Florida and exposed them to the warm Winter climate. With air-conditioning, the state became more comfortable in Summer, and in the 1950s, spurred by a growing network of roads and the airlines, the population increased by 70% in one decade. While this growth rate has never been equaled, growth has continued at an extremely rapid pace. Those who came did not set out to damage the environment. They thought they were improving the world while making a living for their families.

But the result for wildlife and natural habitat was disheartening. Timber land was over-harvested, and vast tracts of land were cleared for development and agriculture. Thousands of years of accumulated water were sucked out of the aquifer. Saltwater shorelines were altered to create high-priced waterfront property, and channels were dredged for recreational boat-ing. As a result of commerical over-fishing and the destruction and degradation of habitat, sports fishing, once a prime attraction for tourists, became an often futile search for game fish. Rivers and lakes were changed in the mistaken belief that government engineers and planners knew better than nature, and fresh water became "managed." Runoff carrying agricultural pesticides and fertilizers polluted waters, and poisoned wildlife. In an attempt to rid the state of troublesome insects, huge quantities of pesticides were sprayed.

Due to all this human activity, many species became severely reduced in numbers, and some became extinct. Even in its diminished condition, however, Florida remains a land of glorious natural places.

FLORIDA IN THE 21ST CENTURY

Both "thanks" and "hope" are key words for the new century. Thanks should be given to those who have inspired and taught love of Florida's nature. They have saved sizable amounts of Florida for future generations. One hopes that future generations will continue to treasure their legacy.

The migration of millions of Americans to Florida, and the immigration of vast numbers of new Americans from other countries, has also had a great impact on the wild places of Florida. Each Floridian uses natural resources, even someone sitting in an air-conditioned home writing a book with the intent of helping to preserve the remaining wilds.

Millions of tourists also use Florida's resources each year. Escalation of the human population from thousands to millions would burden any natural system. Only a natural world as rich as that of Florida could have endured such an onslaught with so much wilderness still surviving.

The damage caused by the human population expansion will never be completely reversed, but there are many positive trends. There is now a small army of naturalists, rangers, and federal and state employees dedicated to the preservation of the remaining natural places. More areas are being protected from development and turned into preserves and refuges. Laws have been passed for the protection of many species. Net-fishing restrictions have begun to have a positive impact on fish populations. Perhaps humans have finally learned a better way. There is much more awareness in the general public of the value of wilderness.

Much of Florida's wilds are in public ownership and new areas are being added. Many of the areas are large enough to provide buffer zones from civilization and corridors for wildlife.

ORGANIZATION OF THIS BOOK

This book is designed to help both the new and the seasoned naturalist explore and enjoy the most interesting natural places in Florida. For this purpose, the sites are organized into five geographic regions. Central Florida often refers to only the interior of Florida, but for this book it incorporates the Atlantic and Gulf Coasts between the southern and northern regions. The tropical Keys are presented separately because they are so unique and distinctly different from the rest of Florida.

There are many schemes for organizing the state. Botanists might divide it by type of plant growth, while geologists might do so by geological formations. A meteorologist would have different ideas, as might park and preserve managers. All schemes for organizing the state have their own strengths and weaknesses.

A LAND OF DIVERSITY

Some authorities have divided the state into more than eighty natural ecosystems, while others have recognized a lesser number. Specific definition is particularly useful for scientists who wish to distinguish how two habitats, which are very similar, differ from each other. In those cases, definitions become a sort of shorthand from one scientist to another, describing similar characteristics and species. If a habitat can be shown to be unique, this description is sometimes useful in winning support to preserve it. Unfortunately, all this definition has created some confusion.

Scientists at the University of Florida (Ecosystems of Florida, Myers and Ewel, 1990) have devised a habitat definition for Florida which is widely accepted. The three major divisions in this system are: uplands, freshwater wetlands and aquatic ecosystems, and coastal ecosystems. Uplands consist of pine flatwoods, dry prairies, scrub, high pine, temperate hardwood forests, and South Florida rockland. Freshwater wetlands and aquatic systems are swamps, marshes, lakes, rivers, and springs. Coastal ecosystems are defined as dunes, maritime forests, salt marshes, mangroves, inshore marine habitats, and coral reefs. These habitats are explained as they are encountered in this book.

Nature does not always fit into clearly defined ecosystems. Systems frequently overlap. Many of the large areas explored in this book contain several types of overlapping ecosystems.

* *BIG YELLOW TAXI, by Joni Mitchell. ©1970 (Renewed) Siquomb Publishing Corp. All Rights Reserved. Used by Permission Warner Bros. Publications U.S. Inc., Miami, FL. 33014.*

Northwest Florida

Northwest Florida is strikingly different from other regions of the state. While most of Florida is flat, or slightly rolling, this area is a land of gentle hills, ravines, occasional cliffs, and the greatest (although modest) elevations in the state. In parts of Northwest Florida, trees markedly change color in the Fall, much like one would expect in Tennessee. The Panhandle has gorgeous white sand beaches, the highest dunes in the state, colorful marshes, spectacular rivers, abundant freshwater springs, and even a system of dry caves.

Along Northwest Florida's coast are quartz sand beaches. Some of the quartz sand came from the southern Appalachian mountains and was slowly carried to the sea by the Apalachicola* River. Several beaches in the Panhandle have been voted "best in America." Barrier islands parallel some of the shoreline. Many of these islands remain wild, and all beckon beachcombers, explorers, and naturalists.

The Gulf Coast has bays, estuaries, and saltwater marshes. Saltwater marshes are intertidal (their boundaries are defined by the limits of high and low tides), and contain salt-tolerant plants and trees. Bays and estuaries are inlets that are parts of the sea.

The Apalachicola River divides the Eastern from the Central Time Zone in many places. The river's muddy waters were a highway that transported Native Americans, European settlers, Civil War soldiers, and Cracker frontiersmen long before it was spanned by bridges or an interstate highway.

Two other large rivers, the Escambia and Choctawhatchee are in this area, as well as many smaller rivers. These three rivers, and other smaller ones, are bordered by alluvial swamps, which are rich in nutrients and low in peat. Many of the rivers of the Panhandle are alluvial, meaning they carry rich sediments. A number of the Panhandle rivers are truly pristine, including the Blackwater, Econfina, and Wacissa. There are many river journeys in Florida, including the St. Johns, which are visually very interesting, but for water purity and isolation, the rivers of Northwest Florida are beyond compare within the state.

The Panhandle has more longleaf pine than any other region of Florida. Longleaf pine once dominated the forests of Florida and the southeast US. But longleaf was substantially lumbered and replaced with the faster-growing slash pine.

This region has two national forests, the much larger Apalachicola and the little-known Choctawhatchee (only about 750 acres). The Choctawhatchee is mostly in Okaloosa County and is predominantly sand pine. The Apalachicola sprawls over several counties and is mostly slash and longleaf pine. Longleaf pine can be found in the large forests of Eglin Air Force Base.

Many of the place names in Northwest Florida are derived from the Apalachee language. These Native Americans lived in the region for centuries in settlements in several areas, and around the red hills of what is now Tallahassee. "Served" by Spanish missions, these people were caught in the warfare between England and Spain. The Native American Yamassee of South Carolina were allies of the British. With British encouragement, they brutally exterminated the Apalachee, carrying some into captivity in South Carolina. The absence of the Apalachee created a void which allowed the Creeks to enter Florida. Florida's Seminoles are descendants of those Creeks.

The major cities in Northwest Florida are Tallahassee, Panama City, and Pensacola. Panama City was allegedly given its name because it would be on a direct line drawn between Chicago and Panama City, Panama. The Pensacola area was fought over by various European colonists, and its name is of unclear Native American origin.

For the meaning of many of the Native American names, see the box on page 159.

Opposite page: an early morning scene in the Apalachicola National Forest with pitcher plants in the foreground.

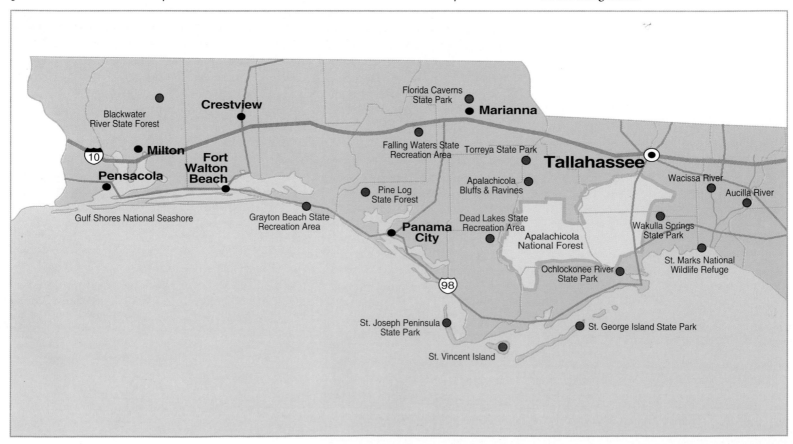

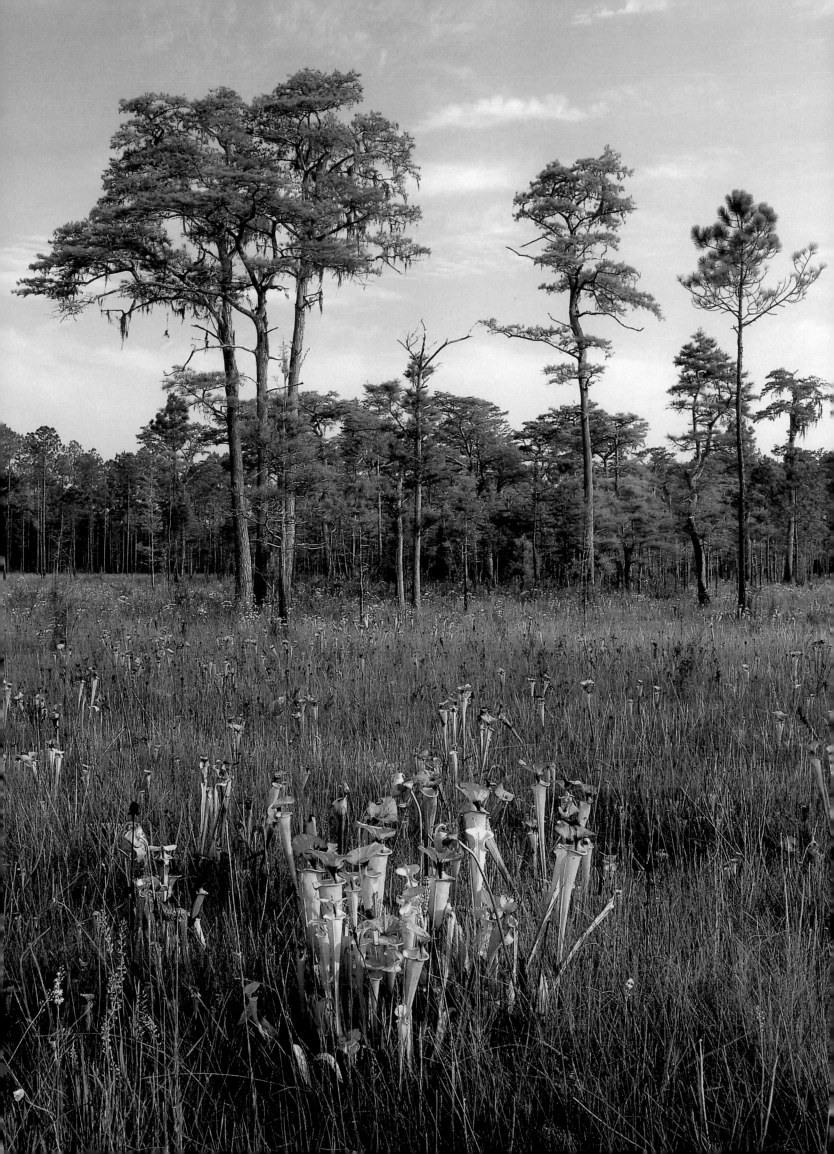

Apalachicola National Forest

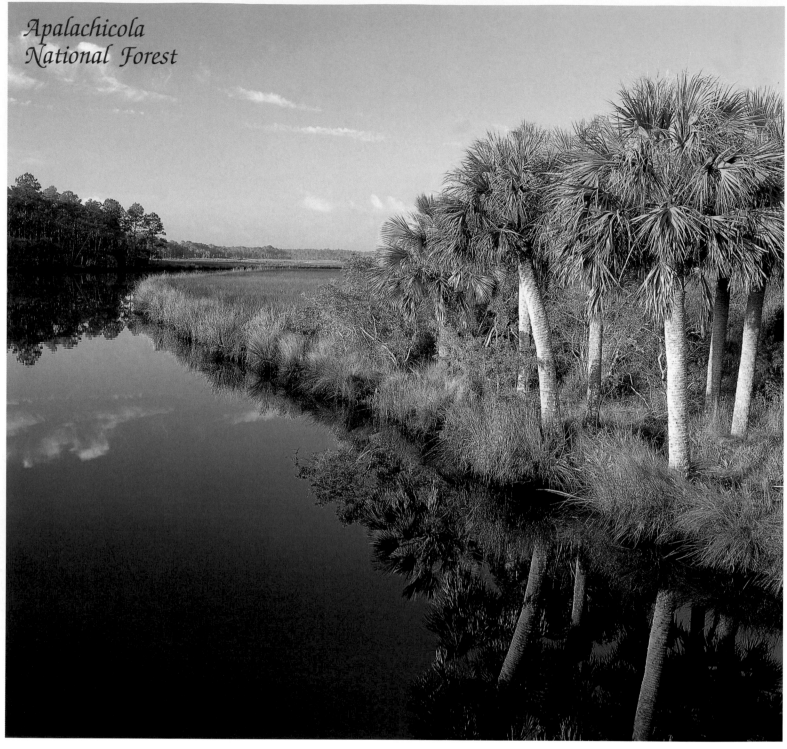

In the vastness of this beautiful forest, there is both solitude and adventure. At over a half-million acres, this forest is so large that it has been divided into two ranger districts for management. The Ochlockonee River separates the eastern Wakulla District from the western Apalachicola District. These two districts together make up the largest national forest in Florida.

When Europeans arrived in America, most of Florida was covered with pine forests and wetlands. At that time wetlands made up about 50% of the state, but they have now been reduced to about 25% of the land area. Perhaps 90% of the pine forests have been cleared. Yet pine flatwoods still comprise the largest single land ecosystem in Florida. Both wetlands and forest are plentiful in the Apalachicola National Forest.

Pine flatwoods are generally found on level ground and on sandy soil which is not well-drained. Pines which grow on elevated areas are called "high pines," or "sandhill." Flatwoods are sometimes called "low pine." A word for flatwoods that includes high pine areas is "barrens."

Within the forest are seemingly endless areas of slash pine and longleaf pine with underlying wiregrass or saw palmetto. Wiregrass is so named because it resembles wire, and is so strong that Seminoles used it to make baskets. Various beautiful wild flowers and herbs color the flatwoods. Longer "leaves" or needles distinguish longleaf pine from slash pine, although this is not true everywhere. Longleaf also has much bigger cones.

The Apalachicola National Forest should be visited many times, and in different seasons, since there is so much to experience. It is readily accessible by car on clay and sand roads, which often seem like endless "roads to nowhere." One can hike 60 miles of The Florida Trail and numerous other trails. There are many excellent canoe trails on its waterways.

Some areas of the Apalachicola are wild and difficult to hike or canoe, and it is suggested that visitors check with rangers before proceeding, not only to make the rangers aware of plans, but also to determine current conditions along the creeks, rivers, and trails.

Above: **Cashie Bayou in early morning. Cashie Bayou is just outside the Apalachicola NF.**
Opposite page: **a typical pinewood and wiregrass scene in the Apalachicola NF at sunrise.**

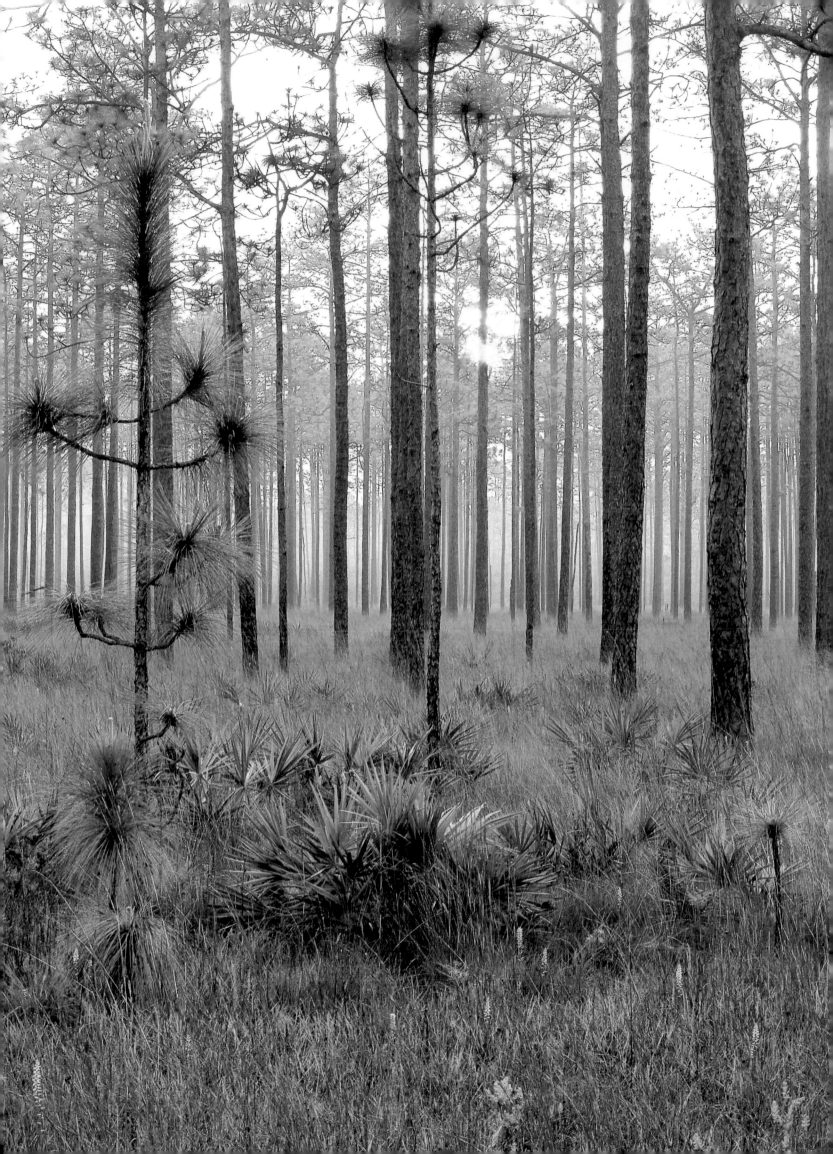

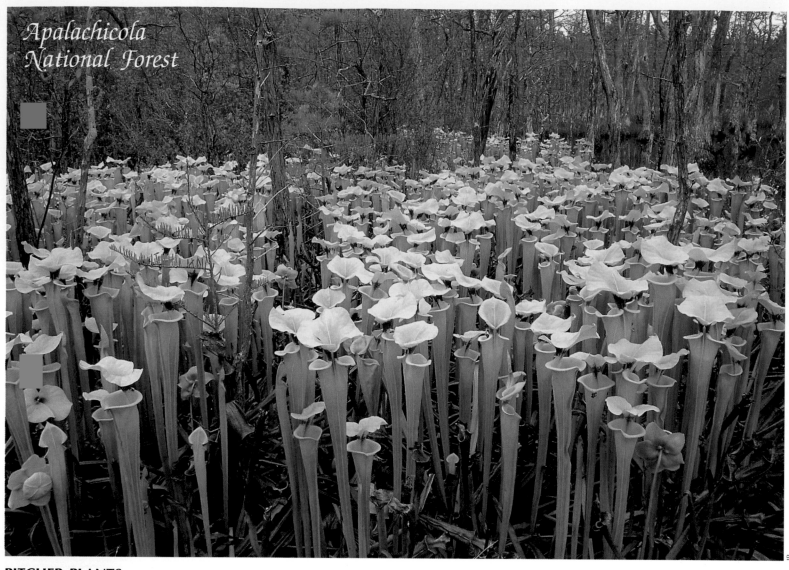

Apalachicola National Forest

PITCHER PLANTS

Carnivorous plants have probably evolved in response to the lack of nutrients in the soil. These plants specialize in trapping insects. They digest the remains of insects, and in one case, snails. The carnivorous plants found in Florida are bladderworts, butterworts, pitcher plants, and sundews. They are found in wetlands, and especially around peat bogs.

Within Florida, pitcher plants are most plentiful in the Panhandle and the North-

east, but one species is found sporadically in wetlands at least as far south as Lake Okeechobee. The upright "pitchers" are really specialized leaves that serve as chambers where the insects decay, and from which nutrients are absorbed. Nectar secretions on the outside lip of the trap draw insects to the plants, and once the prey are inside, their escape routes are blocked by backward pointing hairs.

Many small creatures live in associa-

tion with pitcher plants. Spiders and frogs wait at the mouths of pitchers to catch insects. There are fourteen known species of insects that depend on pitcher plants, surviving nowhere else. These scavenger insects do no harm to the pitcher plants.

The most noticeable pitcher plants are the so-called "trumpets" (shown in the photo above) because they are the tallest. Some trumpets stand as high as two feet, and are brightly colored.

RED-COCKADED WOODPECKERS (RCW)

The red-cockaded woodpecker is an endangered species, meaning one that faces possible extinction, or extinction in one area (called extirpation). This differs from "threatened" species, or those creatures which may become endangered in the foreseeable future.

The Apalachicola forest is home for many of the remaining red-cockaded woodpeckers. They have vanished from other parts of Florida. They are now found only sporadically from the Panhandle south to the Big Cypress.

While many woodpecker species nest in dead trees, red-cockaded woodpeckers require living trees. They prefer longleaf

pines, especially trees that are more than 80 years old. Such trees once existed in vast forests in the southeast and parts of the southwest US. The RCWs also prefer trees which have red-heart disease, a fungus which softens the wood.

Longleaf pine has decreased because of over-harvesting, the destruction of trees during storms and hurricanes, a reduction in the frequency of natural fires that maintained the system, and large-scale land-clearing. Longleaf pine grows slowly, so commercial reforestation projects make use of faster-growing slash pine.

These woodpeckers take years to excavate a tree cavity. They make small pitch

wells at the cavity opening so that resin will flow downward on the outside of the tree. The resin may help to keep out some predators, such as snakes, but some experienced naturalists are doubtful of this. One reason is that resin flow helps to identify active nests to potential predators.

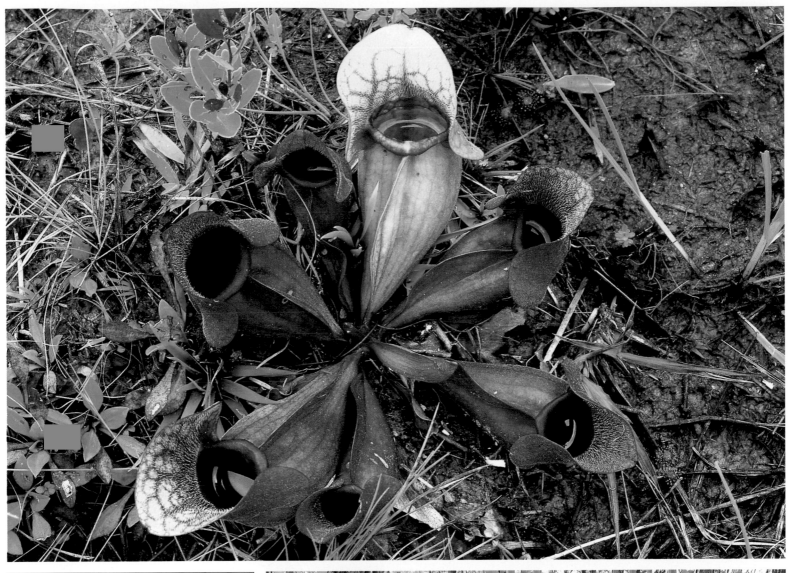

FLORIDA'S ABUNDANT WILDLIFE

What can the visitor expect to see in Florida's wilderness? Florida is blessed with a richness in wild species of all types. Approximately 425 species of birds (about half the number that can be seen in the entire US) can be found in Florida sometime during the year. There are nearly 140 species of reptiles and amphibians, and almost 80 species of mammals. In the fresh waters alone, there are over 200 native fish, not counting saltwater fish that stray upstream. And then there are the bugs! Perhaps 2,000 species of spiders live in Florida. The number of insect species identified is in the tens of thousands, with many more being added through on-going research. On the saltwater reefs are perhaps 50 species of coral, with hundreds of species of fish, and countless marine creatures. Over 300 species of trees are native to Florida, and there are 3,500 species of vascular plants. (Vascular plants are those with veins and leaves.) Many of the parks discussed in this book offer a species list to help the visitor know what to look for. These species lists are usually available in advance or at entrances.

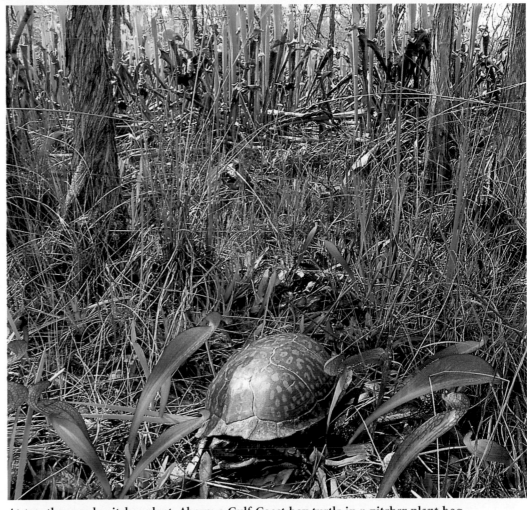

At top: the purple pitcher plant. Above: a Gulf Coast box turtle in a pitcher plant bog.

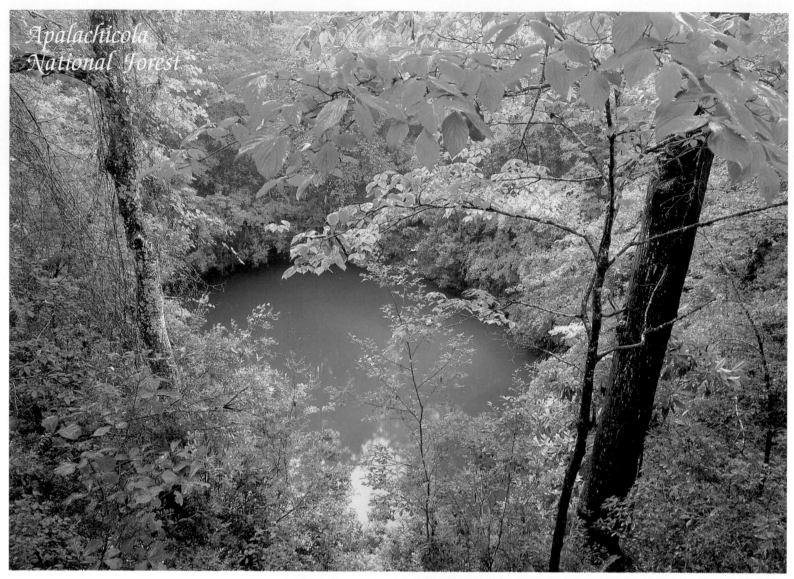

Above: a view of Big Dismal Sink at Leon Sinks Geological Area.
At right: the rose pogonia orchid.

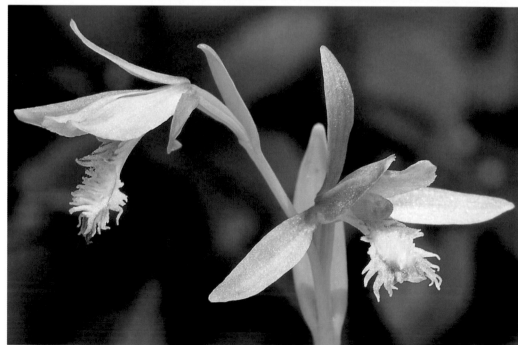

ECO-SPEAK

A hammock is not just a kind of recreational bed stretched between two trees; it is also an area of forested land, usually higher than its surroundings. When hardwoods grow on a hammock, it is called a hardwood hammock. Hardwoods are broadleaf trees, as opposed to trees with needles, which are softwoods (cedar, cypress, and pine). A strand is not just an unruly hair, but a type of swamp with a limestone base unique to Florida (such as the Fakahatchee Strand).

Scrub is not just something you do to your hands when they are dirty, but a valuable, endangered, and very old Florida ecosystem. A stand is not just a table on which to put a night light, but rather a grove of trees. Swamps can be distinguished from marshes because swamps are dominated by trees, such as cypress. Marshes, which may have some trees in them, are dominated by grasses and shrubs. In this book, many of these specialized words are defined as they appear.

In addition to flatwoods and sandhills, there are bays, over 2,700 acres of lakes, rivers, prairies, and swamps (both alluvial and bogs). Atlantic white cedar trees are dominant in some of the bog areas, while shrubs dominate others. There are also large cypress trees, some perhaps 1,000 years old, in some of the remote sloughs. (A slough is a place of slow water flow).

The forest is south of I-10 and north of US-98 in Leon, Liberty, and Wakulla counties. In the east, US-319 skirts the border, while in the west SR-379 is the closest thing to a border. Roads through the forest include SR-SR-12, SR-20, SR-65, SR-67, and SR-267. To get the most from a trip, obtain a forest map from either district office.

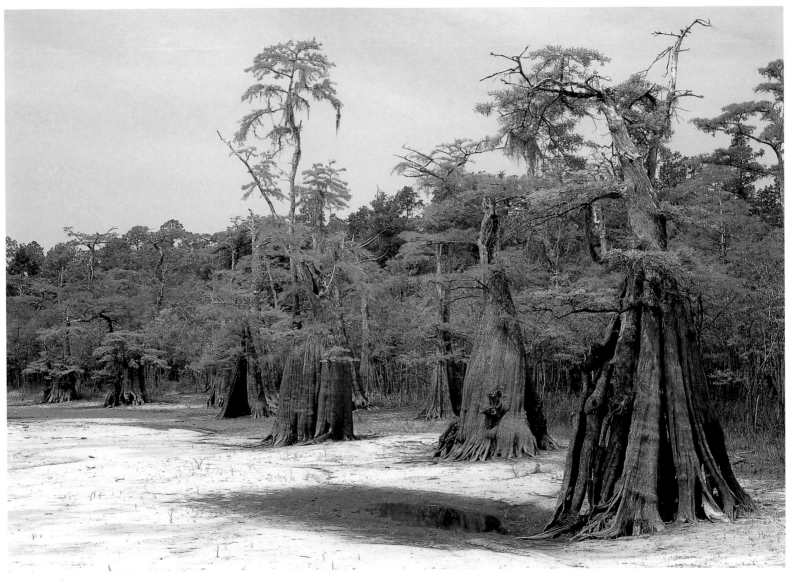

Adventures in the Apalachicola NF

As is fitting for the largest national forest in Florida, a wide range of activities are available. These include camping, canoe trails, hiking, horse trails, fishing, and hunting. Off-road vehicles may use miles of old logging trails. The ranger offices can advise about restrictions. For the naturalist, here are some areas to begin a life-long exploration.

Apalachicola Scenic Byway

This 31.5 mile drive passes creeks, cypress swamps, pine flatwoods, prairies, and sloughs. Among the longleaf pines are colonies of red-cockaded woodpeckers.

Bradwell Bay

Most of the 25,000 acres of Bradwell Bay are primitive bog swamp dominated by titi and hardwoods. There are also small ponds surrounded by pond pine.

It is not easy to access Bradwell Bay as most of it is at least knee-deep in water almost all year. Even the portion of the Florida Trail that passes through it is a difficult, wet journey. Remote and wild, it is a challenge for the ardent naturalist. Forest roads travel through it for those who prefer a drive-by viewing.

Leon Sinks Geological Area

The six-mile trail through this area is a visual treat for naturalists. First-time visitors are usually delightfully surprised by the dozen scenic sinkholes encountered. Big Dismal Sink is the largest, about 70 feet deep. Hammock Sink can be observed from a boardwalk.

This is typical karst terrain which usually does not have waterways, but has sinkholes and caves. This is because the rock below ground dissolves easily, leading to solution sinks. Karst topography is common to much of Florida.

Mud Swamp/New River Wilderness Area

This swamp has no clear trails, and is usually underwater, so it is strenuous to explore on foot. It is possible to drive along the swamp on forest roads where pitcher plants dot the bogs.

The New River passes through this area and can be canoed. However, at times the water level is quite low, and it is advisable to check conditions before embarking.

Rivers

Canoe journeys can be made on various rivers. The forest brochure lists seven specific sites with directions for put-ins.

Top: **strange cypress trees along the New River at a time of low water level.**

The powerful Apalachicola originates at the Woodruff Dam in Chattahoochee, and flows 107 miles, emptying into estuaries along Apalachicola Bay. There are numerous landings along its banks. It is a fast-flowing, vigorous river, that carries a greater quantity of water than any other Florida river. Its water is muddy because it carries a heavy amount of sediments.

On a map, Lost Creek appears to pop up out of nowhere, and travel a short distance before disappearing. This is because it is fed from swamps, and its dark waters travel 30 miles before disappearing underground.

The Ochlockonee River is 102 miles long, a large portion of which is within the national forest (see also Ochlockonee River State Park, page 23). The entire river is a long journey, with few obstacles.

Dark and meandering, the Sopchoppy River twists its way from Bradwell Bay and winds almost 50 beautiful miles before discharging into Ochlockonee Bay and St. Marks National Wildlife Refuge.

Apalachicola Bluffs and Ravines Preserve

From the cliffs of this preserve owned by The Nature Conservancy, the views are more like those found in the northeast part of the US, perhaps from areas overlooking the Allegheny or Hudson Rivers. Two hundred feet below the cliffs is the fast-flowing, muddy Apalachicola River.

The soils of Alum Bluff differ from those of the northeast US, however, as they have not been formed by metamorphic rock (from the inside of the earth), but are made of limestone and various sediments. Neither has the land been bulldozed by glaciers. Rather, the bluffs have been carved over eons by running water, much like the Grand Canyon.

The blazed trail is described as three-and-a-half miles. It seems longer. It would be deceptive to give only its official length. This is not an easy hike. The trail passes up and down two steep ravines and is a good test of one's cardiovascular system. In the rain, the slopes are slippery. The reward for all this effort is the spectacular view. The trail passes through longleaf pine forest and sandhill, and there is mixed hardwood forest in the ravines.

Copperheads and eastern diamondback rattlesnakes are among the snakes found here. Among the arachnids are purse-web and trap-door spiders.

Right: a view of Alum Bluffs and the Apalachicola River.

From I-10 in Gadsden County, go south on SR-12 approximately 19.5 miles to a dirt road, north of Bristol, called Garden of Eden Road and go west a short distance.

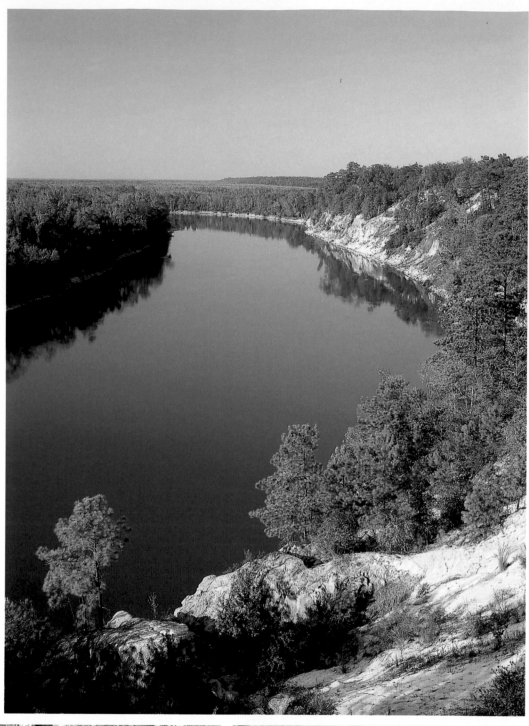

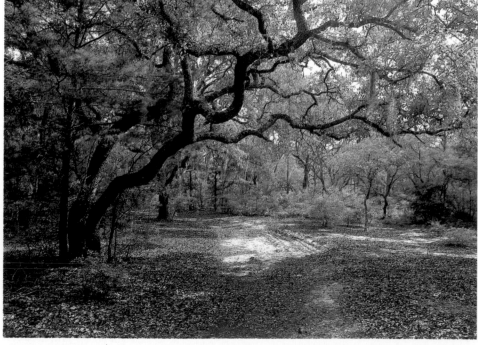

Above and right: the scenery along hiking trails in the Preserve.

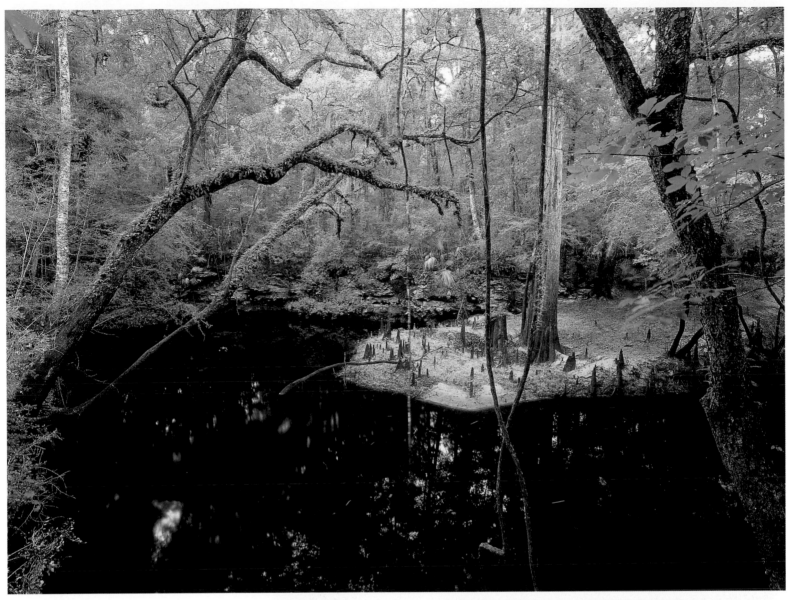

Aucilla River

The beautiful Aucilla River flows from near the Georgia border southward into the Gulf of Mexico. At about three quarters of the distance along its course, it passes through an area of porous limestone. Five miles north of US Highway 98 (or 200 yards north of Goose Pasture Road) the river abruptly disappears into an underground channel. For the next four miles southward, the Aucilla reappears in a series of limestone sinkholes, known as the Aucilla River Sinks. Before the Aucilla makes is final dip underground, it is joined by the Wacissa River flowing from the west. The combined waters of the two streams emerge finally at the community of Nutall Rise, about a half-mile north of US-98. The river then flows freely to the Gulf.

Canoeing on the Aucilla is spectacular both above the sinks area and below Nutall Rise. It is advisable to consider these two sections of the river as totally different canoe ventures. Portage over the sinks area would be extremely difficult. On the other hand, hiking through the sinkhole area is immensely rewarding. Eleven miles of the

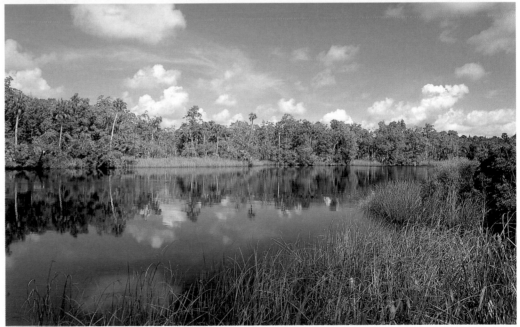

Florida Trail begin before, and end after, the Aucilla Sinks. Armadillos and wild turkey are plentiful.

Canoe trails begin at bridges on US 27 and on CR-257 south of the Lamont. For the lower Aucilla, put in at a landing slightly north of US 98. To access the Florida Trail: at 14 miles east of Newport on US 98, go north for 4 miles on Limestone Industries Road to Goose Pasture Road. Go west about 3 miles to a small rise in the road. The Florida Trail crosses here. Hike south to the major sinks area or north to the river's first submergence. The Aucilla River divides Jefferson and Taylor counties.

Top: one of the many sinks along the Aucilla River with limestone exposed.
***Above:* the scenery along the lower Aucilla River.**

Blackwater River State Forest

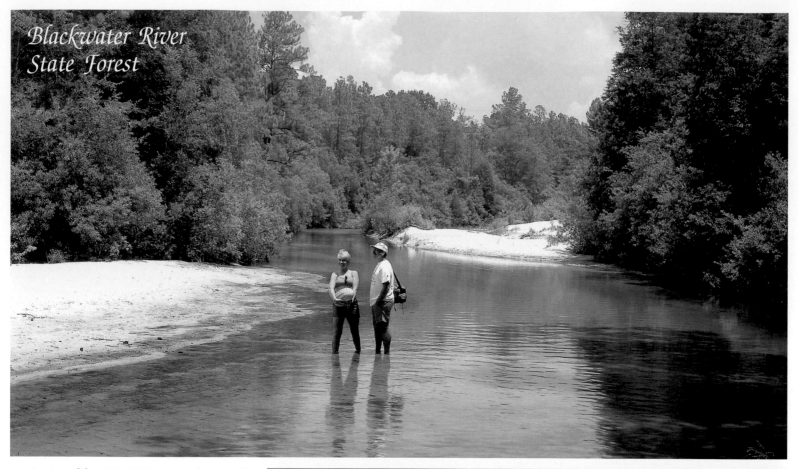

At roughly 190,000 acres, this is the largest state forest in Florida, and home to large stands of longleaf pine. It is adjacent to Alabama and connected to the Conecuh National Forest. As in the Apalachicola National Forest, wiregrass underlies much of the pine, and wildflowers color the green forest carpet in Spring and Fall. This is one of the highest-quality, longleaf, high pine areas in Florida.

Within the forest are four lakes (Bear, Hurricane, Krul, and Karick) and Cold-water Recreation Area. The lakes are popular for fishing, especially Hurricane Lake, where the largemouth bass fishing is renowned.

The Blackwater River and other creeks in the forest have sandy bottoms, and can be overflowing or almost dry depending on the season and rainfall. The river and creeks are very pure, and in a natural state. Coldwater Creek has both sandy and gravel bottoms.

North of I-10 and US-90 in Okaloosa and Santa Rosa counties. This large forest is crossed by SR-4, 87, and 191.

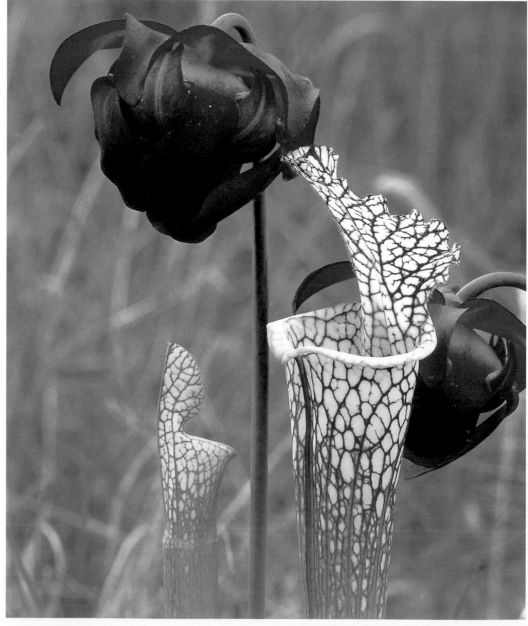

Top: picnicking along Coldwater Creek.
Right: a detail of one of the many pitcher plants, found in Blackwater River State Forest.

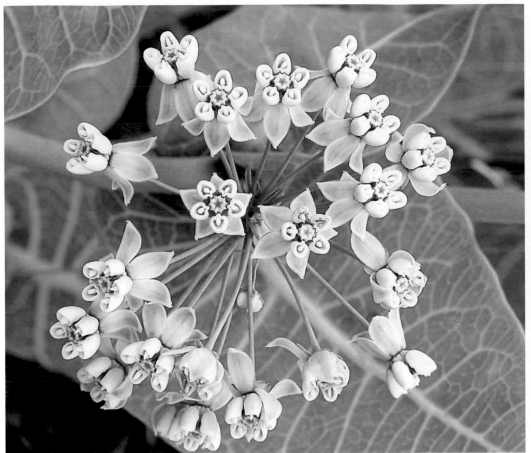

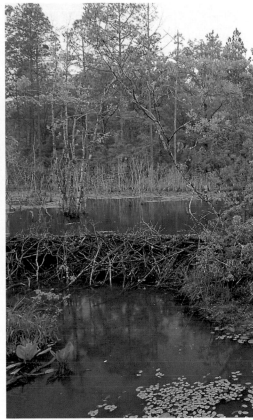

Left: variegated milkweed.
Above: a beaver dam.

ARCHBOLD BIOLOGICAL STATION

TITI SHRUBS

The name of this family of shrubs is pronounced tie-tie, not tea-tea. Two species of titi are widely found in association with swamps in Central, North, and Northwest Florida.

Black titi is found exclusively in northern Florida, and predominately in the Panhandle. Swamp titi, or swamp Cyrilla, is found not only in both northern Florida regions but also in the central region, although it is more prevalent in the north. Both shrubs are tree-like in appearance and height. Black titi is distinguished from swamp titi by vein structure. The veins are obvious on the bottom of leaves of swamp titi. Swamp titi also tends to be more gnarled and twisted, although this distinction does not always hold true. The fruit and the flowers are quite different as well.

One would not think that a swamp shrub was dependent on fire for new life, but that is exactly the case for titi and others. Swamps do burn at nature's interval in dry seasons, with some species benefiting. Fires clear the accumulated plant and tree litter.

Dead Lakes State Recreation Area

This recreation area contains over 80 acres, about a fifth of which is in the much larger area of the Dead Lakes. A ghostly-looking place because of the dead trees, Dead Lakes is actually a wide place in the slow-flowing Chipola River.

The trees in the flood plain have been killed by a combination of natural and man-made events. In the 1800s, a sandbar formed, on which cut and floating logs accumulated, creating a natural dam. Beavers contributed to the construction of the barrier, and high trapped water began to kill trees. This obstruction was eventually blasted out of existence.

Around the turn of the century, a cut was made which connected the fast-flowing Apalachicola River with the Chipola. This cut saved time for steamboats transporting naval stores, and particularly tupelo honey. The waters of the Apalachicola rush into the Chipola, blocking its slower waters like a train rushing by. This has also led to the trapping of water, which killed trees.

Tupelo honey is produced by bees that feed on the flowers of the tupelo trees. Tupelo honey will not turn into sugar, even if stored for years, nor will it turn rancid over time. In days past it was used in medicines the way alcohol is used today.

A man-made dam closed in the Dead Lakes in the 1960s. It was not needed to hold in the waters, as the flow from the Apalachicola did that. Like many environmental engineering projects, it was not well planned. Silt began to accumulate over the originally sandy river bed. The silt eventually stretched over six miles or so of the approximate 14 miles associated with the Dead Lakes. Many fish come into Dead Lakes to spawn, and they could not enter if the water level happened to be low. The dam was removed in the 1980s. The sandy bottom began to appear again, and the fishing is now better than first class. This is arguably the best fishing "lake" in Florida. But one cannot stand on its shores and cast a line. Its shores are swamp, since it is actually a river, not a lake.

Canoes and boats can be rented nearby, but not in the recreation area. There are three very short nature trails in Dead Lakes, with a total distance of less than a mile.

In Gulf County, one mile north of Wewahitchka on SR-71.

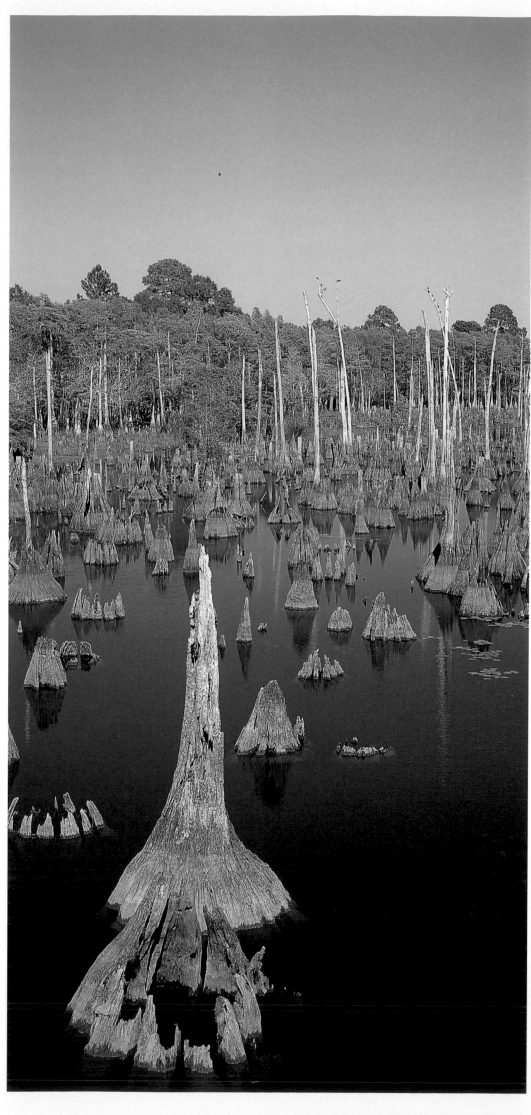

Falling Waters State Recreation Area

The lulling sound and appealing sight of a waterfall is rare in Florida. At Falling Waters, a 67-foot waterfall plunges into a 100-foot deep sinkhole. The sinkhole is connected underground to other sinkholes in the State Recreation Area, but where the water goes is unknown. A boardwalk has been constructed around these sinkholes.

The amount of falling water varies greatly with rainfall. While there are other waterfalls in Florida, this has the longest drop, and is the most consistent. The water comes from a series of small seepage springs, which flows first into a lake; then overflow from the lake continues downhill until it drops into the sinkhole.

A sinkhole begins when acidic rainwater seeps into limestone. The dissolving of limestone takes place underground, but when a sinkhole is created by the collapsing of the earth, it often appears in a sudden and dramatic manner. This is not an unusual event. In fact, several times each year Florida's newspapers print stories about a small business or home that was "swallowed up" by a sinkhole, or how portions of highways "fell in," causing traffic delays.

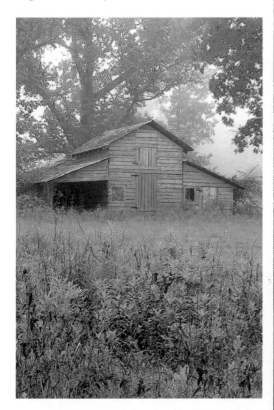

Above: an old barn on a foggy spring morning near Falling Waters State Recreation Area.

West of Tallahassee in Washington County. Exit from I-10 at Chipley, go south one mile on SR-77 to the entrance and follow the signs.

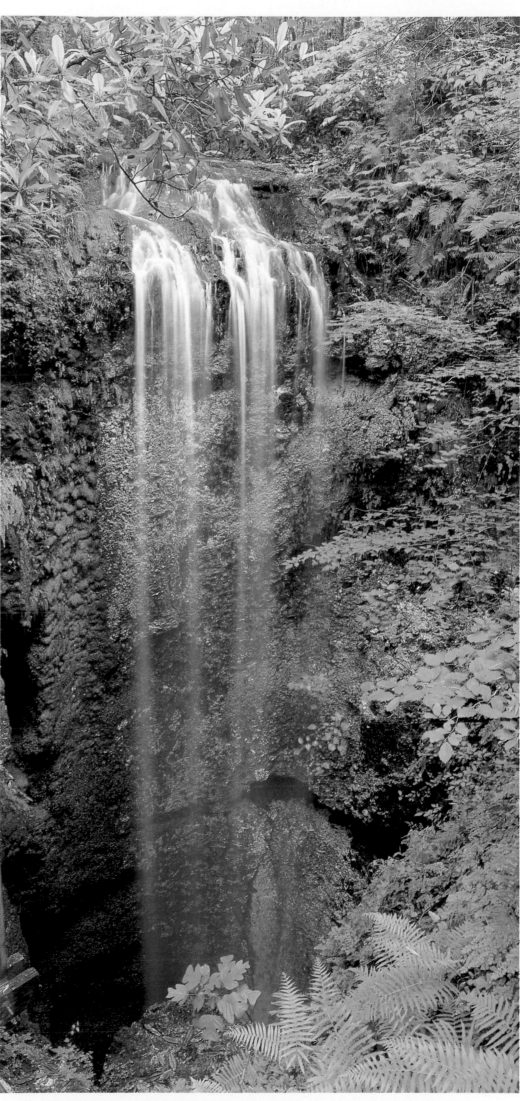

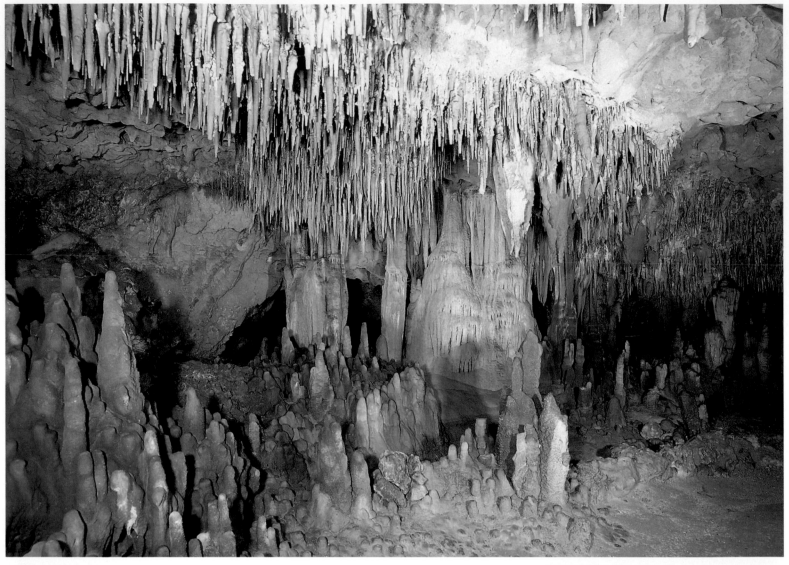

Florida Caverns State Park

Florida Caverns is located in the Marianna Karst Lowlands. It is the only dry cave in the state open for tours. The limestone was formed when Florida was under the sea. Once Florida emerged, movement of water through the limestone created the passages of the caves. Dissolution of the rock is caused by organic acids in rainwater percolating through the soil. The dissolved rock is left behind as formations as the water evaporates.

The cave system has a number of named "rooms" or natural chambers. During the 1930s, young men from the Civilian Conservation Corps chipped and dug out passageways for viewing the caverns. Two spectacular formations that were revealed were "The Waterfall," resembling a waterfall frozen in time, and "The Wedding Cake," with its brilliant whiteness. These formations are minerals deposited by the slow dripping of rain water. Formations descending from the ceiling are known as stalactites, and formations rising from the floor are called stalagmites.

The only mammals with true wings and the gift of unassisted flight are the bats.

Three species of bats are residents of Florida Caverns. All of the caverns except the tour area are closed to the public to protect the bats and caves. Species of bats found in the caves are the eastern pipistrelle (Florida's smallest bat at an average weight of one-half ounce), the southeastern bat, and the endangered gray bat. Visitors may encounter one or two bats hanging benignly from the cave ceiling.

Many creatures live in caves. Some animals, such as mice, that live primarily outside the cave, take shelter near the entrance. The animals that live deeper in caves are less well-known. Deep inside caves are creatures that live their entire lives in the darkness, and many of them have lost their vision in the evolutionary process. One example is a rare amphibian, the Georgia blind salamander. Within the underground waters are sightless crayfish and other creatures.

Although a tour of the cave system takes less than an hour, a full day can be spent exploring the 1,300 acres above ground. Hiking trails lead through dense vegetation to the lovely Chipola floodplain, limestone bluffs, sinks, and springs. There is a multi-use trail and canoe rentals for exploring a portion of the Chipola River.

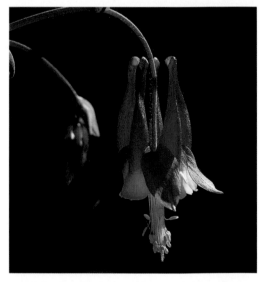

Top: **limestone formations in the Cathedral Room.**
Above: **wild columbine from the limestone area around Florida Caverns.**
Opposite page, top left: **formations in the Round Room.**
Opposite page, top, right: **the Wedding Room.**
Opposite page, bottom: **Blue Hole Spring at Florida Caverns State Park.**

Highway signs for Florida Caverns are located at both I-10 exits in Marianna in Jackson County. Follow the signs to the park located on SR-167 three miles north of Marianna.

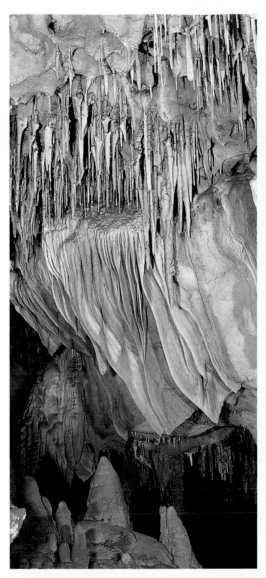

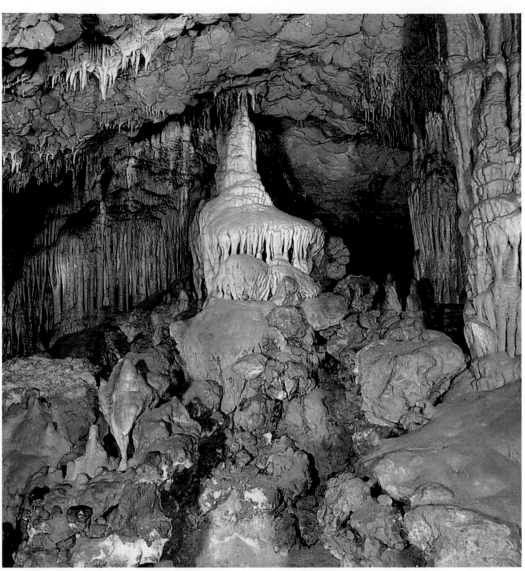

Grayton Beach State Recreation Area

"America's best beach."—*1994*

This vote was not cast by college co-eds on spring break. Nor was it voted so by tourists in search of time-share condominiums. This was the opinion of the director of The Laboratory for Coastal Research.

In much of southwest and southeast Florida, the sea can only be glimpsed between privately-owned high-rise buildings. Grayton, and much of the secluded Panhandle Gulf Coast, provides an undeveloped expanse of natural beaches, like those now lost and lamented in other parts of the state.

Besides the splendid, almost untouched beach, there is much to see and do within Grayton's 1,130 acres. Behind the dunes, there is a nature trail. First come the backdunes, dominated by sea oats. Along the trail is scrub, a hardwood hammock, pine flatwoods, a large salt marsh, and Western Lake. This freshwater lake is separated from the Gulf by a stretch of land known as a bayhead.

Hurricanes strongly influence ecosys-

tems near beaches, not only in the dunes, but in the backdunes and more inland habitats. Grayton Beach is an example showing the effect of hurricanes. It was hit hard by three hurricanes in the 1970s and to a lesser degree by other tropical storms in the 1980s and 90s. Hurricane storm surges can wash sand back from the dunes into areas where it would not nor-

mally be found. Strong winds can cause salty sand to migrate (usually) inland with varied impact on growing things, depending on their salt tolerance.

From US-98 in Walton County, go ten miles south on CR-30A for the most scenic route.

Opposite page: lupines growing along the dunes.

SCRUB BY ANY OTHER NAME

Looking at scrub on Grayton Beach and the scrub at the Archbold Biological Center in Lake Wales, one wonders if it is the same thing. The answer is yes and no.

Scrub habitat originates from ancient beaches. When Florida was mostly underwater, the Lake Wales Ridge and portions of the Panhandle were a series of islands where scrub vegetation survived.

When the seas receded, scrub vegetation migrated back to the Atlantic Coast from the Lake Wales Ridge. It also migrated from the former Panhandle "islands" back to places like Grayton. It is all scrub.

But, it is not the same. Species differ in the scrubs from one coast to the other. Species also differ in the coasts compared

to the Central Ridge.

There are some words which are used to explain this difference, but they can be confusing. Sometimes the scrub on beaches is called "coastal" scrub. This is a reference to its location. The scrub on the ridge is sometimes called "ancient."

This term seems to imply an age difference. After all, cypress trees that were not cut at the turn of the 20th century are now called ancient cypress. In reality, there is some difference in the time that scrub grew on the area, but there is no significant age difference between the plants, trees, and shrubs found in different scrub areas.

For the sake of simplicity, in this book no distinction is made among the various types of scrub.

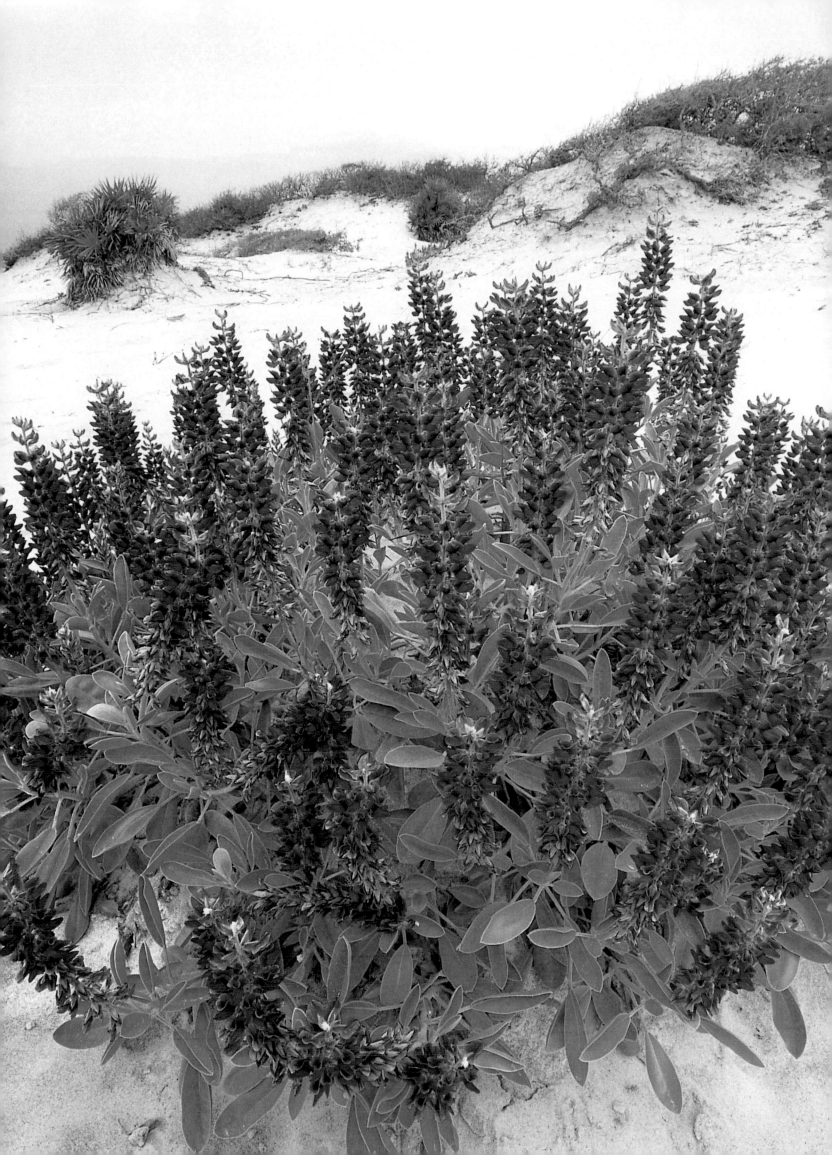

Gulf Islands National Seashore

Gulf Islands National Seashore contains barrier islands which are sand islands parallel to the shore. One theory of how barrier islands form is that rising and falling seas over time have deposited sands on sandbars (or shoals). Barrier islands are always undergoing change, and some are known to move or migrate. They are referred to as "barrier" islands because they protect the mainland from the brunt of storms.

Gulf Islands National Seashore exists in broken stretches from Destin at the east end into Mississippi at the west. It constitutes a large and diverse area not only of barrier islands, beaches, dunes, and estuaries, but also of hardwood hammocks, marshes, pine flatlands, and scrub. The Florida areas are: Fort Pickens (formerly a state park), Perdido Key (including Rosamond Johnson Beach), Fort Barrancas and the Advanced Redoubt (on board Pensacola Naval Air Station), Naval Live Oaks, Santa Rosa, and Okaloosa.

The forest surrounding Fort Barrancas and Advanced Redoubt is an excellent example of sand pine forest. The self-guided Woodlands Nature Trail is located at Fort Barrancas. Fort Pickens is popular for camping, fishing, and swimming. Johnson Beach is a developed beach with outdoor showers and picnic shelters. Two miles east of Johnson Beach is the roadless area of the park, which is more isolated and untouched.

When grasses take root, they make it possible for dunes to grow. They help to slow the drifting of the sand and allow it to accumulate. The dunes on barrier islands are constantly being built up by onshore winds or torn down by off-shore winds. Waves can add to or suck parts of them into the sea. Hurricanes and lesser storms can flatten them and carry them away. Dunes and beaches have a variety of plant life which is unique, such as the familiar cordgrass, salt grass, and sea oat. Some of the dune plant life varies considerably from one region of Florida's coast to another.

Directly south of Pensacola in Escambia County. Parts of the National Seashore can be reached by SR-292, 295, and 399. The major intersecting east-west highway is US-98. Take US-98 to the visitor center at the Naval Live Oaks Area.

Above: **Florida rosemary, pines and oaks growing in the Fort Pickens area.**

THE STORY OF GERONIMO

The well-known Native American leader, Geronimo, was imprisoned at Fort Pickens for a while after he broke his surrender agreements with the US military a number of times (sometimes with just cause). Geronimo was born in southeastern Arizona when it was part of Mexico.

There was long-standing hostility between Mexicans and Apaches. His wife, three children, and mother were scalped by Mexicans when he was about 20. Geronimo was fierce and fearless in battles of revenge. Paratroopers still scream his name when jumping out of airplanes. He has become a symbol of courage against tremendous odds.

Ochlockonee River State Park

The 102-mile Ochlockonee (*O-clock-nee*) River begins in Georgia and flows through Lake Talquin before spilling into Apalachee Bay near Panacea. Unfortunately, too many travelers experience it only as they pass over a short bridge on I-10, if they notice at all.

Off US-319, the river can be explored by boat or canoe from Ochlockonee River State Park. Canoe rentals are available. This can lead to other river explorations, since the park is located near the confluence of the Ochlockonee River with the Dead River and the Sopchoppy River. The park also offers the best way to access St. Thoms Island Wilderness in St. Marks National Wildlife Refuge.

The 400 acres within the park are mostly grassy ponds and scenic pine flatwoods. They are filled with wildflowers in the Spring and Fall. As with the adjacent wildlife refuge, this is an excellent place for viewing birds of all kinds. The red-cockaded woodpecker is found here, and benches have been placed on some of the trails for easy observation of their nests. White-tailed deer are plentiful. This jewel of a park is rarely crowded.

At top: pine woods, grasses, and blazing star wildflowers.

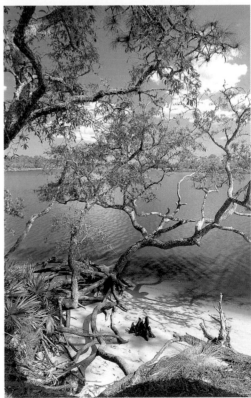

Above: **an oak tree along the Ocklochonee River.** ***Left:*** **a red-bellied woodpecker.**

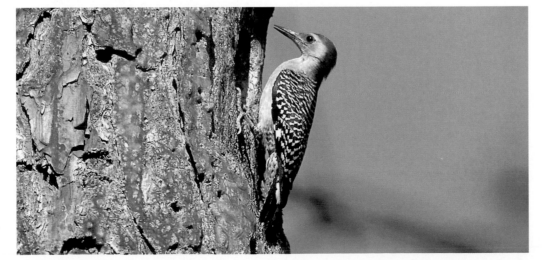

On US-319 four miles south of Sopchoppy in Wakulla County. US-319 is a connecting road to the north at I-10 and to the south at US-98. This park is much closer to US-98 than I-10.

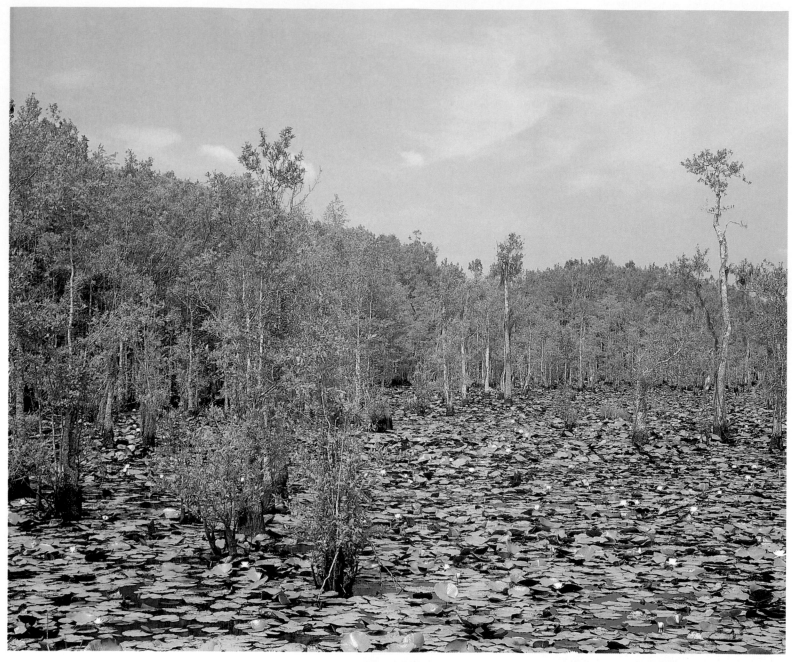

Pine Log State Forest

Despite being close to Panama City, this forest is little-known and little-used. Outside of the camping area, Pine Log can usually be explored without running into another human. It is filled with wildlife, a large variety of plants and trees, and a number of hiking trails, from a few miles in length to eight miles of the Florida Trail.

The 6,911 acre forest is named for Pine Log Creek, whose tannin-colored waters pass through it. Pine Log is Florida's first state forest, established in 1936. There are two lovely lakes within the forest, one with a sandy shore and open to swimming.

Top: a lily pond near the forest.

Right: a cypress pond within the forest.

14 miles north of Panama City Beach on SR-79 or 35 miles south of I-10 at Bonifay on SR-79 in Bay County, just south of Ebro.

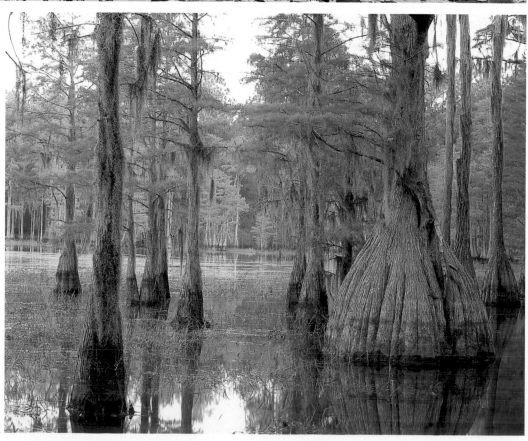

THE FLORIDA TRAIL

The Florida Trail, or Florida Scenic Trail, is part of the national system of hiking paths. The goal of the National Trail Association is to connect as much of the US by natural footpaths as possible.

Because Florida is flat, it is perhaps the easiest state to hike. Florida Trail Association members are volunteers who maintain and blaze trails within Florida. The association sponsors camping, educational events, and hiking, often combined into recreational weekends.

The state office can be contacted at Florida Trail Association, PO Box 13708, Gainesville, FL 32604. There may be more than 2,500 miles of designated hiking and multiple use trails in Florida, and some of the prime trails are included in what is known as the Florida Trail. As of 1998, 1,000 miles of the Florida Trail had been completed, with 300 more to be added.

Above: **a portion of the Florida Trail in Pine Log State Forest.**

St. George and Little St. George Islands

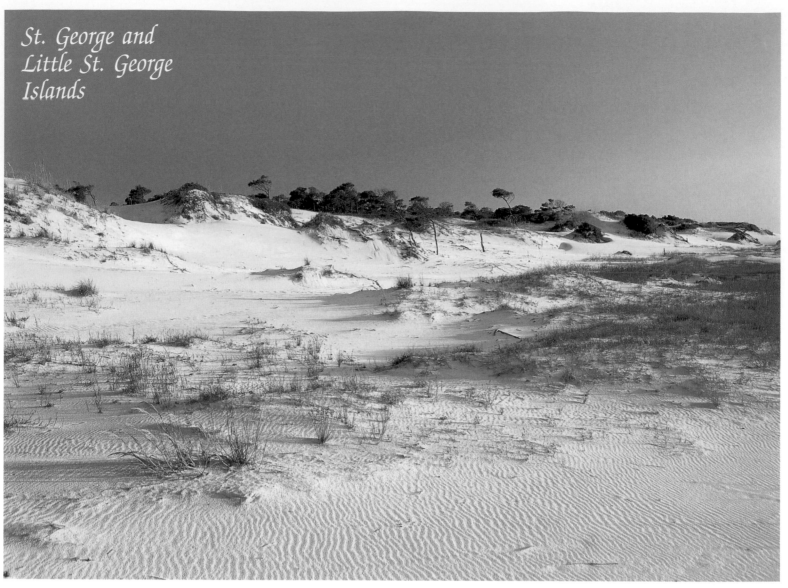

The Panhandle is rich in natural barrier islands. In addition to those in the Gulf Islands National Seashore, there are Dog Island and the three "saints"—St. Andrews, St. George, and St. Vincent. There is also St. Josephs Peninsula, which was once a barrier Island.

St. George Island is connected to the mainland by a single bridge and is the most accessible of the barrier islands. The park includes the entire eastern portion of the island, nine miles of pristine beach plus hiking trails. Beach, dune, marsh, and scrub can be explored.

Little St. George Island once was a part of St. George. However, powerful former Congressman Bob "He-Coon" Sikes was responsible for the dredging of a channel in the early 1970s, which separated it from St. George.

Locals call this channel "Government Cut" or "Bob Sikes Cut." This project redesigned what nature had taken over 6,000 years to create. The justification for this project was navigational improvement, as the accumulation of sand around St. George was causing boats to get stuck.

Cape St. George State Reserve on Little St. George Island is accessible only by boat. The benefit of this is that the smaller is-

land is undeveloped and remains in a wild state. There is no scheduled boat service, but a few companies in the area rent boats or conduct guided tours.

Reached by a prominently marked bridge in Eastpoint off US-98 in Franklin County.

Top: large dunes and dune vegetation at sunrise.

Above: colorful grasses and a distant waterway.

Opposite page: red-winged blackbirds feeding on sea oats.

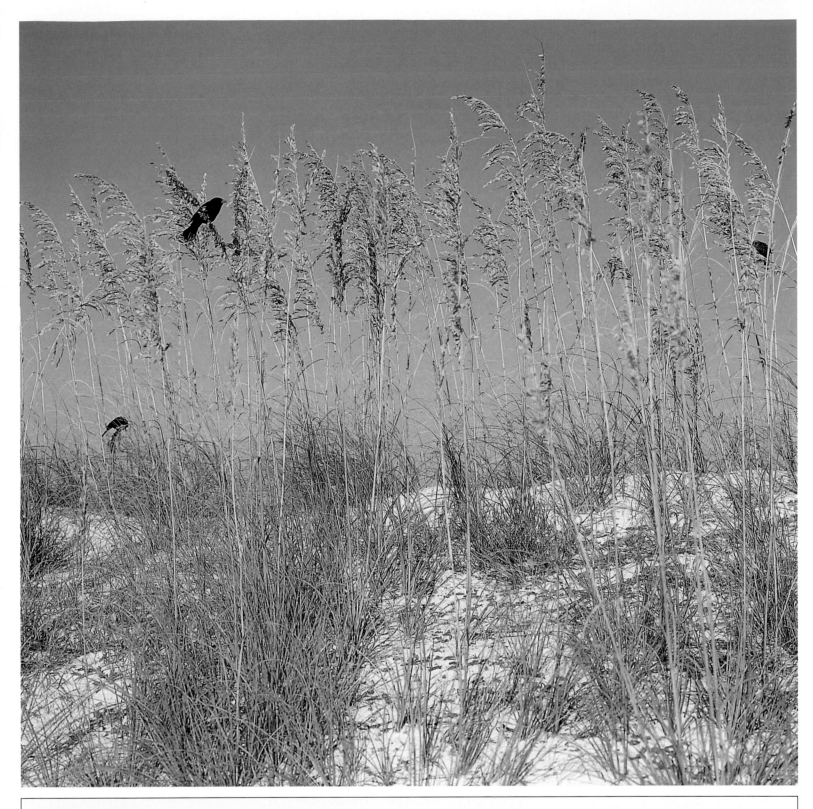

WATER WORLD

Wind and fire have played vital roles in forming Florida, but water gives it life and has shaped it most. Many think of Florida's beaches as paradise vacation spots, and so are familiar with the rougher waters of the Atlantic Ocean, and the gentler seas of the Gulf of Mexico. Florida's coastline greatly exceeds 1,000 miles, and the state has over 1,700 rivers and streams, nearly 7,700 natural lakes, many marshes, sinks, swamps, and more than 300 major springs (27 of which are considered powerful, first magnitude springs). It has large bays, many estuaries, and natural inlets along its coasts. Underground, there is a vast, slow-moving sheet of water, the veins and arteries of the state.

Geologists have defined five aquifer systems for Florida, including a sand and gravel aquifer in a small part of the western Panhandle, a surface system that can be seen above ground, and an intermediate aquifer between the surface and deeper aquifers. The most important aquifers for humans are the Floridan Aquifer, which begins in South Carolina and underlies the entire peninsula, and the Biscayne Aquifer in the southeast, which is above the Floridan Aquifer and separated from it by limestone.

In the winter months, Florida receives rains from frequent cold fronts. In the warmer months, the plentiful rainfall is mostly from local thunderstorms. This rainfall is governed by a combination of the Gulf Stream (a current in the ocean), the Bermuda High (an area of high pressure typically close to that island in the warmer months), and the Jet Stream (powerful air currents located high in the atmosphere). Most of Florida gets around 60 inches of rain a year in a normal year; on the average the wettest area is around Tallahassee. The number of days with rainfall is not much different from the rest of the eastern US, but the rains are more intense in Florida.

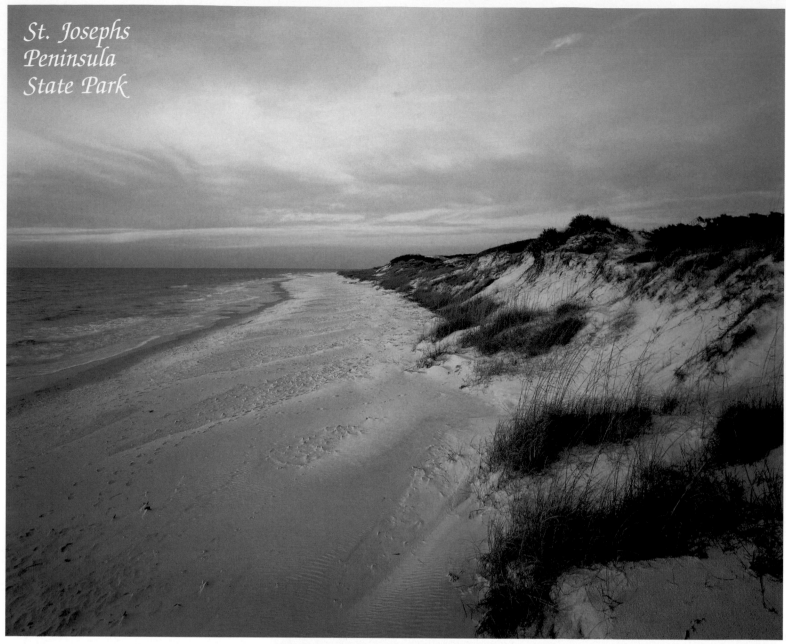

St. Josephs Peninsula State Park

This 20-mile peninsula was once a barrier island. A land bridge has formed connecting it to the mainland. There are beautiful wild beaches to be hiked. The number of hikers allowed into the north part of the peninsula is controlled. In addition to beach, there are pine flatwoods, hardwood hammocks, and scrub.

St. Josephs is well-known as a "must" for birders. A variety of flycatchers, plovers, terns, warblers, and waterbirds can be seen. In Fall, numerous migratory hawks, some traveling between Canada and Peru, use the peninsula as a stop on their journey. These birds of prey include not only Cooper's hawk and the sharp-shinned hawk, but also the endangered peregrine falcon. As happened decades ago with brown pelicans, pesticides caused female peregrines to produce eggs with thin shells. Unlike the brown pelicans, the peregrines have not recovered well from this human-inflicted disaster.

25 miles west of Apalachicola in Gulf County. From US-98, turn west on CR-30A and follow the signs.

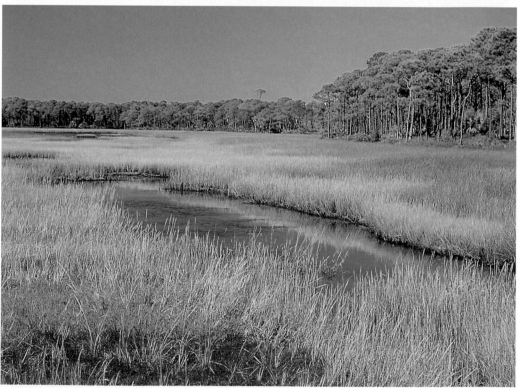

Top: the dunes along St. Josephs Peninsula at sunset.
Above: the colorful marsh in fall along the bayside of St. Josephs Peninsula.
Opposite page: gulls along the beach at sunset.

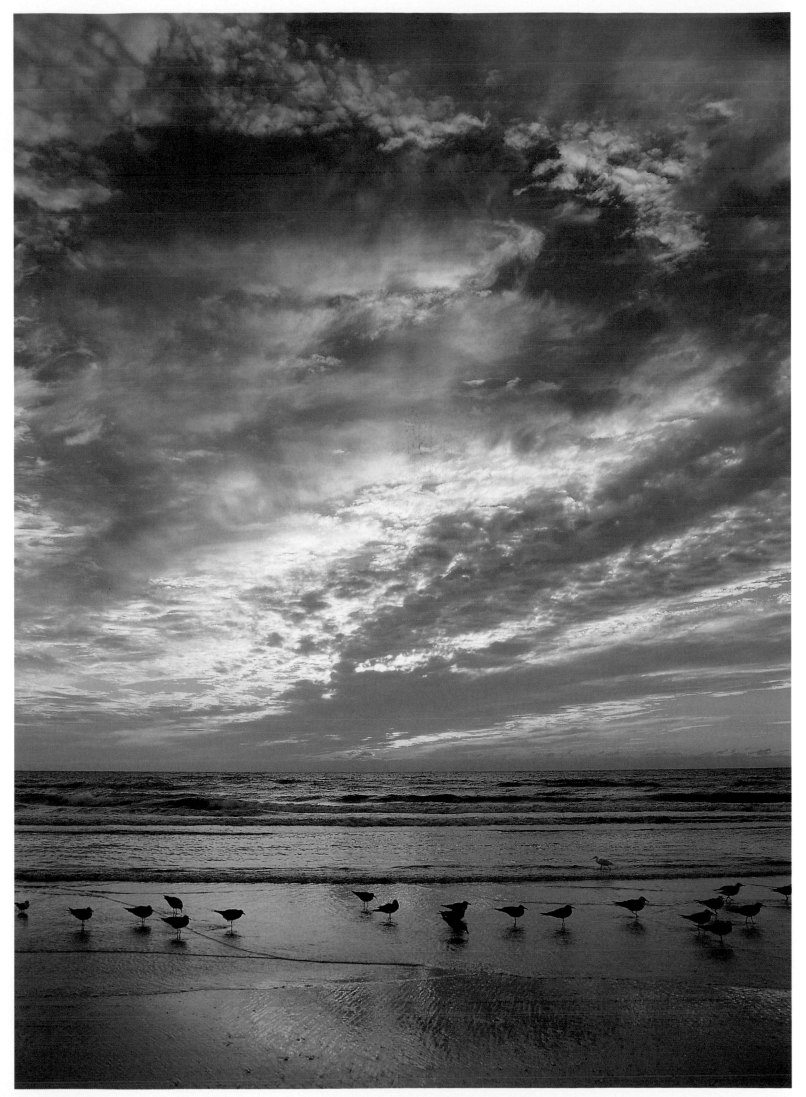

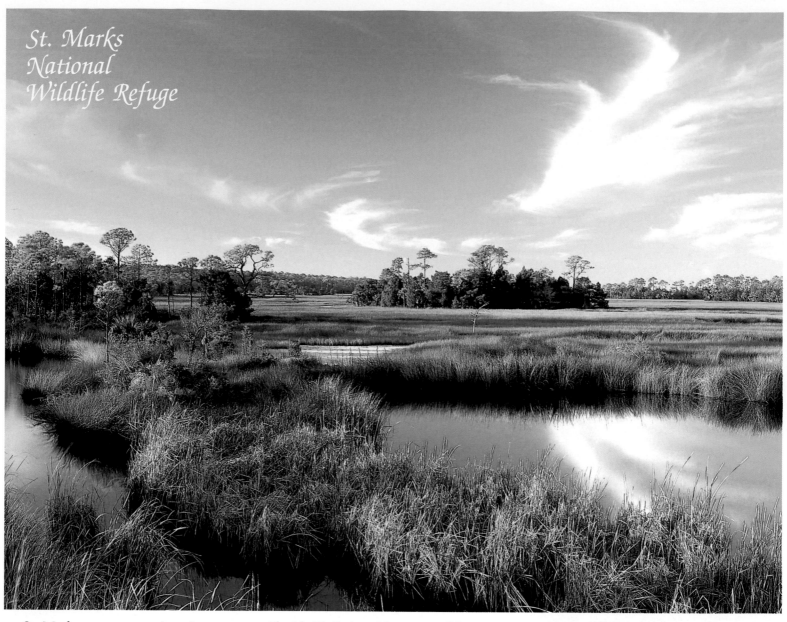

St. Marks National Wildlife Refuge

St. Marks serves as a wintering retreat for migratory birds and waterfowl. Ducks, geese, and other migrating birds shelter here on their journeys. Bald eagles are among more than 300 types of birds which have been observed at St. Marks.

During their northward migration in late March or early April, St. Marks is the most likely place in Florida to see migrating hawks. Also, during September and October, the hawks soar on thermals in clusters known as "kettles" because the concentrations of birds appear to "boil" as they circle and rise up and down in what seems like a cauldron in the sky.

At almost 100,000 acres, St. Marks is so large it has been divided into three districts for management: St. Marks, Panacea, and Wakulla. Of this 100,000 acres, about a third is part of Apalachee Bay.

There are a number of interesting ways to see the wildlife in St. Marks. The sole road for vehicles is called "Lighthouse Road" because it ends at a scenic lighthouse, which is still operated by the Coast Guard. There are hiking paths along the top of dikes built to control water flow. Part of the dike road system is in the Florida Trail. As with many wilderness areas, there is an old logging pathway, the Aucilla Tram Road.

In the hammocks, lakes, marshes, pine flatwoods, springs, and bay, the success of St. Marks as a refuge can be seen by its inhabitants. The alligator population at St. Marks was estimated to be approaching 3,000 as of 1998. Alligators are one of over 100 reptile and amphibian species which can be found in the refuge.

The refuge is rich in small creatures, such as butterflies. The annual arrival of migrating monarchs on their way to and from Mexico is the most notable butterfly event, but many other types of butterflies can be seen.

In the Spring there are many varieties of lovely wildflowers. A small population of Florida black bears lives at St. Marks and these bears are frequently seen. Also at St. Marks there have been sightings of the jaguarundi, a small tropical cat that resembles an otter, which was introduced into Florida. There has been at least one confirmed sighting of the endangered Florida panther in the refuge.

Top: **early morning view of the marshes.**
Above: **water lilies and marsh.**

From Newport on US-98, go south four miles on CR-59. Signs are prominent. Located in Jefferson, Taylor, and Wakulla counties.

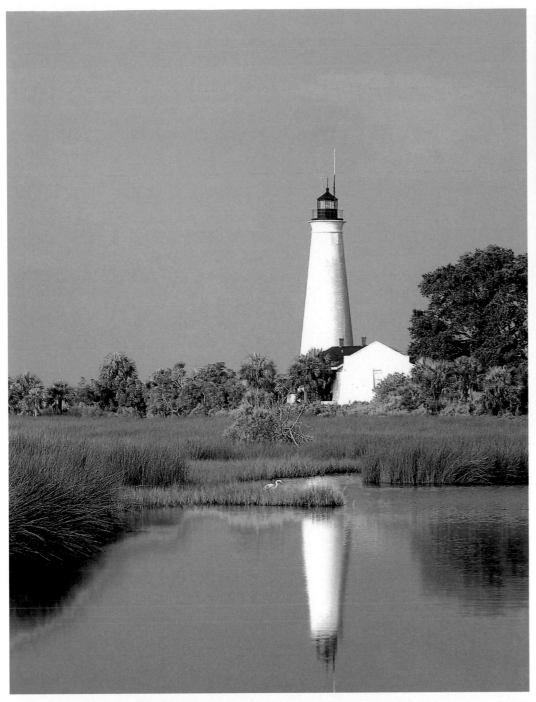

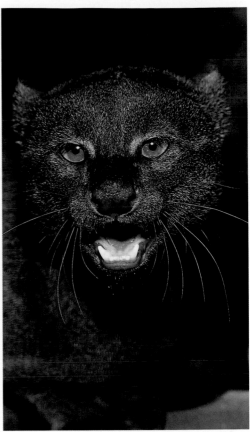

Left: the St. Marks lighthouse with a lone egret feeding in the marsh.

Above: the jaguarundi, a cat native to the southwestern US and Central America, which has been introduced to Florida and may have established colonies in some areas of the state, such as St. Marks. Some mammal experts dispute the presence of this exotic creature.

Below: a coastal marsh at sunset near St. Marks.

WHAT IS A PRESERVE?

Here are a few helpful descriptions of those places which are not "parks," including abbreviations often seen.

Forest. *Forests are managed for multi-use, but timber production is the primary use. Most forests have hunting seasons. A national forest is abbreviated NF, while SF means state forest.*

Preserve. *The major function of a preserve is preservation. Hunting is allowed in both preserves and refuges so long as it does not conflict with the primary purpose for which the lands were acquired. Lumbering is not usually allowed in preserves and refuges, but there have been exceptions.*

State Recreation Area. *These areas are intended for human activities, such as swimming or having a picnic. The abbreviation is SRA.*

Refuge. *A refuge is usually designated for the protection of some specific plant or animal. Hunting is allowed in some cases.*

Wildlife Management Area. *Wildlife is managed for hunting. The abbreviation is WMA.*

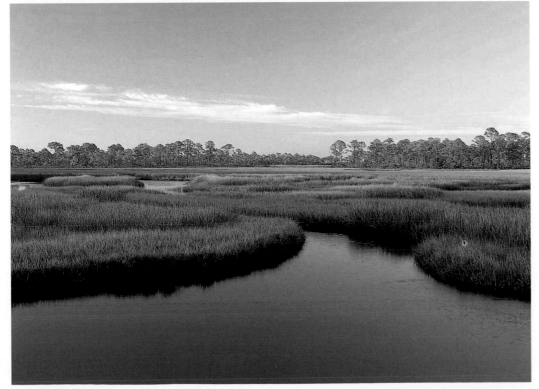

St. Vincent National Wildlife Refuge

The 19-square miles of St. Vincent are some of the wildest in Florida. The island is truly in primitive condition. Only a short distance from the mainland across Indian Pass, it can be reached by boat, canoe, or kayak. In its bayous, alligators float in brackish water.

The bay-side of the island is a nine-mile stretch of pinelands and bayous. The bayous are rich estuaries for mullet and redfish. The gulf-side is wildly tropical in appearance, with endless palms, sand dunes, and congregations of seabirds.

Hiking the 80 miles of trails is a challenge for the serious wilderness adventurer. There are no "facilities." Water and food must be carried, as well as repellent. Every insect pest known in Florida is apparently here to challenge the hiker, especially in summer. The policy for the refuge is that visitors must "Pack it in, and pack it out," which includes water, food, and trash.

Once a privately-owned hunting preserve stocked with exotic animals such as zebra, the US Fish and Wildlife Service has now re-established red wolves on St. Vincent. Red wolves are extremely wary and rarely seen. The red wolves hunt many of the predators of loggerhead turtle eggs, so the loggerhead turtles are making a comeback. If red wolves are found, it is usually around the lakes where native white-tailed deer and Asian sambar deer (descendants of those imported for the private hunting preserve) are also seen. The sambar deer is a large species of elk (up to 700 pounds) which has unusually large ears. There are six large lakes on the island; five brackish and one freshwater.

St. Vincent is brimming with wildlife. Bald eagles, gopher tortoises, indigo snakes, venomous cottonmouths, pygmy and eastern diamondback rattlesnakes, waterbirds, and wood storks are some of the most interesting species. The loggerhead turtles lay their eggs on the beaches in summer.

The Nature Conservancy purchased the island in 1968, and transferred it to the US Fish and Wildlife Service. There are times when access to St. Vincent is restricted. It is best to call the refuge office in advance.

This barrier island in the Gulf of Mexico is southwest of the city of Apalachicola in Franklin County and is reached by boat. A list of boat rentals and guides is available from the Chamber of Commerce in Apalachicola.

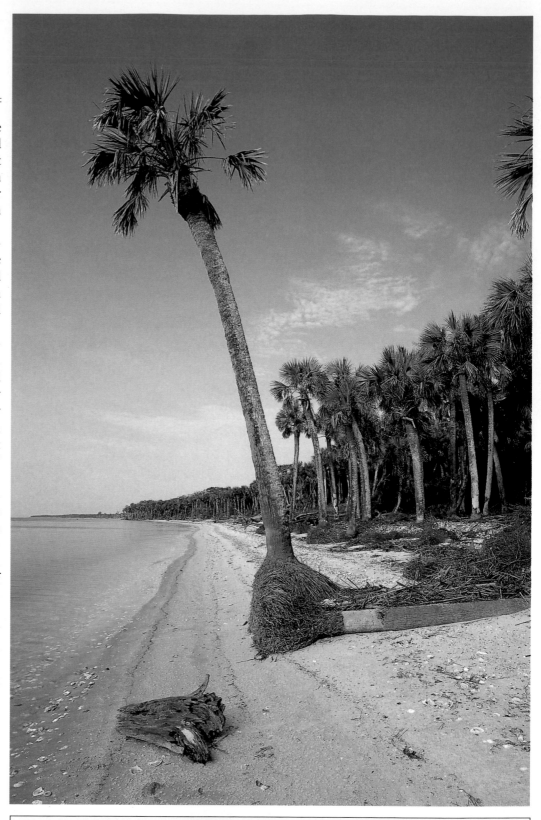

WHERE OUTBOARD MOTORS CAN'T GO

In the twisting, shallow narrows of St. Vincent's bayous, poling is the only way to move forward. For those who wish to visit the island with the help of an expert guide, Tom Brocato of Broke-a-Toe Outdoor has the skill and knowledge to navigate these tangled passages

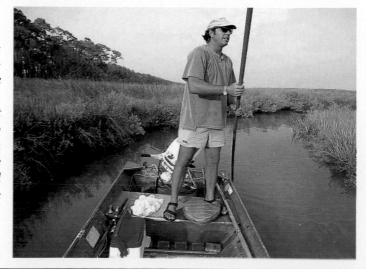

Top: a colony of red wolves has been established on the island. *Above:* one of the Asian sambar deer remaining from the days when the island was private hunting preserve. *Right:* one of the many primitive roads on St. Vincent Island. *Below:* southern red cedar with berries.

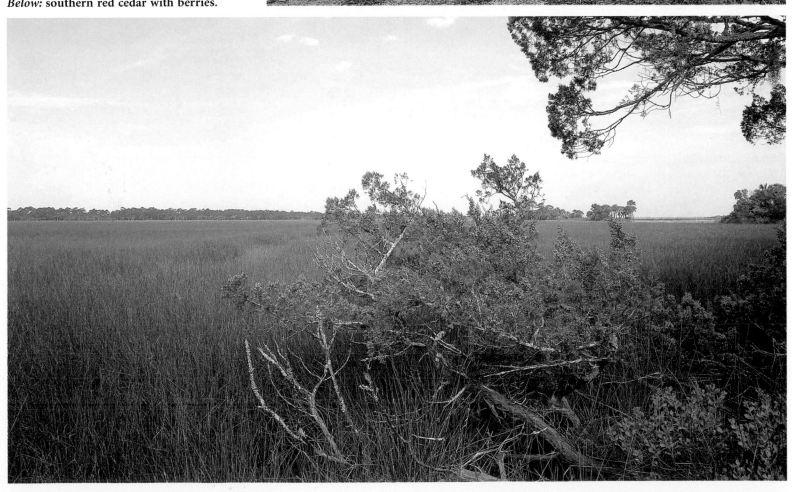

Torreya State Park

Torreya is a wonderland for nature-lovers. It contains a wide variety of flora. A 31-page checklist of plants is available from the visitors center, and it is single-spaced. Perhaps 120 species of plants here are considered threatened or endangered. It is estimated that over 140 bird species can be seen in the course of a year. Over 60 reptiles and amphibians can be found in the park, including eastern diamondback rattlesnakes and copperheads. Among the mammals are raccoon, bobcat, deer, gray fox, beaver, fox squirrel, and river otter.

This park can be enjoyed by someone with little knowledge of nature because of its spectacular views and colorful panoramas. The serious naturalist, however, could easily spend weeks in the park investigating the wide variety of trees, plants, and wildlife.

The park's namesake is the endangered Florida torreya tree. It is found only in this area, as is the Florida yew. Torreya trees were so widespread at the turn of the century that they were reportedly used as Christmas trees. However, the torreyas were later almost wiped out by a fungus. They are now found only in a small area.

About 12,000 years ago, glaciers covered much of North America, and the climate at Torreya was extremely cold. It is believed that some of the plant and tree species here are remnants of the last ice age. They managed to survive after the climate changed. Such species are called relict species.

There are three hiking trails in Torreya. The Weeping Ridge Trail is short, not difficult, and leads to the only waterfall in the park. Although the waterfall is small, the tranquility is immense. The Torreya Trail is seven miles of slopes and ravines that have been eroded by the many white-sand-bottomed steams found in the park. This trail can be shortened to as little as two miles and is considered to have some of the most challenging hiking in Florida due to its steep and sometimes slippery slopes. The Rock Creek Trail is also seven miles (plus two miles for access), but must be accessed off the Torreya Trail and completed in its entirety.

The view of the Apalachicola River from the heights of the park (like the nearby Nature Conservancy Apalachicola Bluffs and Ravine Preserve) is scenic and reminiscent of more northern forests. The park's greatest elevation is over 250 feet, and the overlooks are 150 feet above the river. In the fall of some years, visitors will be impressed by the changing of leaf colors.

The color change here is far superior to any other place in Florida, since many hardwoods found here are more typically found in the Appalachian Mountains of Georgia.

The Gregory House is a plantation era mansion which was moved into Torreya SP from across the river by the Civilian Conservation Corp in 1935. There are several CCC era structures in the park, including a magnificent stone bridge. In the former servants' quarters are the rangers' office and a gift shop. There are ranger-guided tours of the house. There are Civil War gun emplacement sites in the park, but it would take a truly imaginative and knowledgeable Civil War buff to make much of the sunken earth where the guns of war once stood.

West of Tallahassee in Liberty County. South of I-10 between Bristol and Greensboro. From SR-12 follow the signs to CR-1641. Take CR-1641 to the end.

Top: the Apalachicola River from Rock Bluff.
Below: a torreya tree.
Opposite page: strange formations in clay ravine.

Wacissa River

Eight or more springs give rise to the crystal-clear Wacissa River which flows southward for about 12 miles through a corridor of magnificent cypress and other huge trees. Nine miles below the head springs, the river passes Goose Pasture campground, the terminus for most canoe ventures. About three miles farther south, the river bends eastward and joins the Aucilla River. The combined streams disappear into an underground channel and eventually emerge at the community of Nutall Rise. The Aucilla (plus Wascissa), then flows unobstructed to the Gulf.

The Wacissa River is one of the most beautiful canoe trails in Florida. It is not well-known and has not been highly promoted because the lands through which it flows have been privately owned. Downstream along the Wacissa are several sizable springs, the largest of which is Big Blue, about 50 feet in diameter. This is a popular spot for swimming and diving.

Allen Green, "the Canoe Man," leads tours of the Aucilla and Wacissa. He can be contacted at POB 277, Lloyd, FL 32337.

In Jefferson County. From US-27, go south on SR-59 to Wacissa. SR-59 splits, with one part continuing to US-98, and the other becoming an unmarked road which leads directly to the spring just south of town.

Bottom, right: mist rising over the head spring.

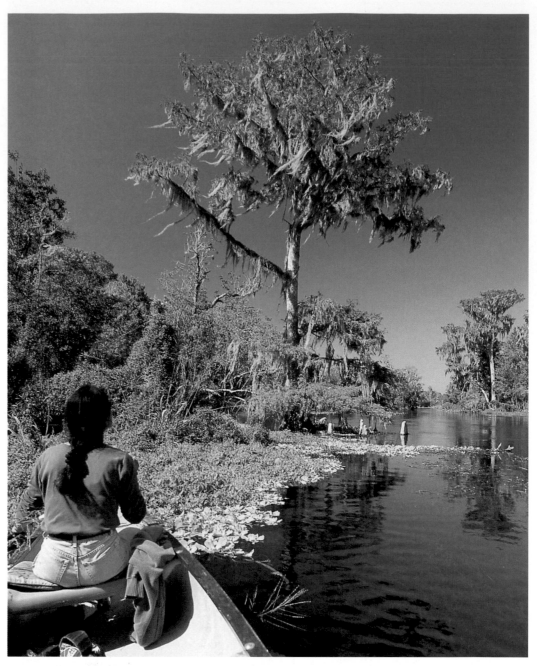

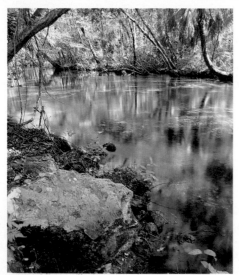

THE SLAVE CANAL

According to local legend, Native Americans had a secret waterway through swamps which allowed them to carry goods by water, bypassing the portion of the Wacissa which flows underground. This valuable route was initally kept a secret from the white settlers who eventually discovered its existence. The settlers then used their black slaves to improve this secret channel, hence the name, Slave Canal.

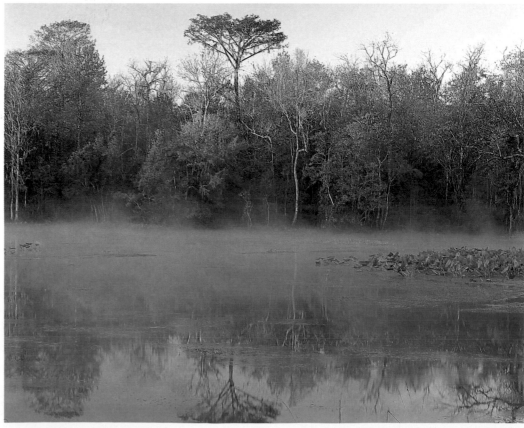

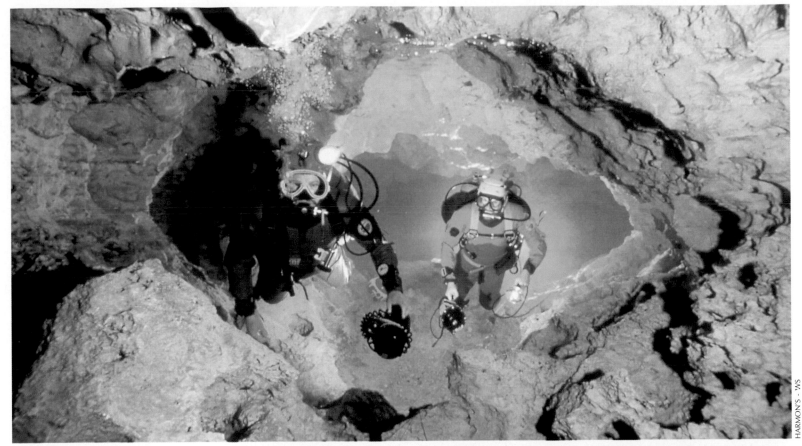

HARMON'S · WS

Wakulla Springs State Park

This is perhaps the deepest and most productive spring in the world. Here, Mother Nature pours forth an average of 400,000 gallons of water per minute. The daily output has exceeded a billion gallons. To put this in perspective for a homeowner, at only one-half cent a gallon, the average water bill would be $2,880,000 *per day!*

To protect the spring, access is limited. The only way to fully appreciate this place is to take an officially-guided boat tour. The bones of a mastodon, a predecessor of the elephant, have been found here. No private boating or fishing are permitted.

The property on which the spring is located was once controlled by Ed Ball, a lover of nature who administered the Dupont Estate. Ball was so powerful in politics he was able to influence the nomination of senators and governors. He built a lodge on the grounds near the spring, which now serves as a hotel.

Ed Ball played a role in a bitter political campaign between George Smathers and then US Senator Claude Pepper. Congressman George Smathers had been elected with the help of Pepper and had promised to never run against the senator. But with encouragement from Ball, Smathers took on Pepper and won after a vicious campaign in which Pepper was smeared as "red pepper."

On SR-267, four miles west of the community of Wakulla in Wakulla County.

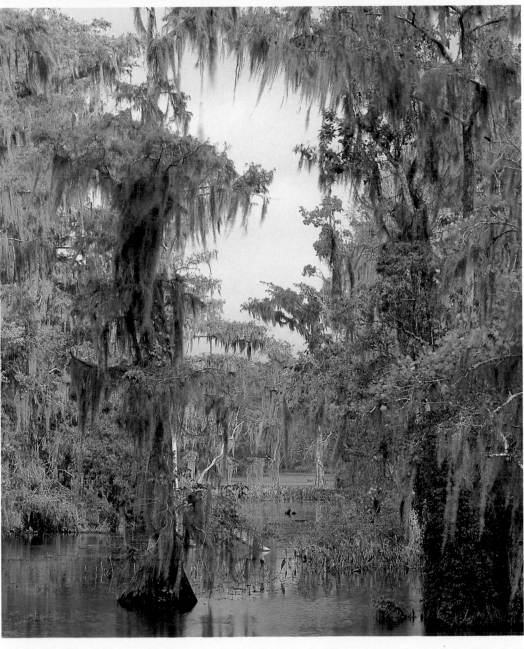

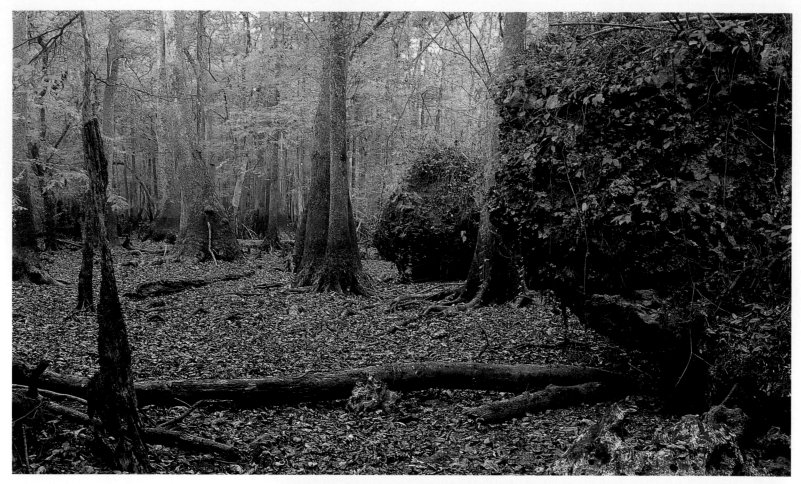

Other Northwest Florida Adventures

APALACHICOLA RIVER WILDLIFE AND ENVIRONMENTAL AREA

Almost 56,000 acres of swamp and watery hammock in Franklin and Gulf counties. Accessible only by boat. There are many landings, starting with Land's Landing in Wewahitchka in the north. A list of regulations and an area map is available from the Florida Department of Environmental Protection or the Florida Fish and Wildlife Conservation Commission.

EGLIN AIR FORCE BASE

South of I-10. North of Ft Walton Beach. Crossed by SR-85, SR-87, and SR-285. The Air Force controls a large portion of the Panhandle, where there are campsites by permit only, and longleaf, high pine areas.

MACLAY STATE GARDENS

From I-10 in Tallahassee, exit north on US-319. Go one mile. Best seen January through March. Although this is not a wild place at all, it is very interesting due to its wide variety of flowers. Some hiking and two nearby lakes.

PONCE DE LEON SPRINGS SRA

East of Ponce de Leon on SR-181A from US-90. The spring flows into Sandy Creek and then the Choctawhatchee River. Two

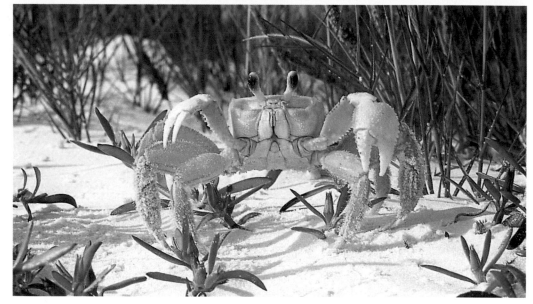

nature trails.

ROCKY BAYOU SRA

East of Niceville five miles on SR-20. Three trails, scrub, sand pine, and the brackish Rocky Bayou, which is part of Choctawhatchee Bay.

THREE RIVERS SRA

Two miles north of Sneads on SR-271. Adjoins Lake Seminole for four miles. Includes two nature trails, beaches, and great birding.

TOPSAIL SP

From US-98, ten miles east of Destin. Gorgeous beaches, two lakes, high sand dunes, and hiking trails.

ECONFINA RIVER STATE PARK

Located in Taylor County. From US-98, go three miles east of the Aucilla River, on SR-14.

About 3,000 acres along the Econfina make up the park. The Econfina River is a 43-mile blackwater river which originates in swamps, then flows into the Gulf of Mexico.

As the river meanders to the Gulf, its banks become salt marsh with scattered coastal hammock. In the marsh are numerous small estuaries. At the mouth of the river are oyster beds, which can be dangerous to boaters at low tide. The inland portions of the river are best accessed by canoe or kayak rather than motorboat.

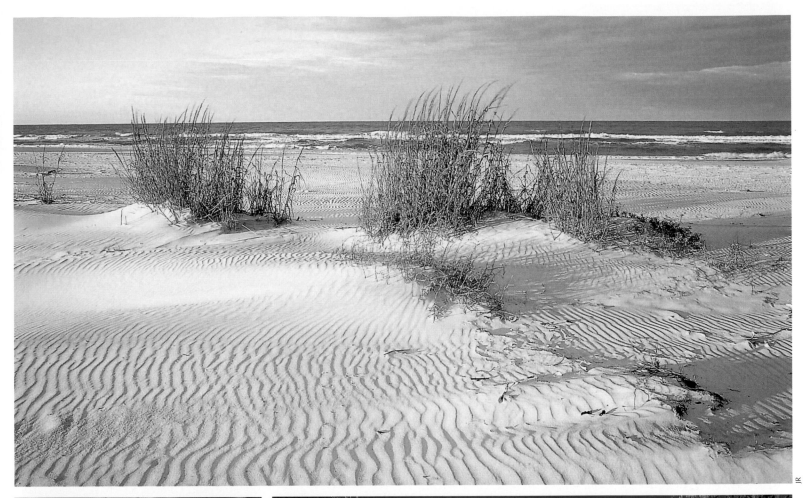

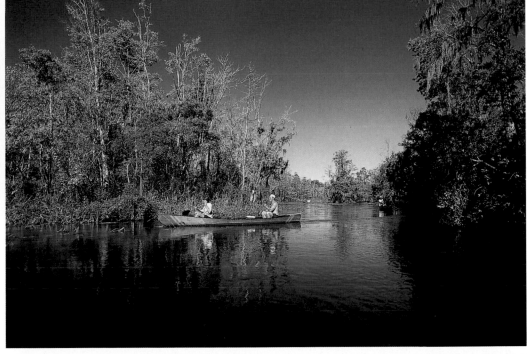

Opposite page, top: tupelo and other trees in the Chipola River floodplain.
Opposite page, below: a ghost crab on the white sand beach of St. George Island.
This page, top: a portion of the beach at St. Josephs Peninsula.
Above: a spiderwort blooming in Blackwater River State Forest.
At right: canoes on the Wacissa River.

FIRE AND HABITATS

Many ecosystems in Florida are dependent on fire for their existence. Some plants and trees need fires to prune them or to open the canopy to admit sunlight. Fire can be a kind of sanitation service, burning off litter, and turning it into rich nutrients for the soil.

To some habitats fire is not an enemy, but a preserving friend, as the habitat will disappear or change into another entirely different ecosystem without fire at the right time. Many birds, mammals, reptiles and amphibians adjust to fire, some going underground, or leaving the area temporarily.

Before modern times, fires were mostly natural occurrences, although Native Americans sometimes used fire to clear lands or to hunt. Early settlers burned off land as an easy way to clear a field for agriculture. In the last fifty years, human presence has restricted natural fires by a network of roads. No one with a dwelling near a natural area welcomes a potentially home-destroying blaze, so forest fires that occur naturally are often fought and stopped.

For these reasons, management of many ecosystems, such as forests and scrub, is now thought to require planned burns. There are many factors that contribute to a decision about when to burn. These include, for example, rainfall or lack of it. Controlled burns are largely determined by the uniqueness of each area, and authorities are hesitant to write explicit frequency guidelines for burning for fear that such an artificial regimen could do more harm than good.

North Florida

Traveling from Savannah to Jacksonville on I-95, it would be difficult to tell where Georgia ends and Florida begins if it were not for a sign announcing the border. The only other clue is also the sudden appearance of palm trees planted in the middle of the interstate.

North Florida east of the Panhandle is very much like south Georgia. Both states have tidal estuaries along the coast as far as one can see from the highway. Tall marsh grasses extend to the Atlantic Ocean interspersed with winding waterways.

In the northeast of Florida, the barrier islands are more similar to those in the Carolinas and Georgia than those along the Gulf Coast. There is a difference not only in the sand, but in the species associated with the dunes.

Florida is not well-known for whale-watching, but the shallow coastal waters of northeastern Florida fall within an area formally designated, under the Endangered Species Act, as critical habitat for the severely endangered North Atlantic right whale. There are only 300-350 right whales

surviving in the North Atlantic, and their main calving ground is from Jacksonville Beach north to Brunswick, Georgia.

Georgia's spectacular Okefenokee Swamp continues into Florida through the Pinhook Swamp and into the Big Gum Swamp of Osceola National Forest. The rivers of this region include the small and lovely Ichetucknee, the Santa Fe, and the Suwannee, which also extends from the Okefenokee Swamp, through the Suwannee Valley to the Gulf. Two national forests are within this region, the Osceola and the Ocala. The Ocala has the largest forest of sand pine in the world in an area known as the "Big Scrub."

The longest river in Florida, the St. Johns, reaches 300 miles from South Florida to North Florida. The Suwannee River is 280 miles long, but only 207 miles of it are in Florida; the beginning is in Georgia. Early naturalist John Bartram traveled on the St. Johns River and described the adventure in his journals. The river was also used for transportation by the great wildlife artist, Audubon, who

came to paint Florida's birds. The St. Johns is one of America's few north-flowing rivers. Its source is in marshlands 25 miles north of Lake Okeechobee.

This is a generally flatter area than the Panhandle. Moving south through the region, there is a gradual transition to the type of terrain most people think of as Florida. The vegetation appears less northern and more tropical. Many tropical trees and plants reach their northernmost limit here.

The major cities of this region include Gainesville, Jacksonville, and St. Augustine. St. Augustine lays claim as the oldest, continuously inhabited city in North America. Jacksonville was named for President Andrew Jackson. General Gaines, who captured Aaron Burr, is the namesake for the city that is home to the University of Florida.

Opposite page: **a canopy road in Big Talbot Island State Park. The large oaks are covered with resurrection fern, so named because it perks up after a rain.**

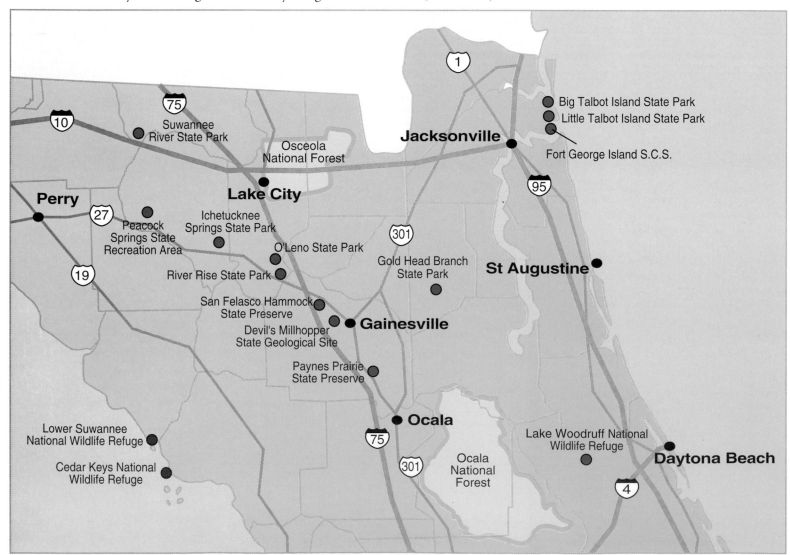

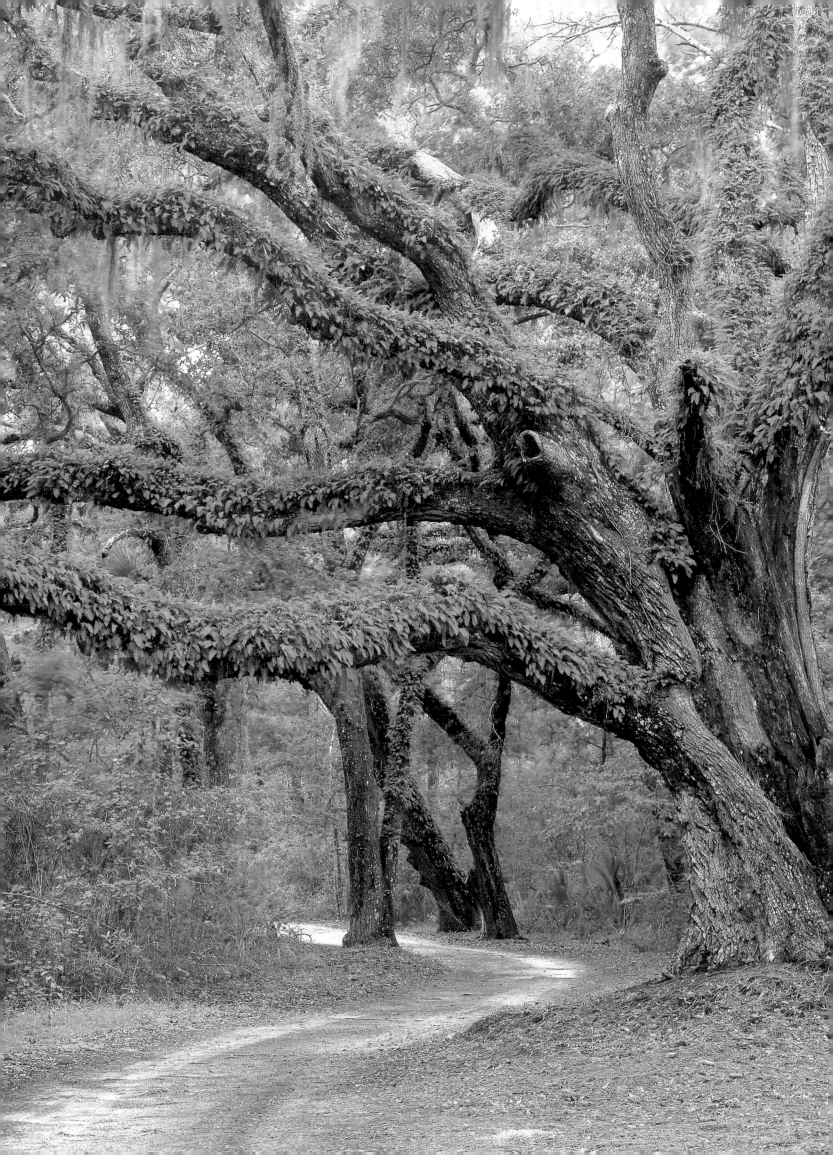

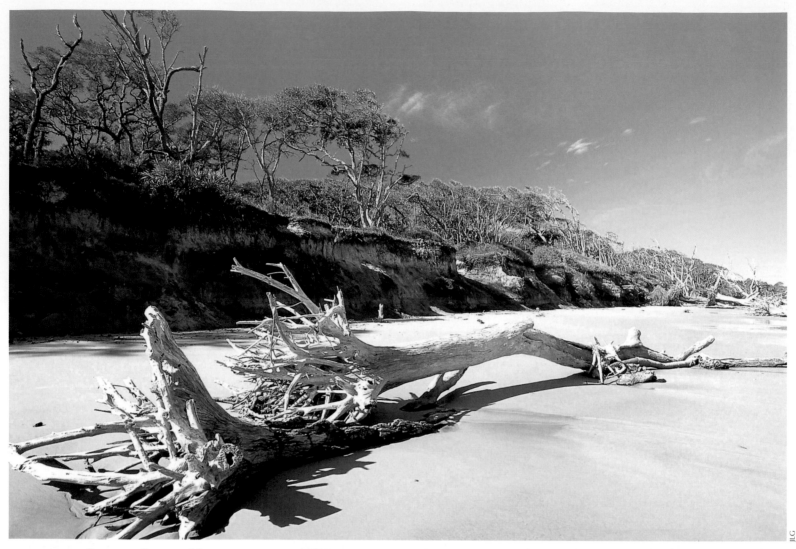

Big and Little Talbot, and Fort George Islands

These three islands are close together physically, and while they share much in common, they are visually quite different. Big Talbot is an island of high bluffs, forests, and trails, with oaks draped in Spanish moss. Little Talbot is known for its beautiful beaches, marshes, tidal flats, and its many shorebirds. Fort George has lovely canopy roads and an old plantation house.

Together these islands offer much hiking and many nature experiences. Also, on Little Talbot it is easy to study how sandbars were colonized by plant communities to form barrier islands.

East of Jacksonville in Duval County, and south of Amelia Island along A1A. A1A is a coastal road easily accessed by going northeast from I-95.

At top: a beach scene at Big Talbot. Note the high bluff behind the bleached remains of a dead tree.
Right: the wind-swept oaks on the bluff at Big Talbot.
Opposite page, top: a coastal marsh, Little Talbot Island State Park.
Opposite page, bottom: exposed tidal flats between Little Talbot Island and Ft. George Island state parks.

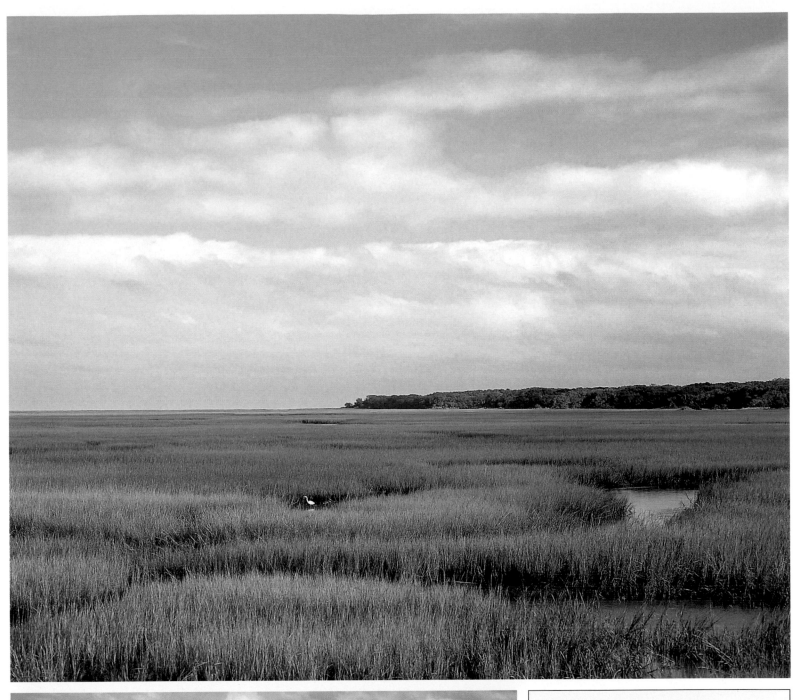

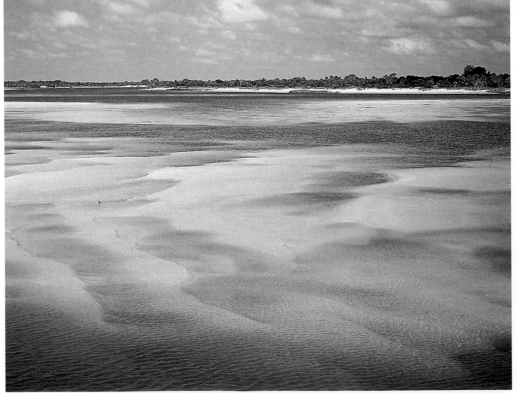

RIGHT WHALE CALVING

Endangered North Atlantic right whales arrive in the waters between Jacksonville and Bruswick, Georgia, beginning in December, about the time the tourists arrive to escape the northern winter here. Calving occurs in January, and most of the whales have left on their northern migration by March.

These whales are mostly found during this time in relatively shallow water, from 30 to 40 feet deep. This made them easy hunting in the middle 1800s for whalers. For a while, Fernandina was port to whaling ships. Today, mother right whales face a different threat—being struck by ships.

In 1996, six right whales were found dead in the southeastern US, several close to a US Naval gunnery range. This sparked strong protests from conservationists, and the Navy agreed to modify its operations to reduce the chance of harming the whales.

Devil's Millhopper State Geological Site

Geologists believe that this giant sinkhole was first formed between 10,000 and 14,000 years ago, and that an additional opening was formed within the last 1,000 years. The age of this sinkhole has been reported in the popular press at up to 17,000 years, but geologists say this is not so. At points the sinkhole is 500 feet across and 120 feet deep. It is a giant, deep bowl of life, filled with lush cinnamon and rattlesnake fern, and fallen trees.

If one is adventuresome, and does not mind getting wet, it is a first magnitude experience to be at the bottom of the millhopper when it is raining. The rain strikes the vegetation loudly while ground water pours from holes in the porous rocks creating waterfalls that issue from the sinkhole walls. The flow of water from the walls is not influenced by the immediate rain but by the level of ground water.

The half-mile nature trail around the rim can be walked with or without the rain. Less than five miles from busy I-75, this is a quiet woods where the rain can be heard hitting the trees and leaves.

Paleo-Indians, who may have witnessed the formation of the Millhopper, thought it was created by the devil of their religion. Fossilized bones and teeth found at the bottom may have fed this myth. Crackers thought it resembled the shape of the funnel through which grain was sent to be ground into grist. Thus the name.

Several very large species of moths are found in the vicinity of the Millhopper and in this area of Florida. These include the polyphemus, royal walnut, luna, imperial, blind-eyed sphinx, and white-lined sphinx. The area around the sinkhole is also home to bolas spiders that lasso moths with a ball of sticky silk. The moths are lured by pheromones produced by the spider that mimic the scent of female moths.

Until 1974, the sinkhole was clogged with vegetation and trash. The sink had become the site of late night beer parties for students from the University of Florida. The state has wisely stepped in, preserving a geological wonder.

Northwest of Gainesville in Alachua County on CR-232. Exit I-75 at SR-222 and go east. Turn northwest on NW 43rd St., then west on CR-232. The Millhopper is on the right.

Right: ferns grow profusely inside the sink.

Opposite page: one of the many small waterfalls cascading down the steep sides of the sink.

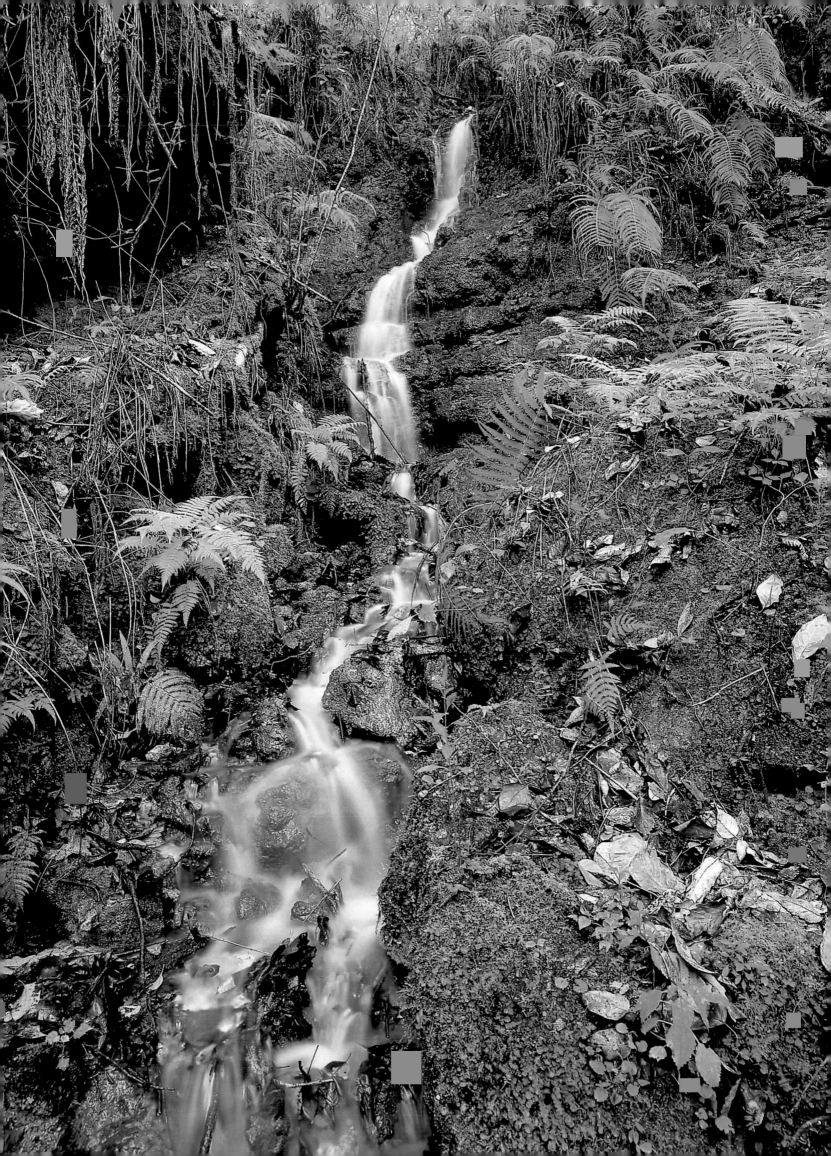

Gold Head Branch State Park

This unusual park is basically a scrub habitat, but it does include some surprises. A large ravine is the most significant feature in the park. A trail leads through it with portions on a boardwalk over a clear creek. The beautiful Loblolly Trail begins at the south end of the ravine. It is named for the loblolly pines. This park also includes a three-mile segment of the Florida Trail.

The ravine has been created by clear, springfed creek-water wearing away at the sides of pine highland before it runs into Lake Johnson. The creek can flood when rain is heavy. The ravine with its flowing water is called Gold Head Branch, because supposedly miners once panned here for gold. No gold was found then, nor can it be found now. There is no proof that there was ever any mining here.

There is longleaf pine on sandy areas, a hardwood hammock around the ravine, a lake in which swimming is allowed, two smaller lakes (one in a scrub habitat), a marsh, and several sinkholes.

Ravine vegetation changes as the elevation changes. The ravine shelters ferns and wildflowers. Around the lake and in the woodlands, bald eagles, American kestrels, gray and red foxes are sometimes observed, as well as deer, fox squirrels, and turkeys. This is also habitat for indigo snakes and eastern diamondback rattlesnakes.

Scrub jays are one of the approximately 125 to 130 bird species seen in Gold Head. Scrub jays do not easily adapt when their scrub habitat is converted to an orange grove or a subdivision. This has happened to a large portion of their special habitat, making them a threatened species. The Florida scrub jay is now considered a separate species from the western scrub jay. It lives only in Florida, and is the only bird species found nowhere but Florida.

The park has been built around land originally donated by Mike Roess. The park facilities were developed during the 1930s by the Civilian Conservation Corps.

Six miles east of Keystone Heights in Clay County, on SR-21 about 45 miles south of Jacksonville.

At top: **Gold Head Branch flowing through a deep ravine.**

Right: **a tiger beetle.**

Opposite page: **shoreline vegetation on one of the lakes at Gold Head Branch State Park.**

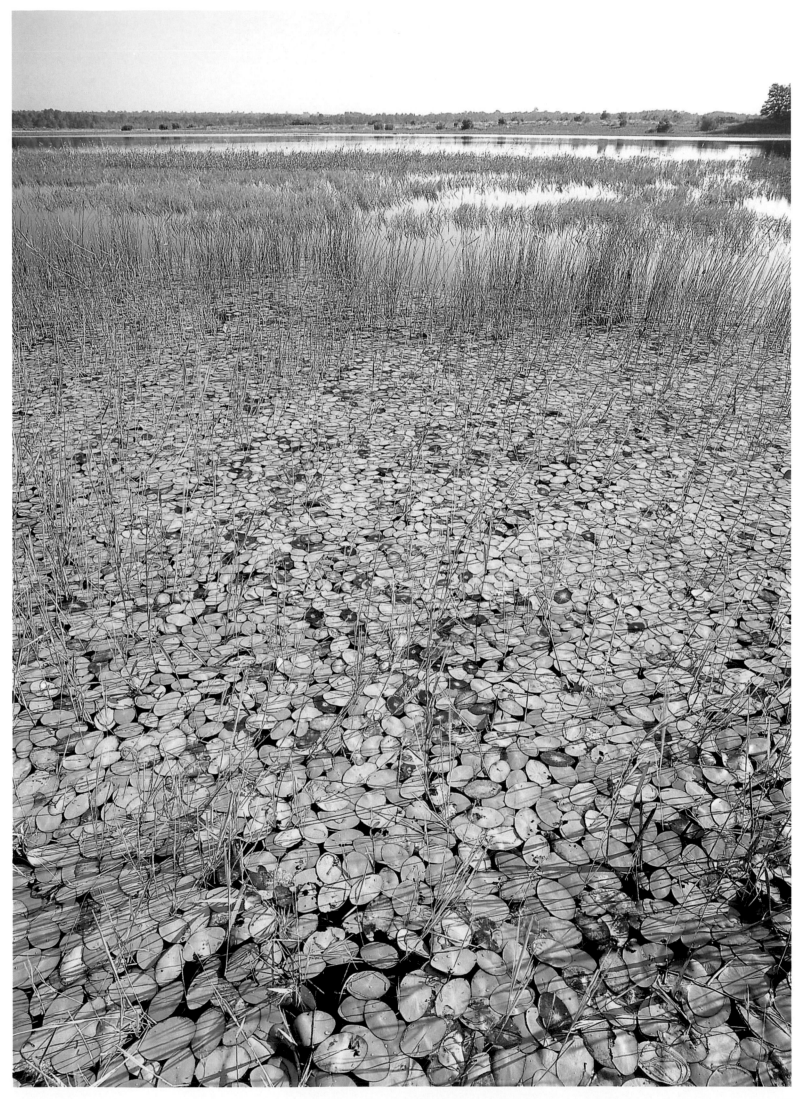

Ichetucknee Springs State Park

The Ichetucknee River flows from nine major springs and many smaller ones. It runs six miles to join the Santa Fe River. Three-and-a-half miles of the river are within the 2,300 acres of the park. There are four hiking trails for exploring hardwood hammocks, sandhill, and river flood plain. The finest trails pass along the river and springs near the headquarters area. The terrain has several sinkholes, and the river has considerable floodplain along its course

The river can be explored by inner tube, canoe, or snorkeling, but access is limited to protect the park. Sometimes it is necessary to close portions of it. Tubing at the north end is limited to the summer months. The south end is open for tubing year round. The water is clear, blue, and very inviting on hot days.

Without controls the park might be overwhelmed by visitors, whose sheer numbers would do it harm. On a busy weekend in Summer, Ichetucknee is a reminder that even humans respectful of nature can damage delicate places. Without the controls and the diligence of park personnel this beautiful place would long ago have been seriously diminished as a nature site.

Much of the wildlife goes into hiding when large numbers of humans appear in the Summer. The naturalist might prefer a winter trip. Then the lucky visitor might catch glimpses of otters and alligator snapping turtles. Easier to observe are the longleaf pine, oaks, and a variety of other trees in the hammocks. The habitats within the park are excellent places to view flora and fauna typical of North Florida.

Florida is blessed with a number of lovely locations which have all been given the name "Blue Hole." This park's Blue Hole is crystal clear, about 32 feet deep, and measures 85 feet by 125 across. It pours out an average of 60 million gallons a day, and is the largest spring in the park. The entire system releases more than 233 million gallons a day.

In Suwannee County, the south entrance is five miles west of Ft. White on US-27. The north entrance is on CR-238.

At top: **the water grasses bend with the flow of the Ichetucknee River.**

Above: **thousands of visitors enjoy riding a tube downstream.**

Opposite page, top left: **cardinal wildflowers along the spring run.**

Opposite page, top right: **the limestone chimney.**

Opposite page, lower left: **diver in front of the cave entrance at Blue Hole, Ichetucknee Springs.**

Opposite page, lower right: **on weekends the spring run is crowded with all kinds of inflatables.**

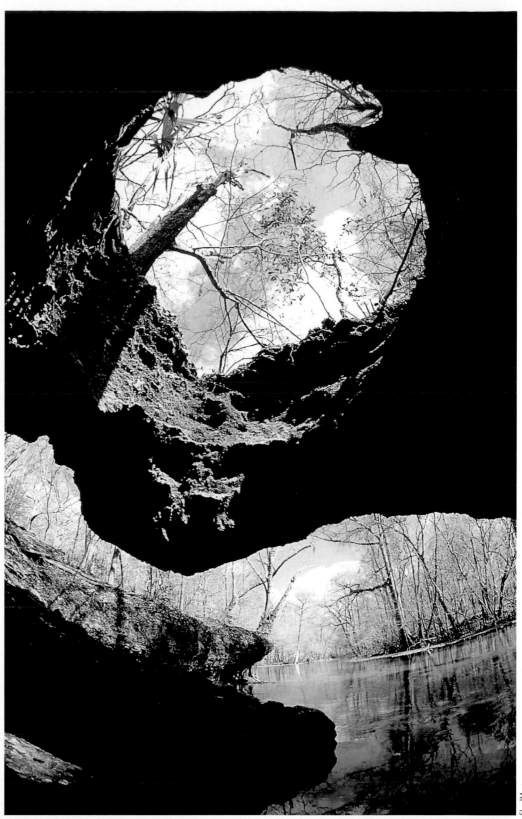

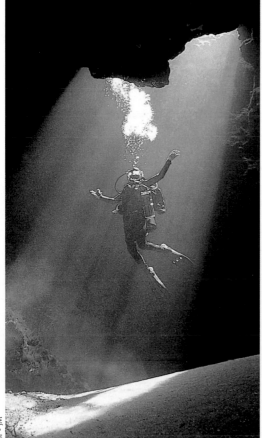

SI - JM

SI - JM

49

Florida's Springs

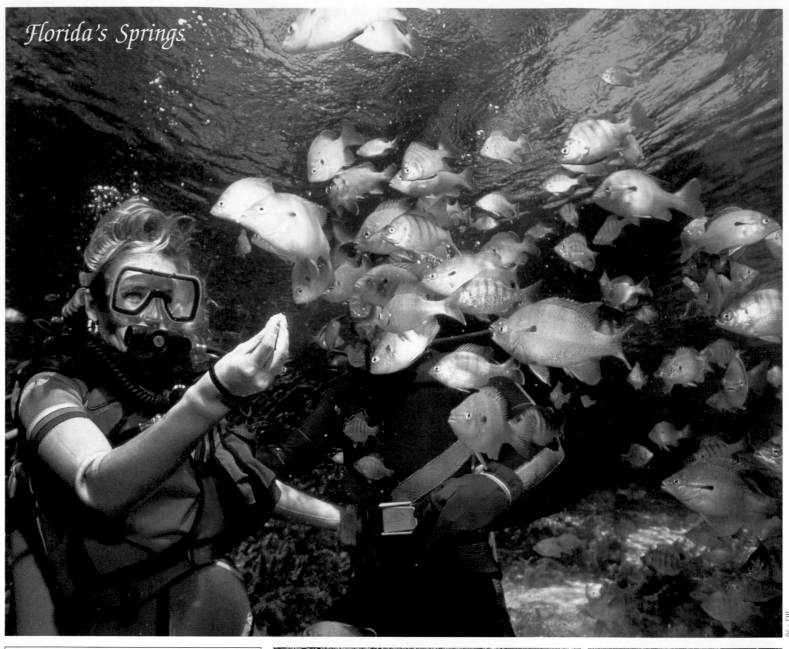

FLORIDA'S SPRINGS

The town of High Springs is the center of an area which contains some of the finest springs in Florida. These springs also provide ample challenge for experienced divers and underwater cave explorers. Cave diving is dangerous and a suitable sport only for the highly-skilled and adventurous few.

Florida has one of the largest concentrations of springs the world. There are 27 first magnitude springs in Florida that each discharge more than 64 million gallons per day. Florida's springs account for one third of all the first magnitude springs in the US.

Many springs such as the behemoth Wakulla are on public land, but some, like Ginnie Springs and Devils Den are popular, privately-owned concessions. People come to cool off in the Summer and to experience the beauty of Florida beneath the surface of these pristine waters. The appeal of springs is not just for diving but also for swimming and tubing.

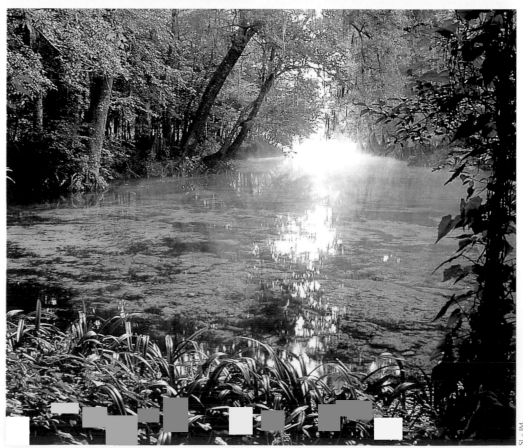

Opposite page, top: a diver feeding bream at Ginnie Springs.

Opposite page, bottom: a scenic spot along the Sante Fe River showing the crystal clear spring water.

Above: water darkened with tanin from the Santa Fe River mixes with the crystal clear, blue water of Ginnie Springs.

Right: a scuba diver at Devil's Eye Spring at High Springs.

DANGERS TO FLORIDA'S SPRINGS

Nitrates from animal waste, fertilizer, and septic tanks are increasing in some of Florida's springs. The springs are safe for drinking and swimming, but the eco-system may become changed in time if this continues. The springs with increasing levels of nitrates include Wakulla, Ichetucknee, and Rainbow Springs. Springs along the Santa Fe and Suwannee River also show increased levels of nitrates.

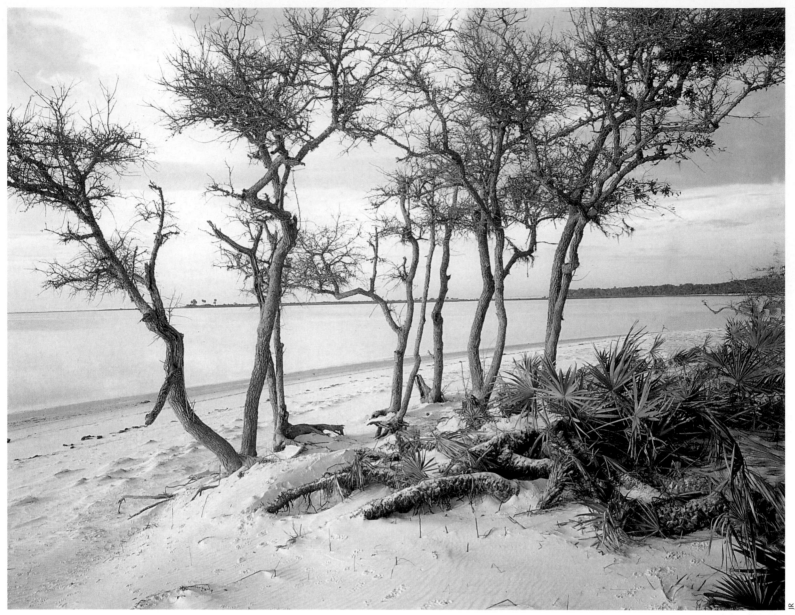

Lower Suwannee and Cedar Keys National Wildlife Refuges

These protected wilderness areas are near the mouth of the Suwannee River. The largest is the Lower Suwannee Refuge, at 52,000 acres. Portions of the huge Lower Suwanee NWR are the areas most accessible by land. The Cedar Keys Refuge is mostly accessed by boat. Many days of motor boating would be required to see the entire area, and much time could be pleasurably devoted to canoe and kayak adventures.

The offshore Cedar Keys NWR is made up of 12 islands in wild, primitive condition. Seahorse Key is closed entirely in Spring to protect the nesting birds. These include brown pelicans, great egrets, snowy egrets, tri-colored herons, great blue herons, double-crested cormorants, and night herons. Magnificent frigate birds, usually seen in the tropics, also are present in the summer months. The University of Florida has a marine research station here.

Cottonmouths are abundant on all the islands. These snakes are exceptional for the manner in which they feed. They wait below the nests of waterbirds for dropped fish and hatchlings that fall from the nests. When the nesting season is over, they apparently stop eating until the birds return, although there are southeastern Florida five-line skinks and rodents on the island that a snake might use to break his fast.

The soul and spirit of this area are in the water. There are substantial fishing and oyster industries around Cedar Key that are dependent on water quality. Sport fishing is more than a pastime here; for many it is a way of life. Seemingly endless marsh that is teeming with fish and crabs characterize the coastline, while countless islands dot the horizon, with names like Deer, Hog, and Snake Key. No two islands appear the same, and wandering from one to another on a sunny calm day is a joy and discovery for any nature lover.

The boater should have charts and a boat with a shallow draft as there are many shallow areas. Waves break over exposed shoals even several miles from the mainland. During low tide, boaters can easily become stranded.

In addition to the two national wildlife refuges, the state has set aside two nearby wilderness areas, adding significantly to the preserved wilderness. They are Cedar Key Scrub Wildlife Management Area and State Reserve and Waccassa Bay State Preserve. The scrub area has excellent hiking trails and is often deserted, even on weekends. Wacassa Bay State Preserve is moslty saltwater marsh, coastal hammocks, and islands. It is best accessed with a kayak or a shallow draft boat.

Seventeen miles south of Chiefland in Levy County from US-19 on US-347 for the Lower Suwannee. Offshore from Cedar Key for the Cedar Keys Refuge.

Top: **along the beach at North Key in Cedar Keys National Wildlife Refuge.**
Opposite page, at top: **a view of one of the beaches with wildflowers at the Lower Suwannee NWR.**
Opposite page, bottom left: **wild iris or "purple flag."**
Opposite page, bottom center: **palms along a remote beach.**
Opposite page, lower right: **coreopsis and phlox along the roadside.**

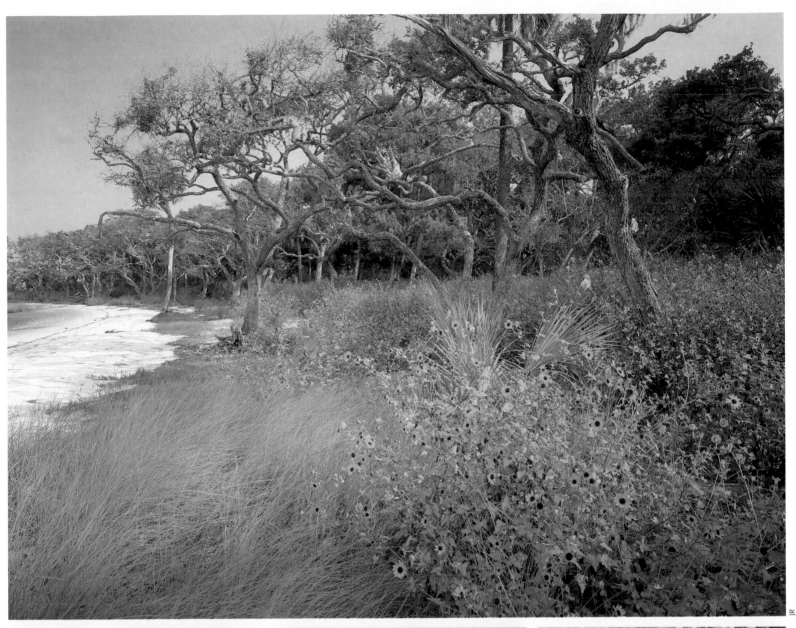

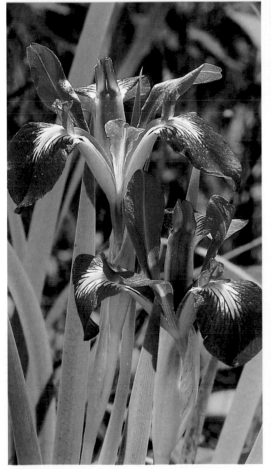

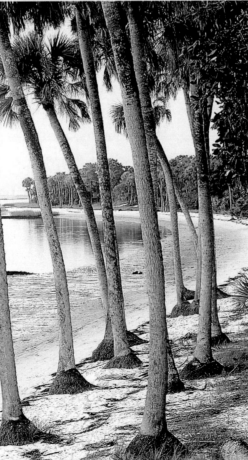

KAYAK TRIPS

One interesting way to explore this area is by kayak. Author and naturalist Jeff Ripple is pictured here exploring the Cedar Keys National Wildlife Refuge. This is one of his favorite sea kayak journeys.

Ocala National Forest

The 384,000 acres of the Ocala National Forest include pine flatlands, sandhill, and mixed hardwoods. But more than half the forest is the world's largest sand pine scrub, the famous, 205,000-acre "Big Scrub."

There are many lakes in the forest, four major springs, a number of smaller springs, highlands marsh, rivers and creeks. Inside the scrub area are "islands" of longleaf pine.

Springtime is rich with beautiful wildflowers. Over the course of the year, more than 200 bird species can be seen. Black bear, bobcats, and deer are among the mammals. Over 100 species of reptiles and amphibians can be found here, including the seldom seen Florida gopher frog, which is one of the animals that often shares gopher tortoise burrows. This is perhaps the best place in the state to see Florida scrub lizards. Another common lizard which may be heard thrashing loudly in the leaf litter or seen shooting across one's path is the six-lined racerunner.

There are many roads and trails, including 75 miles of the Florida Trail. There are also many fine canoe adventures, including the lovely spring runs, and portions of the Florida Canoe Trail. The following are just some of the wonderful highlights of the Ocala Forest.

ALEXANDER SPRINGS

Water flows from the springs into Alexander Creek, a canoe trail rich in beauty, and a great place to observe turtles. Among the species which can be seen here are the Florida snapping, Florida redbelly, Florida softshell, and the peninsula cooter. Alexander Creek flows into the St. Johns River.

In water output, Alexander is one of 27 first magnitude springs in Florida. First magnitude springs account for almost 80% of the spring water output in Florida. At more-or-less 75 million gallons a day in output, Alexander is neither the smallest nor the largest, but it is certainly a candidate for the most enchanting spring and canoe trip in North Florida.

Diving, swimming, and snorkeling are allowed in the spring. There is a one-mile boardwalk with access to and from the Florida Trail, which curls around Alexander Spring and overlooks the run.

SALT SPRINGS/SALT SPRINGS RECREATION AREA

Salt Springs is named for the salty taste of its waters. An average 52 million gallons of water per day pour from it into Salt Springs Run and Lake George. This is a favorite swimming spot for locals and

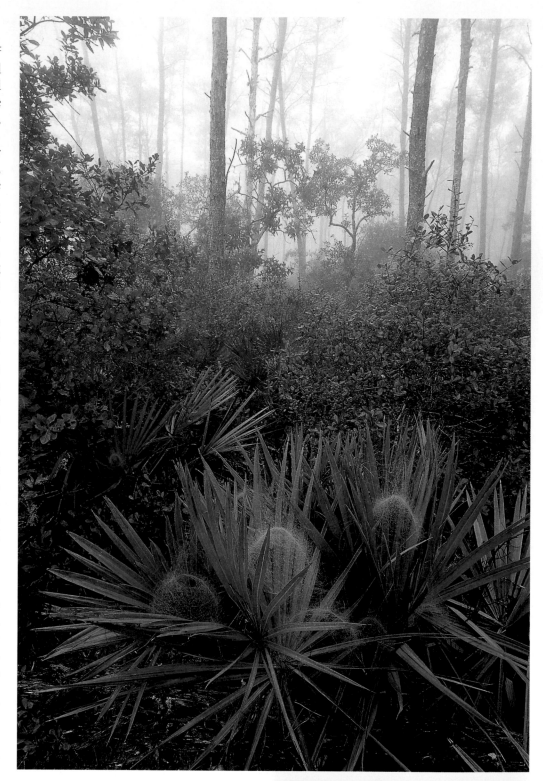

visitors alike. The minerals which give the water a salty taste may be the residue of an ancient time when seas were higher.

SILVER GLEN SPRINGS/SILVER GLEN RECREATION AREA

Once a large private campground, this popular recreation area is being allowed to return to its natural condition. It is a first magnitude spring in which the introduced fish, Central American tilapia, are often seen, especially in Spring.

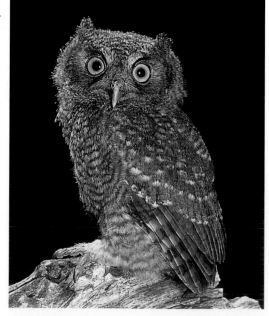

Top: saw palmettos with filmy dome spider webs at dawn, Ocala National Forest.

Right: a juvenile screech owl.

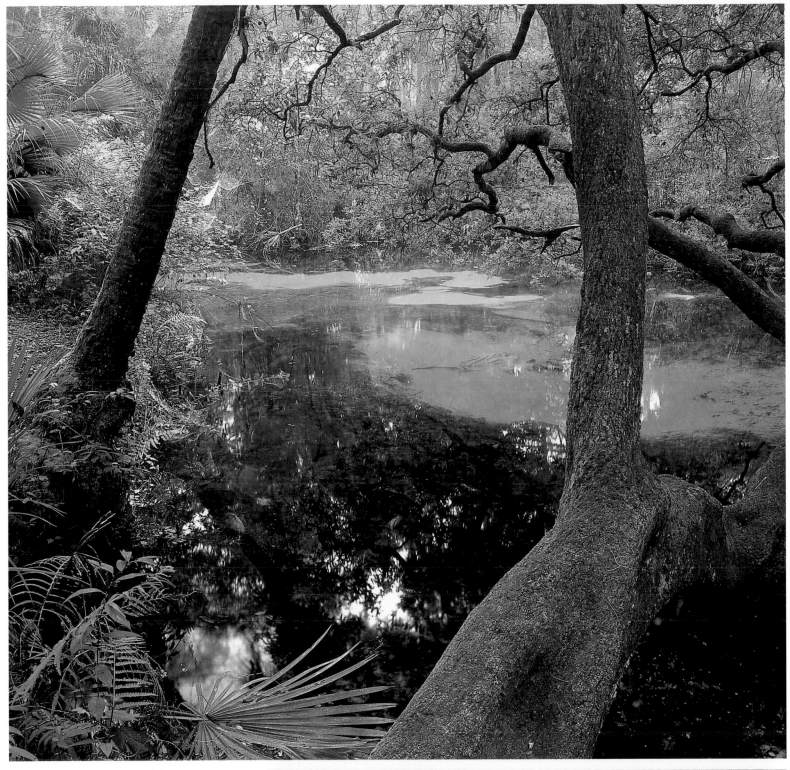

FERN HAMMOCK SPRINGS

This spring is found within the Juniper Springs Recreation Area. Fern Hammock is an incredible, little spring with few equals. Its clear waters pass through a lovely wilderness along a mile or so of nature trail which is wonderful in itself. At the spring, the water bubbles up through small vents. Both active and inactive vents are easily seen from the short boardwalk. No canoeing, swimming, or wading is allowed in its pristine waters.

Top: at Fern Hammock Springs, the vents through which the underground water flows are clearly visible from the boardwalk. Use of this spring is forbidden to protect its fragile beauty.

Right: Ocala National Forest is one of the best places to see the scrub lizard.

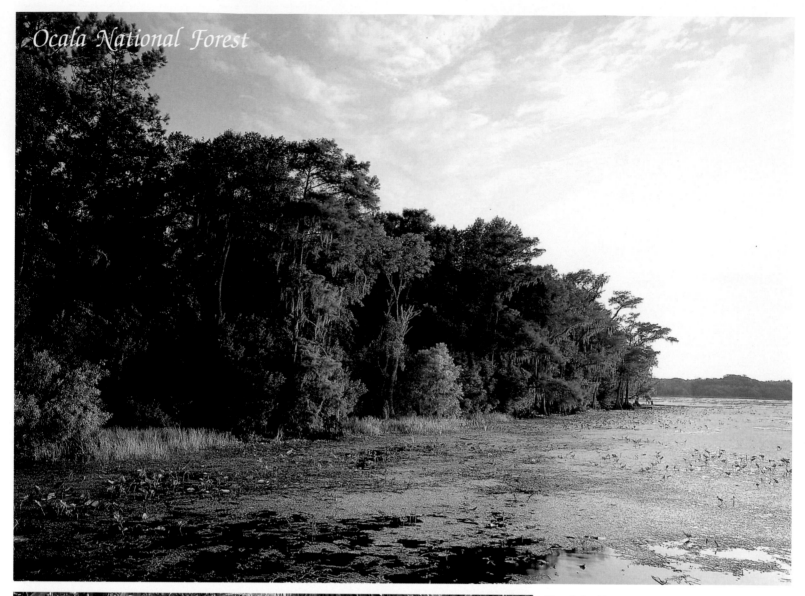

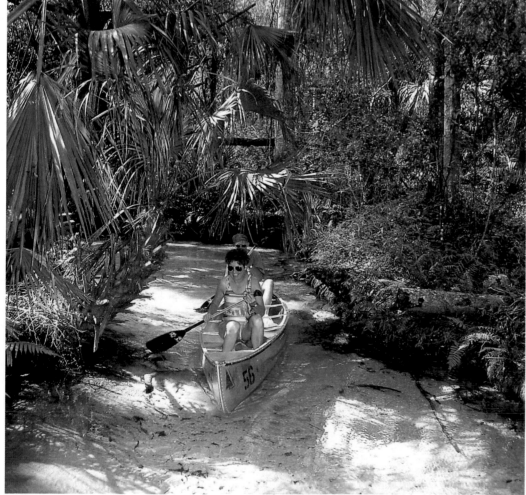

Top: Lake Eaton at sunset.
Left: the popular Juniper Springs canoe run.
Below: a pair of river otters resting on a log.

JUNIPER SPRINGS

Snorkeling and swimming are available in the head spring. Canoes can be rented at the Juniper Springs concession for use on the very popular seven-mile spring run. Nearby is the Juniper Prairie Wilderness, more than 13,000 acres, with perhaps 100 small lakes, marshes, and lonely trails.

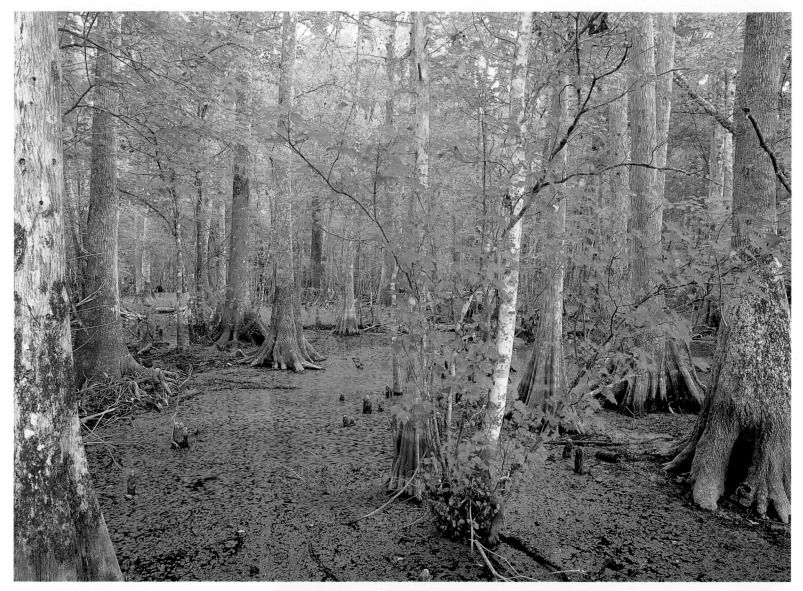

OKLAWAHA RIVER

The 19.5 mile canoe trail on the river is the longest in the forest. There are several canoe-launching sites along its meandering course, notably at the SR-40 and SR-316 bridges. This springfed, blackwater river is 79 miles long. It begins at Lake Griffin and empties into the St. Johns River.

LAKE EATON DRY SINK

A half-mile walk through sand and pine scrub leads to this large sinkhole which is 110 or more feet deep and 450 feet wide. Like the slightly larger Devil's Millhopper (near Gainesville), this sink is filled with lush vegetation, including loblolly pines and magnolia. Unlike the Devil's Millhopper, which may be 15 millennia old, this sinkhole is a mere youngster at perhaps 100 years. Furthermore, it is dry at the bottom except during the heaviest rains.

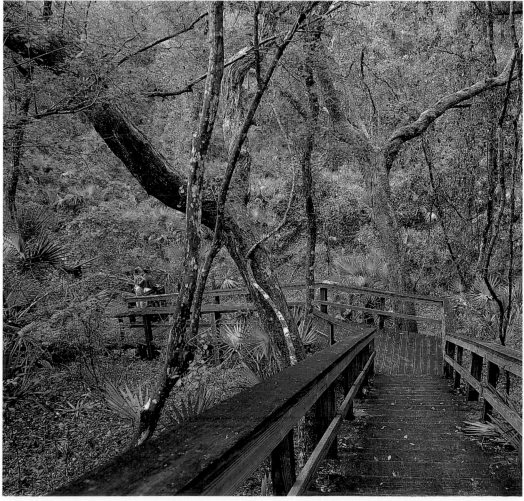

Top: a cypress swamp along the Oklawaha River.
Right: the boardwalk leading down into Lake Eaton Dry Sink.

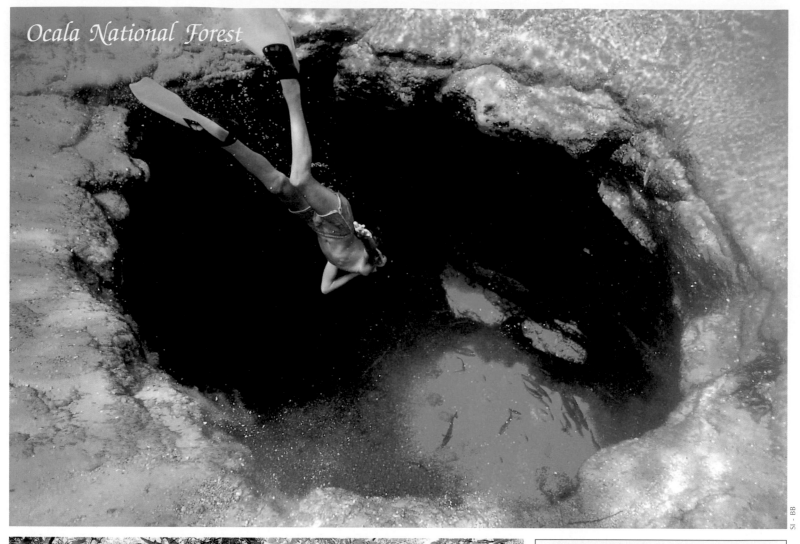

SI - BB

Top: snorkeling in Silver Glen Spring.
Above: a trail leading through the "Big Scrub."

From I-75, exit east at Ocala for Silver Springs. The most useful road from the west is SR-40. Many roads lead into the forest and its surrounding areas. A map is available at the ranger station on SR-40. The forest is located in Lake, Marion and Putnam counties.

SEMINOLE BREAD

Coontie is the only cycad native to the US and is only found in Florida and Georgia. Cycads are living fossils, representing what was once the dominant plant form when dinosaurs lived. Both male and female plants develop large "cones," by which they reproduce. The Native Americans in Florida ground up coontie root to make an edible meal. However, coontie must be properly prepared because it contains harmful toxins.

O'Leno State Park and River Rise State Preserve

A small town was established here in the 1800s. It was apparently named for the gambling game of Keno. The citizens eventually changed the name to Leno. This has been corrupted over time so that the area is presently known as O'Leno (from "Old Leno").

The springfed Sante Fe River, which flows 76 miles from Putnam County into the Suwannee, disappears into an underground channel in O'Leno State Park. It reappears as a full-fledged river in River Rise State Preserve. The various plant communities include hardwood hammock, pine flatlands, sandhill, high pine, and swamp.

A prominent trail along the river, including the view from a small suspension bridge, is lovely. It passes along the banks and around the area where the river disappears underground. From the banks, many turtles can be seen sunning themselves, and deer are often seen hiding in the shadows or going to the water's edge to take a drink.

Wildlife is plentiful in O'Leno. In the early morning, snakes may be stretched on the road to warm themselves with a "jump start" from the asphalt. Deer wander along the road at times, so drivers should be careful.

Two nature trails, the Limestone and the River Sink trails, are within the park's boundaries. The quiet hiker might startle deer. Other hiking trails and horse trails are within River Rise State Preserve. Of the total 10,000 acres in the two parks, O'Leno is the larger, with 6,000.

From I-75, north of High Springs five miles on US-41/441 in Columbia County.

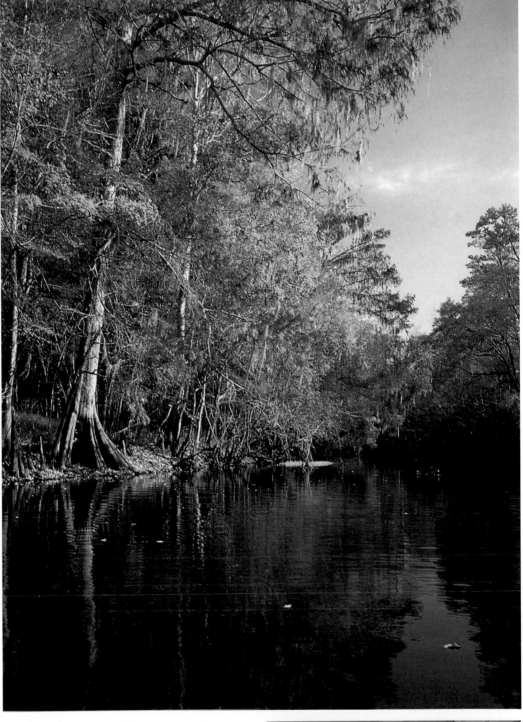

Above: the Sante Fe River in River Rise State Preserve.
Bottom right: a barking tree frog in O'Leno State Park.

PERILS OF A NATURALIST: TICKS

Ticks look like a mole on the body which has grown legs. It is very distressing to see these critters embedded in the skin of one's children or companions.

Unlike redbugs (called chiggers), ticks can live on just about anything with blood. In their larval, nymph, or adult stages, they are blood-suckers. Like mites, they have six legs as larvae, and eight as nymphs and adults.

They carry disease: Lyme and several flu-like diseases. Thus repellent is recommended, if it can be used. There are a number of commerical repellents for prevention. However, if a tick digs in, the best solution is to take hold and yank it off. All other remedies are futile.

In the warmer months in Florida, the most common ticks are the lone star ticks, so named for the white dot on the female. In Winter, the most common are deer ticks, which are more prone to carry Lyme disease. The other tick sometimes seen (or unpleasantly experienced) is the dog tick. Florida has ticks year round.

The chances of contracting Lyme disease in Florida are fairly remote. There are, however, other severe tick-borne diseases. So, if a flu-like disease occurs shortly after a visit to the woods, it is wise to consult a physician.

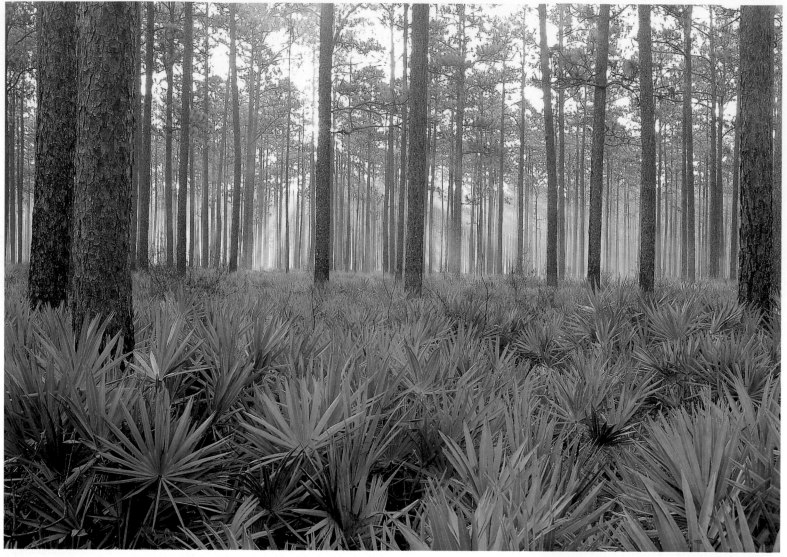

Osceola National Forest

Nearly 200,000 acres lie within Osceola NF, criss-crossed by a maze of roads and trails. It is the smallest of the three large national forests in Florida and also the least used. This is because it is in a less populated area of the state, and some of it is not easily accessible. This makes it a challenge for the ardent naturalist.

Here are mostly pine flatwoods, with some longleaf pine areas, understory, and wiregrass. The forest also contains interesting lakes, rivers, springs, and especially swamps.

BIG GUM SWAMP WILDERNESS

At over 13,600 acres, this is a very large cypress and sweet gum swamp, with some marsh and titi bogs, surrounded by pine flatlands. A portion of the St. Marys River passes through it. Hiking Big Gum is difficult at best. It is an extremely wet experience most of the year, and a compass should be carried as it is easy to become lost on unblazed trails. Another possibility for hikers is to follow the abandoned railroad bed (the main line and the spurs). On the western border of the swamp there is a difficult and overgrown hiking trail.

THE FLORIDA TRAIL

Twenty-three miles of the Florida Trail are in the Osceola Forest. Some of it follows old railroad beds. Other portions are on boardwalks through cypress swamps. The trail is entered from the Olustee Battlefield State Historic Site, which is on US-90, two miles east of the town of Olustee. There are two other trail heads and an overnight camp area (brochures are available).

The only significant battle in Florida during the Civil War occurred at Olustee. It was a decisive victory for the Confederacy. If the battle accomplished anything, besides taking a good number of lives, it probably kept the Union forces from making further efforts in Florida.

OLUSTEE BEACH

There is a roped-off swimming area, with white sand beach at Ocean Pond, a round freshwater lake of about 1,750 acres. Boating is also allowed. There is a short nature trail including a boardwalk.

PINHOOK SWAMP

Who is to say where the Okefenokee Swamp in Georgia ends and the Pinhook Swamp in Florida begins? If Georgia and Florida were one state, this would be con-

sidered to be part of the Okefenokee. Here are blackwater swamps and freshwater marshes. A large portion of the pine flatwoods is flooded for much of the year. It is one of Florida's wildest areas.

Top: **sunrise in slash pine and palmetto forest.**

Above: **a cecropia moth, which is found in North Florida.**

This very large national forest is east of Lake City and I-75 along US-90 in Baker and Columbia counties. The south end of this portion of the Florida Trail begins at Olustee on US-90. Penetration into the Pinhook Swamp is difficult. Many roads are hard to find unless the visitor is familiar with the area. It is best to obtain a forest map from the ranger station on US-90, and to check with rangers on the current condition of roads.

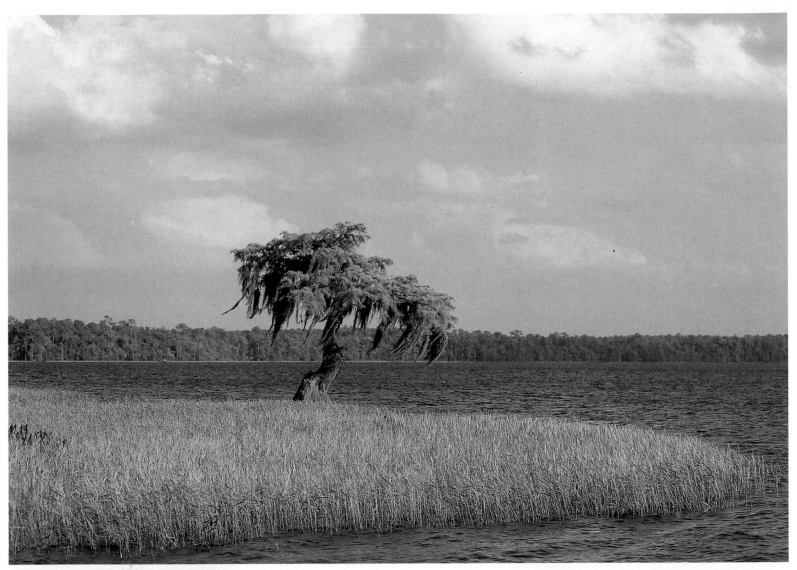

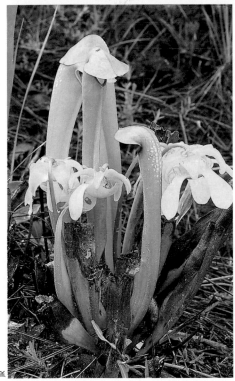

Top: Ocean Pond in Osceola National Forest.

Above: hooded pitcher plants from Big Gum Swamp.

WILDLIFE IN THE OSCEOLA NF

Threatened creatures in the Osceola NF include the flatwoods salamander, spotted turtle, red-cockaded woodpecker, and Florida weasel. Osceola NF is rich in wildlife, including several species of bats and mice. Carpenter frogs and many-lined salamanders can be found there, particularly in the Pinhook Swamp area. Both are northern species that barely enter Northeast Florida.

Perhaps the Forest's most familiar animal is the Florida black bear, a subspecies of the American black bear, found in Florida and Georgia.

The subspecies is larger than black bears in other parts of the US. Black bears overall are the smallest of bears. An adult male Florida black bear may weigh 200-600 pounds, and be five to six feet long. They often lose their black guard hairs when it becomes warm. They look generally more brown than black bears in other regions.

Black bears are seen in swamps and remote woods. Osceola is rich in both. They are also found in the Apalachicola and Ocala National Forests, the Big Cypress area in South Florida, and occasionally seen in a few other forests, parks, and preserves. A small population at St. Marks NWR is seen fairly often.

It is estimated that there are perhaps

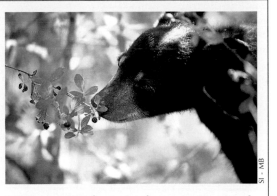

1,500 to 2,000 bears in the state. Previously reduced by habitat loss and hunting, Florida's bear population may lose as many as 75 individuals to car accidents each year.

There has never been a documented case of a bear attack on a human being in Florida. Still Florida black bears should be given all the respect given to other wild animals, and they should not be fed.

Bears, with their love of honey, are a problem for beekeepers. They also are known to raid chicken coops. In some bear areas the rattling of the trash can announces the arrival of a bear scavenger. Unfortunately, bears that stray onto farms and into towns and yards are sometimes shot. It is best to leave the handling of a "nuisance" bear to wildlife officials whenever possible.

Osceola National Forest

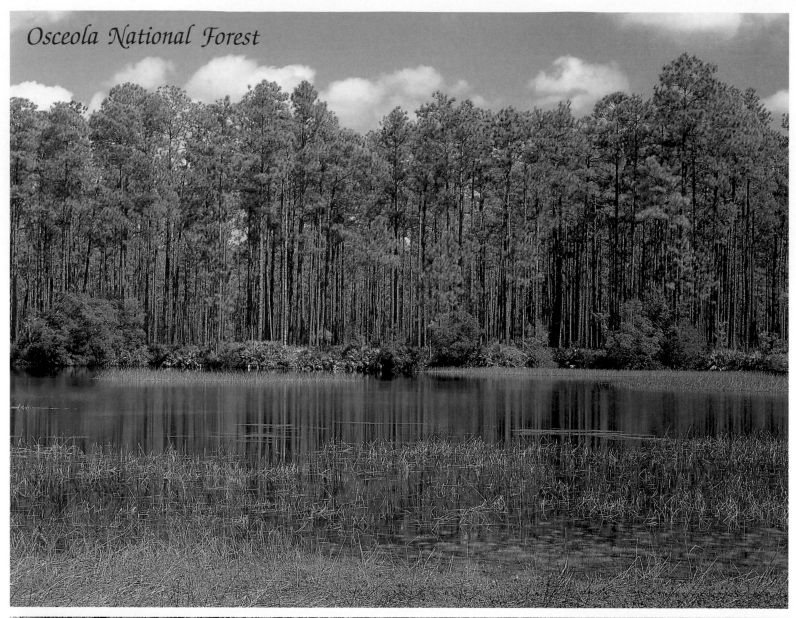

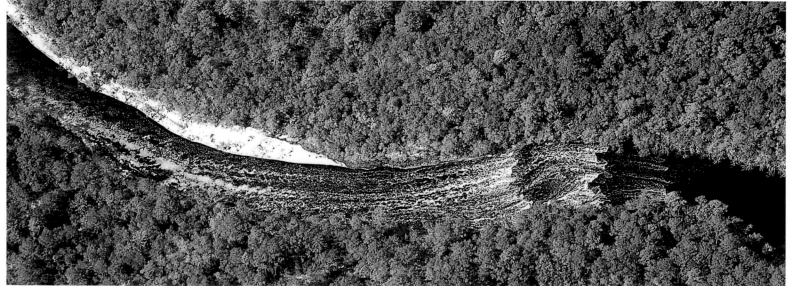

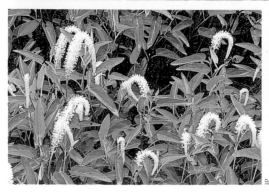

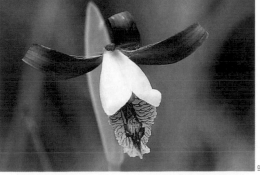

Top: One of the many small fishing ponds in the Osceola National Forest.

Above: an aerial view of Big Shoals on the Suwannee River near Osceola National Forest.

Bottom left: lizard's tail wildflowers in Big Gum Swamp.

Center left: a rosebud orchid in Big Gum Swamp.

Opposite page, top: the boardwalk in a cypress swamp of Osceola National Forest.

THE TRUE OSCEOLA

Osceola, the Seminole leader, probably never set foot in the area which bears his name. The area which is associated with Osceola is called the "Cove of the Withlacoochee." It was further south, about 20 to 30 miles from the Gulf of Mexico on the Withlacoochee River.

It is frequently said and written that Osceola was a chief of the Seminoles. Historians report that this is not so. Rather, he was a natural leader, and a brilliant tactician who inspired others to follow him, but he was not a chief, an inherited position among the Creeks who became Seminoles.

Not a Seminole by birth, he was half white. His father was William Powell, and among whites he was called "Powell" at times. His mother was a Creek from Alabama.

His first band of warriors was not composed of Native Americans, rather it was mostly "Black Seminoles," runaway slaves who lived with the Seminoles.

"Osceola" is a mispronunciation of Asi-yaholo, which means "speaker of the black drink." Seminole males were given a name at birth and another when they went through their rites of manhood. Sometimes, they were given a third name, indicative of their adult life. This is the case with Osceola or Asi-yaholo. His name refers to the taking of the black drink, part of purification ceremonies associated with the annual Corn Dance and gathering of the Seminoles. "Osceola" has been taken as the last English name of many modern Seminoles.

What is the "black drink?" It is a purgative, but if it doesn't work, vomiting is induced. It is believed to be medicine for many ailments. Medicine men have their own special formula. There may be as many as 14 or 15 different plants, grapes, and tree leaves in it. These can include St John's wort, cassine, sweet bay, among others. The black drink is boiled until midnight, then taken four times.

Osceola can be thought of as a freedom fighter. Forces of the US, once led by Andrew Jackson, attempted to either exterminate the Seminoles or move them to reservations in Oklahoma. At one point, the US reduced the numbers of Seminoles in Florida to fewer than 100.

The three "Seminole Wars" were in reality a long skirmish in the wilderness that lasted about a half century. They were wars of great frustration for many a general, and one of the chief frustrations was the inability to capture or defeat Osceola. One would have hoped that the brave Osceola could have died honorably in battle. However, a US general named Jesup infamously captured Osceola under a flag of truce. Otherwise Osceola might never have been caught. Locked in prison, Osceola died very quickly, allegedly of disease.

Not even Osceola's bones could rest in peace. A physician severed his head and preserved it. The severed head was eventually sent to the New York Academy of Medicine. It may have been intended for use in phrenology, the bizarre study of the significance of bumps on the head, a "science" long ago dismissed as useless. This building where the head was kept later burned to the ground. The remainder of the corpse is still buried in South Carolina.

Paynes Prairie State Preserve

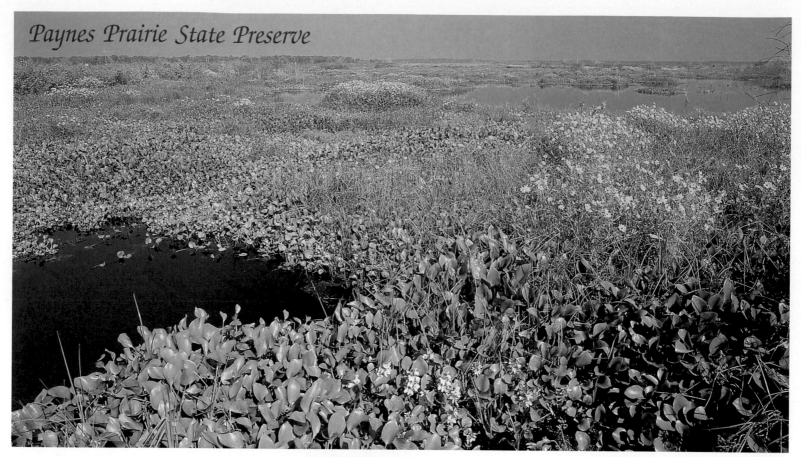

Paynes Prairie was one of the original settlements of the Seminoles. The nearby town of Micanopy was named for another Seminole leader who, like Osceola, was captured under a flag of truce. He was then forced to sign a peace treaty that he could not read.

In the 19th century (1871), Alachua Sink, which drains Paynes Prairie, became plugged. The thousands of acres of marsh land became a lake so large that steamboats were soon traveling across it. When the plug broke free twenty years later, the lake drained in three days, and within two years a "prairie" was formed. This type of dramatic change is not a rare event in karst terrain.

At the present time, Paynes Prairie is a highlands marsh (but in times of heavy rains, it almost becomes a lake again). An alternative term for Paynes Prairie would be a basin marsh. Marshes, like the Everglades, often have a superficial resemblance to prairies in the west. They are mostly tree-less, flat, and covered with grasses.

Today the 21,000 acres of Paynes Prairie (except for the paved highways running through it), are similar to when it was first observed by the early American naturalist William Bartram. In 1774, he called Paynes Prairie the "great Alachua Savannah." He described it as a "level green plain" that had "scarcely a tree or bush of any kind." It is full of tall grasses, rushes, and grass-like sedges that wave in the wind.

American bison, scrub cattle, and Spanish horses have been reintroduced into

the preserve. However, they range over many square miles, so the best chance of seeing them may be from the 50-foot observation tower that overlooks the prairie.

Paynes Prairie has one sizable lake, small marshes, mixed forests, and pine flatwoods surrounding the "prairie" area. The preserve can be explored by a number of trails. Skittish deer and sandhill cranes are frequently encountered. The vast majority of the cranes are migrants that are seen from November into early March.

A highlands marsh is wet less time than other marshes. This allows it to have a wider variety of plant life. Paynes Prairie has over 300 species of plants. Since it is a marsh, trails do become flooded at times.

Exit I-75 in Alachua County at Micanopy, south of Gainesville. East on CR-234 to US-441. North about a half-mile to Paynes Prairie.

Top: swamp marigolds in a marsh.
Above: grasses and wildflowers in an old **pasture.**
Opposite page, top: yellow marsh flowers in the **great expanse of Paynes Prairie.**
Opposite page, bottom: a scenic sinkhole.

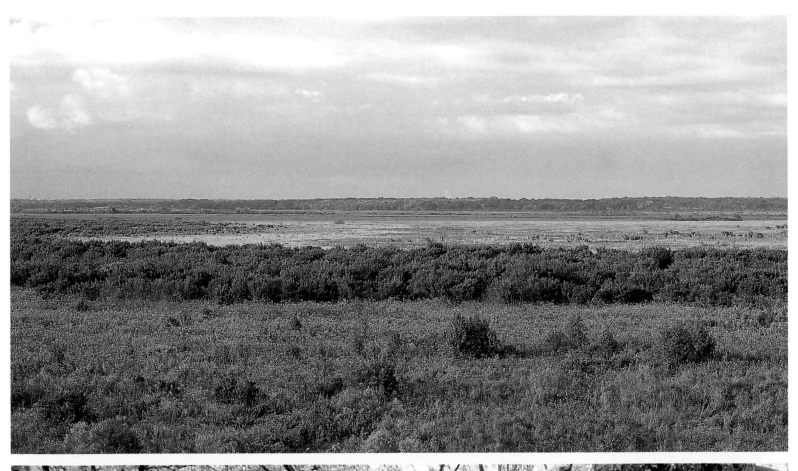

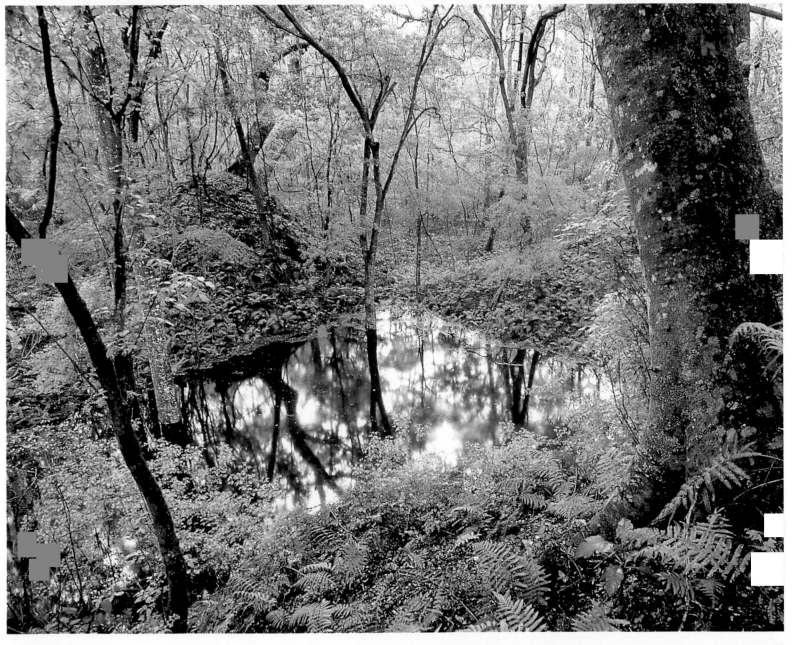

Peacock Springs
State Park

This is a beautiful spring; it is nevertheless one of the most dangerous in Florida. It contains 30,000 feet of underwater caves in the subsurface limestone, one of the longest underwater cave systems in North America. The caves have claimed the lives of over 50 divers in recent years. Its underwater caves are a labyrinth in which divers can become lost and run out of air. Yet diving continues because there is so much underwater wonder. Only experienced, cave-certified divers are allowed to enter the caverns.

The two major springs are named Peacock and Bonnet. In addition to the springs, the caves can be reached through the Orange Grove Sink.

For the non-diver, there are over 250 acres to be explored, including six sinkholes in the karst terrain. There are no trails here, so hikers must carefully make their own way.

Sixteen miles south of Live Oak or four miles north of Mayo in Suwannee County. Located on SR-51, which crosses I-10.

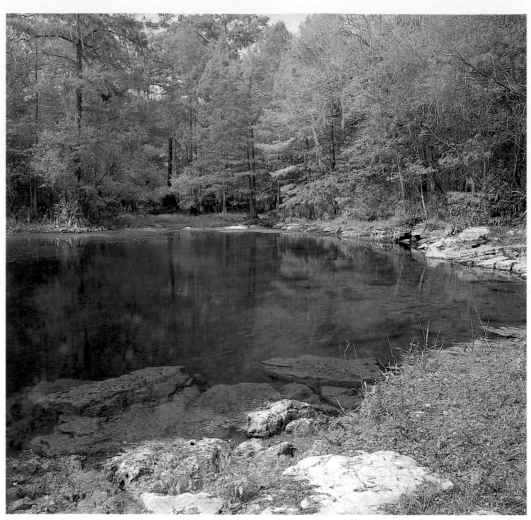

66

KP-WS

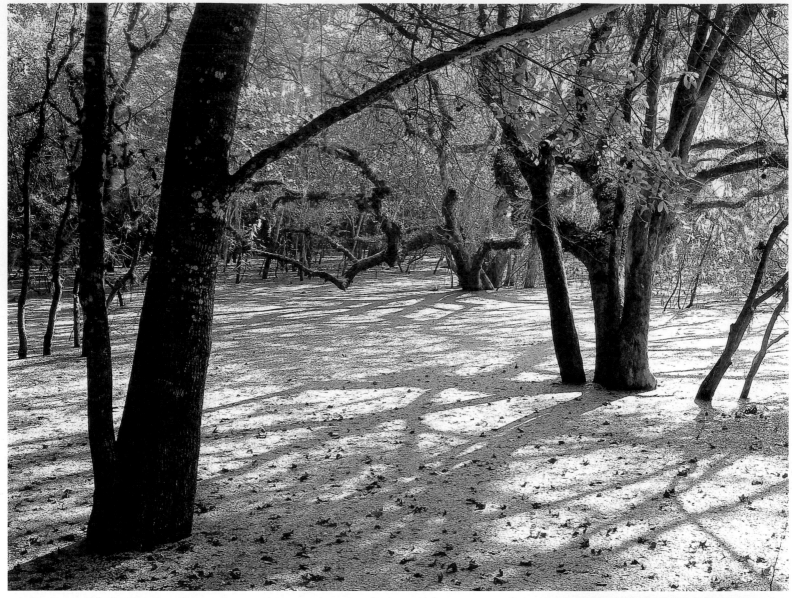

San Felasco Hammock State Preserve

Only a few miles from Gainesville is the most diverse hammock in Florida. Its 6,900 acres are magnificent and contain over 150 different tree species. There are perhaps 1,500 species of plants. Such richness is unique and deserves protection.

There are two major trails that total ten miles. These trails are adequate for the preserve staff to drive vehicles. They are beloved by local joggers, marathon champions, and were used by at least one Olympic track team. Many area residents use them daily for exercise. These and the unmarked trails take the visitor through hammock and pine flatlands, and by prairies, sinkholes, and ravines. There are over 100 little springs, and several hundred sinkholes in this preserve.

Leaving the main path is prohibited in parts of the preserve in order to protect delicate portions. The visitor should check with the preserve office before trekking off to see such wonders as Big Otter Ravine, where there are two caves. A nearby chert outcrop in a floodplain was chiseled perhaps ten millennia ago by Paleo-Indians to make weapons and tools.

Another wonder is the Breathing Oak. Beneath it must lie a cave or cavern. When high pressure dominates the local weather, the tree "breathes in." In times of low pressure, there is a flow of air out from beneath the tree. The tree is dead, killed by the Storm of the Century, a rare Winter storm in the 1990s. Yet it still "breathes" and will as long as it stands.

Purse-web spiders build their webs along the base of trees in the hammock. White-tailed deer are very abundant, and it would be a rare event for a visitor not to see several deer or more. A number of large moths can be seen before sunrise and after dark (see account of Devil's Millhopper). In the sweetgums, oaks, magnolia, and other trees a variety of bird species can be heard calling and seen flying. Armadillo, gopher tortoises, and wild turkeys announce their presence by thrashing loudly in the leaf litter. Bobcats, fox squirrels, and gray foxes are less obvious inhabitants of the hammock.

Horseback riding is allowed in the preserve. Limited, ranger-guided, overnight camping is sometimes available.

Top: a swamp with shadows on the pond surface.

Above: a huge oak tree in San Felasco Hammock that may be well over 800 years old.

Opposite page: cypress trees in one of the many ponds of San Felasco Hammock.

Northwest of Gainesville on the same road as the Devil's Millhopper in Alachua County. San Felasco is a few miles further west on CR-232 or Millhopper Road. Exit off I-75 at SR-232 and go east. Turn north on NW 43rd St. then west on CR-232.

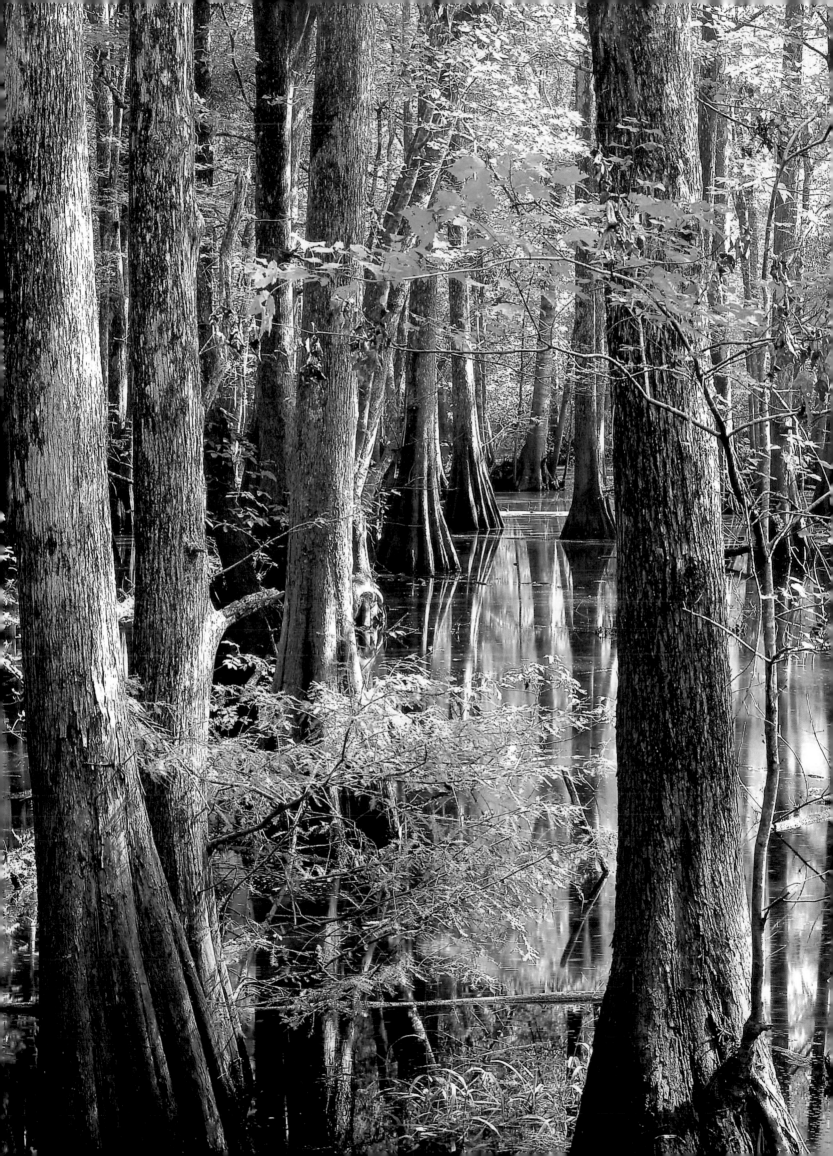

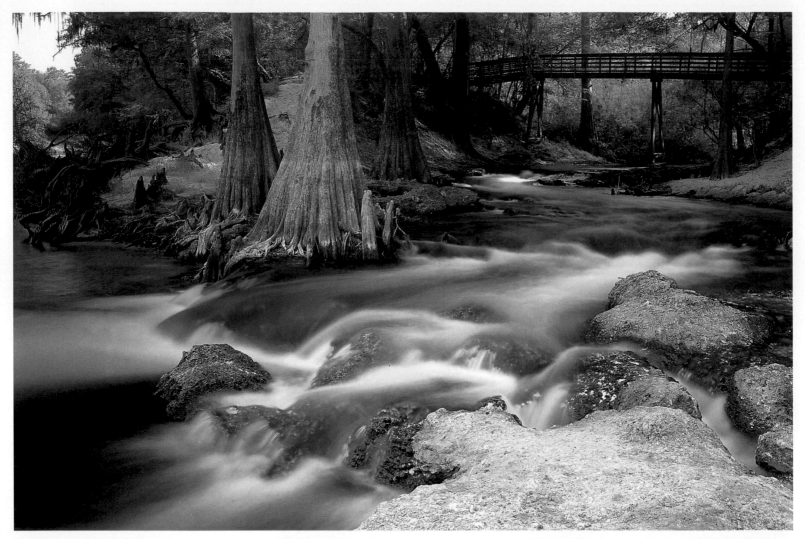

Suwannee River State Park

The legendary Suwannee is a fast-flowing river. It begins in Georgia's Okefenokee Swamp and ends at the Gulf of Mexico near Cedar Key. Moving southwest from Georgia, it is fed by many springs. Its upper stretches, wild and remote, are a reminder of earlier eras.

Along its way south, the Suwannee makes connection at this 1,300 acre park with another Georgia river, the Withlacoochee. There are two Withlacoochee rivers in Florida. This can sometimes be confusing. (The "other" Withlacoochee is in Central Florida.) The northern Withlacoochee from Georgia is a springfed, blackwater river which travels 23 miles in Florida to meet the Suwannee. From an overlook at the park, the observer can see the confluence.

There are beautiful cypress in this area. Another tree, the cedar elm was first reported in Florida from Suwannee River State Park, where it grows to be over 50 feet high. This river is also the southernmost range of the alligator snapping turtle and the redbelly water snake.

The area can be experienced by canoe or by hiking several trails. The longest trail is the Big Oak Trail, at over 11 miles, but

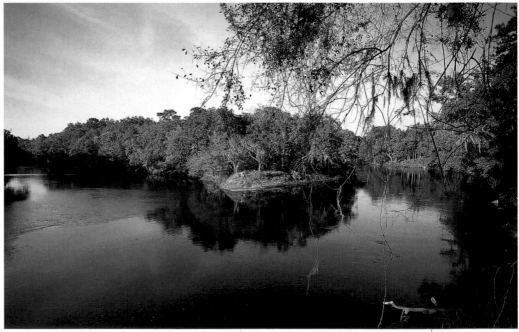

perhaps the most lovely is Lime Sink Trail which leads to Lime Springs. Lime Sink is appropriately named, as its waters are very green in appearance, however the name derives from the outcrops of limestone along the spring run. The trails along the Lime Sink should be hiked by anyone who appreciates Florida's beauty.

Steamboats traveled these rivers in olden times when the shores were wilder. A steam boat moving along the Suwannee through the untouched wilderness would make quite a picture.

Top: a spring run in Suwannee River State Park.

Above: the confluence of the Suwannee River and the Withlacoochee River.

Opposite page: Lime Springs Run flowing into the Suwannee River.

Thirteen miles northwest of Live Oak off US-90 which meets I-75 in Lake City. There is also an exit from I-10 about six miles northwest of Live Oak. Follow signs. Located in both Madison and Suwannee counties.

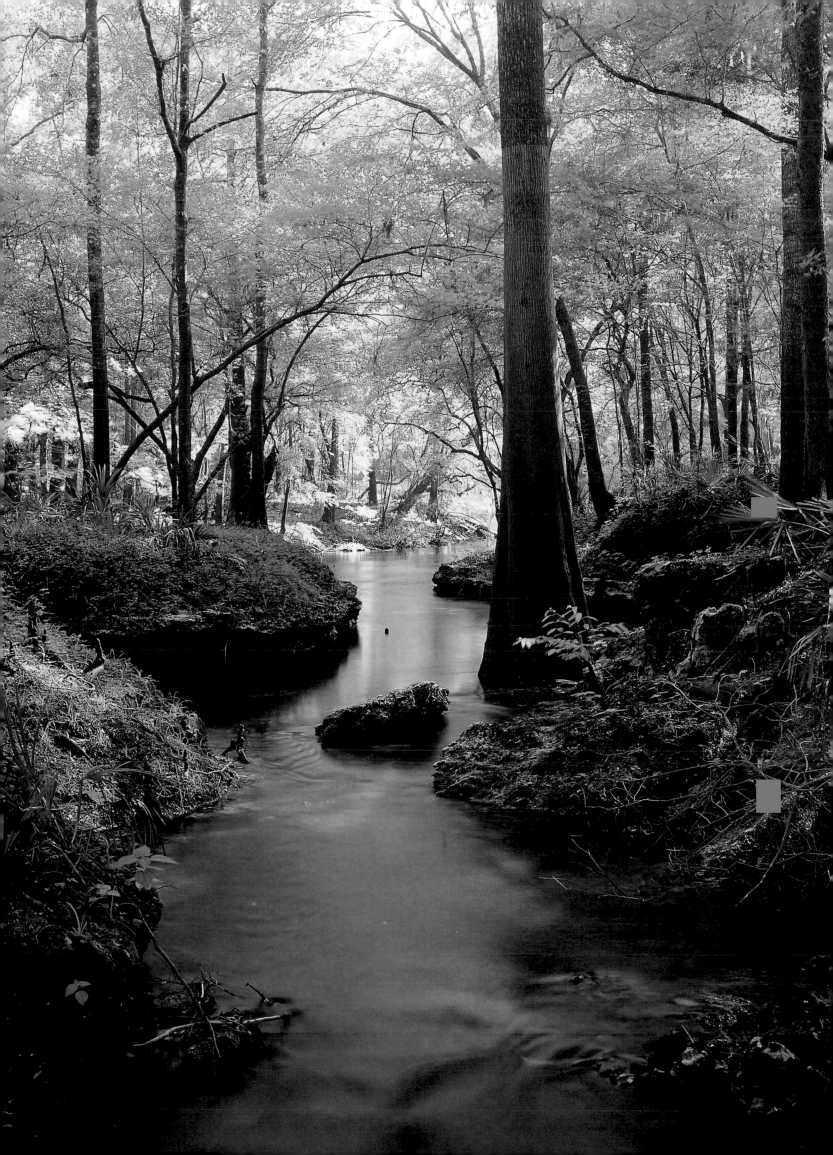

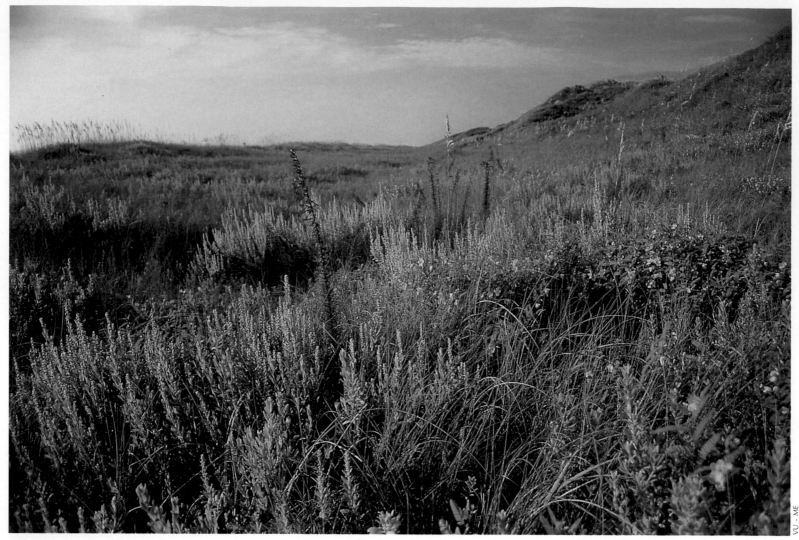

Other North Florida Adventures

AMELIA ISLAND SRA

On A1A between Little Talbot State Park and Fernandina Beach. Beaches, coastal forest, and salt marsh. Thunder along the Atlantic on horseback. Horses are available from a concession.

BIG SHOALS RECREATION AREA

On SR-135 north of White Springs. Bluffs and white water too dangerous to canoe. Over 1,000 acres for hiking or horseback riding.

CROSS FLORIDA GREENWAY

Thanks to the efforts of Marjorie Carr and others, there is no Florida Cross State Barge Canal but instead, the "Greenway," which stretches 110 miles from the West Coast to the St. Johns River. The Greenway approximates the path the barge canal would have taken. The concept is that the land along it is now dedicated to conservation and recreation.

MUSEUM OF NATURAL HISTORY

On campus at the University of Florida in Gainesville. Informative exhibits on Florida wildlife and Native Americans.

RAINBOW SPRINGS STATE PARK

On US-41 north of Dunnellon. One of the loveliest and most popular springs. Canoe rentals, tubing, and swimming.

ANDREWS WILDLIFE MANAGEMENT AREA

Five miles north of Chiefland in Levy County off US-19/98. This wildlife area of 4,000 acres is named for the Andrews family. For almost five decades, they saved the largest remaining Gulf Hammock hardwood forest in Florida. It is located on the banks of the historic Suwannee River. The biggest individuals of several Florida tree species are found here.

TOMOKA STATE PARK

I-95 parallels the general area. From US-1, turn east on SR-40. Go to North Beach and continue a little more than three miles. Audubon came here to paint birds, and he was not disappointed. This is a coastal hammock and marsh area, rich in magnolias, oaks, and palms. The Fred Dana Marsh Museum at Tomoka has exhibits dedicated to the early Native Americans and the environment. Associated with the park is a legend that Chief Tomoka drank from a sacred cup containing magical powers much like the Fountain of Youth sought by Ponce de Leon. There is a hiking trail for exploration of the hammock.

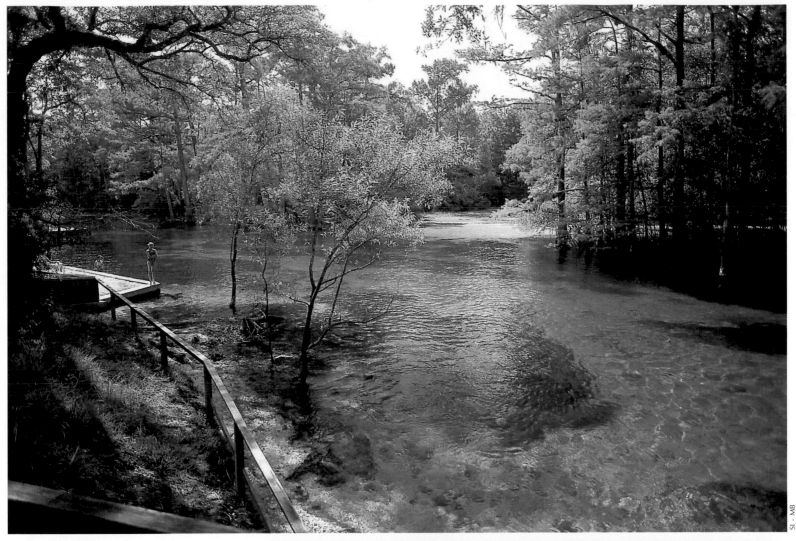

MANATEE SPRINGS
STATE PARK (above)

Manatee Springs is west of Chiefland in Levy County. From US-19/98, turn onto SR-320 and go west for five miles.

This is one of Florida's 27 first-magnitude springs. Manatee Springs occasionally gives winter shelter to some of Florida's remaining 2,000 West Indian manatees.

In summer, this shady park is extremely popular for picnicking, swimming, snorkeling, and canoeing. The waters from the spring flow into the Suwannee River.

There are sinkholes connected by underground waterways which have been explored by skilled cave divers.

Canoes can be rented. A boardwalk crosses a cypress swamp and leads to the junction of the spring run and the Suwannee River. There is an eight-and-a-half-mile hiking trail through hardwoods and pines, and also shorter nature trails.

Opposite page, top: the coastal dunes of St. Johns County. The red flowers are standing cypress and the yellow flowers are partridge-pea.

Opposite page, bottom: a coastal maritime forest hammock in St. Johns County.

Right: Ocean Pond in Osceola National Forest.

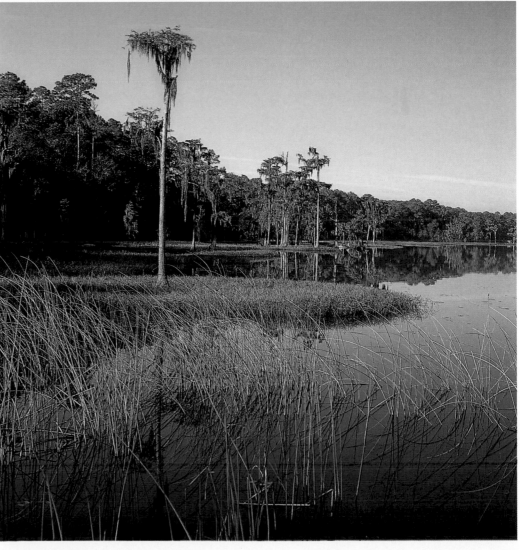

Central Florida

Aside from the tourist corridor along Interstate 4, Central Florida is a naturally gorgeous area, characterized by an abundance of lakes and rolling hills.

An outstanding feature of this area is the Central or Lake Wales Ridge, a higher area which includes much of Florida's remaining scrub habitat. This slightly elevated ridge became haven to life when higher seas covered much of Florida. The remaining areas of scrub have been greatly reduced by human activity.

However, in the past few decades, there has been a growing awareness of scrub as a valuable ecosystem. There was even a movement at the start of 1999 to replace the Florida state bird, the mockingbird, with the scrub jay, a symbol of the threatened scrub habitat.

Over 50% of Florida's lakes are associated with the Central Ridge system. This is Florida's "lake district," and it is unique in the southern US. From the air, the landscape is dotted with small, shallow lakes.

Of the five largest lakes in Florida, four are located here. Lake Okeechobee, the largest, stretches into South Florida. The third largest is Lake Kissimmee; the fourth is heavily polluted Lake Apopka; and the fifth is Lake Istokpoga. (The second largest is Lake George which is in North Florida.)

The St. Johns River has its headwaters in marshes of this region. Other rivers include the Hillsborough, Peace, Wekiva, and Withlacoochee.

Moving southward through the region, there is a shift toward more tropical vegetation. This is the region in which mangroves begin to appear along the coasts, particularly the Gulf Coast.

Along the Atlantic Coast, sea turtles nest heavily on the beaches of the barrier islands. The turtles also nest on the Gulf Coast, but their numbers are much greater on the Atlantic. The Atlantic produces surf-quality waves, and has inlets, sandy beaches, and rocky shorelines.

One very large natural area within the Central Region is the Green Swamp (see page 88). It is more than a staggering half-million acres of mixed habitats; it dwarfs all other natural places within the region. Despite its size, it is little explored, and something of a mystery to many Floridians and tourists, most of whom have only a vague idea where it is, or what it is.

There are migratory animals other than birds that affect the region. They are called "snowbirds"—human refugees from Winter, not only from the northern US, but also from Canada. Their range is all of Florida, but concentrations are heavy in Central Florida.

In the middle of the state lies one cause for the pilgrimage, the entertainment center of the region, Disneyworld. The Orlando complex, including Disneyworld and the other theme parks, produces the largest tourist revenues in the state. The weekend tourist population in the Orlando-Kissimmee entertainment area often exceeds the total population of Native Americans in Florida who (reluctantly) greeted the Europeans.

Opposite page: **cabbage palms in a swampy area of Merritt Island NWR.**

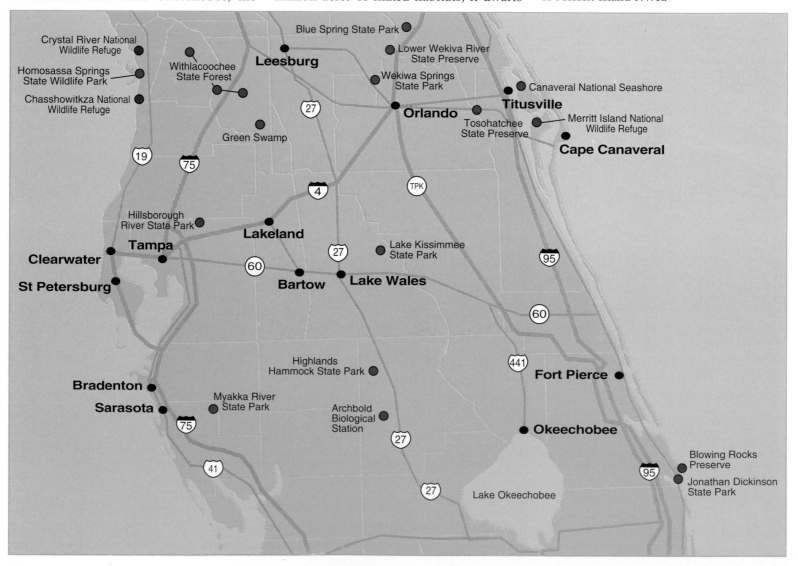

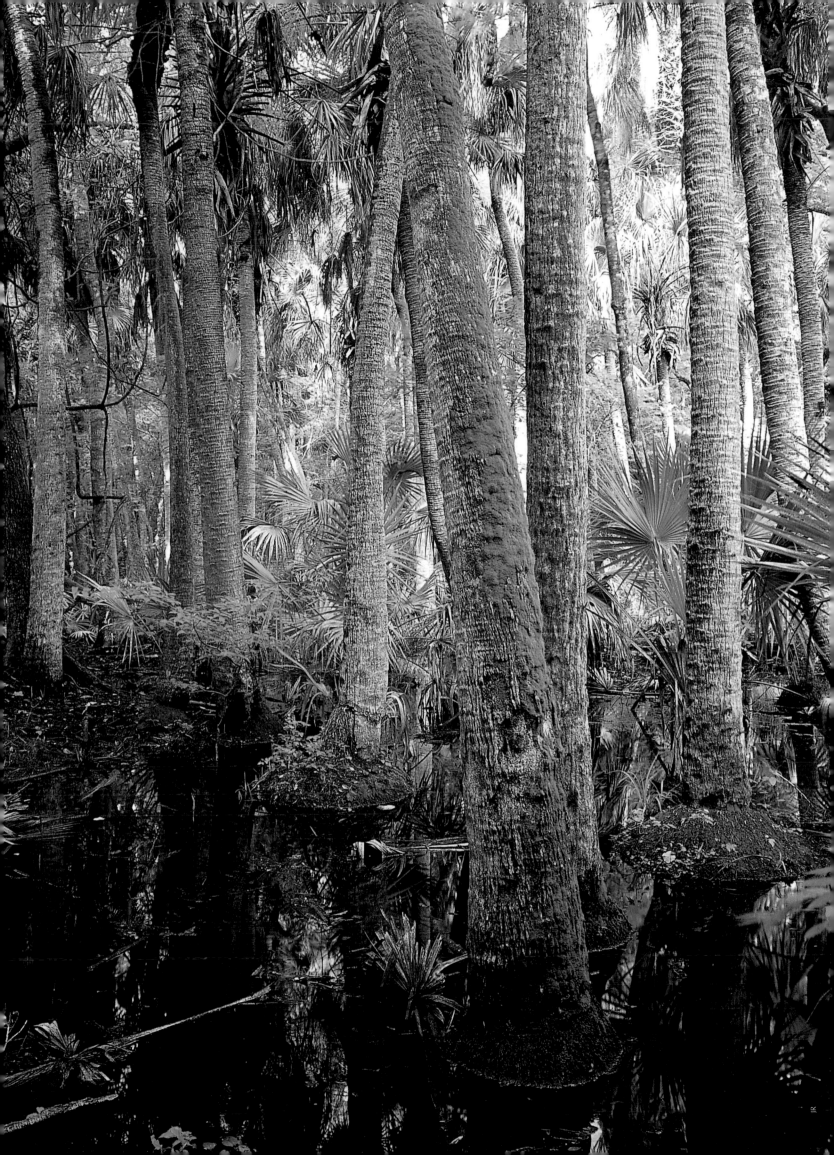

Archbold Biological Station

The late explorer, Richard Archbold, obtained this property from the Roebling family and established a private research station. (The Roeblings built the Brooklyn Bridge.) Archbold is not open to the public in the sense that one can just arrive and explore. This is not encouraged. Rather, there is a standard educational tour, or the staff will design custom tours for those with a special interest. These tours are free; however, a donation to the Scrub Fund would be helpful in preserving this threatened resource. This is primarily a research station. The educational tours are a bonus for the public.

A short nature trail through scrub is located to the south of the main office. This tour provides some quick instruction for identifying the plants and trees of scrub habitat. Hoof prints in the sand are probably deer. The quiet visitor may catch a glimpse of a large buck. There are miles of scrub habitat around the Station, but the true adventure at Archbold is one of the mind. Here are found some of the premier scientists in their fields working at an idyllic pace on many important ecological questions.

Early settlers did not think much of scrub. It was an obstacle in the way of their journeys and settlements. Scrub was burned and ripped away for agriculture, particularly orange groves. Scrub is not a theme park or a roller coaster ride. Some folks consider scrub downright ugly. This is because they are not aware of the biological richness of this unique environment.

Scrub survived on the Lake Wales Ridge when the Ridge was no more than a series of islands in high prehistoric seas. This scrub now shelters more than 40 rare, threatened, or endangered species. These include not only scrub jays and the Florida mouse, but also lizards, plants (such as two members of the mint family), and many little-known insects and spiders.

The concept of biological diversity is relatively new. Every living thing makes its contribution to the natural world, and when we lose any living thing irretrievably, the world is that much poorer.

Scrub is vanishing in Florida. If there were laws for the protection of ecosystems, scrub would be an endangered habitat on the verge of extinction. If Florida's scrub vanishes, many species will also disappear.

Call or write in advance. Information is on page 158. Archbold is in Highlands County south of SR-70 on Old SR-8.

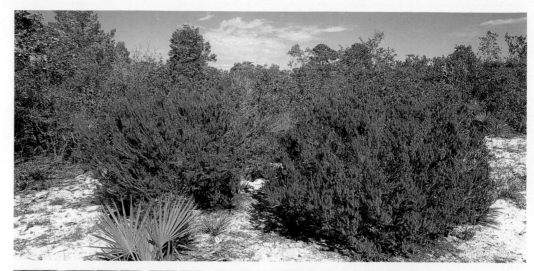

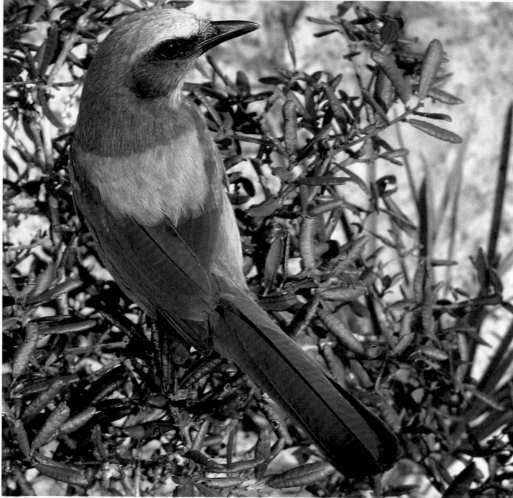

Top: an example of typical sandy scrub terrain with Florida rosemary in the foreground.
Above: one of the interesting creatures found at Archbold, the scrub jay. These birds have been intensely studied because of their interesting family organization. Although the young of most other species fly away from the nest as soon as they can and are rarely seen again by their parents, the young of scrub jays remain near the nest and help their parents raise the next generation.
Opposite page: three species of reindeer lichen. These lichen are found in scrub habitat with scrub oak and rosemary.

ENDANGERED ECOSYSTEMS?

At first glance it seems like a good idea to protect ecosystems as threatened or endangered. Laws could be passed sheltering them. Funds would be provided for buying up scrub areas, for example. However, this does not always help the endangered animals. Animals often live in a variety of habitats and move about. Therefore, protecting animals instead of ecosystems means many ecosystems are protected, instead of just those designated.

The issue is further complicated by the overlap of habitats. This is evident in many of Florida's forests, parks, and preserves where there are several ecosystems with gradual (or abrupt) transitions between them. Scientists sometimes differ in opinion about the definition of an ecosystem and how best to protect it, so imagine the problems that legislators might have.

Blowing Rocks Preserve

More than 100,000 years ago, Blowing Rocks was a barrier island. Now, when the surf is up, and the tide is high, the Atlantic surges through the ancient limestone and erupts through several fissures and solution holes in the rock. The resulting plumes can spout as high as 50 feet. Hence, the name "Blowing Rocks."

The dark rock formation looks more like volcanic lava than limestone. But if one looks closely, imbedded shells can be seen in the limestone. Peeking through some of the "blow holes," the waves can be seen surging to shore on the beach below. The three-quarter mile of limestone at Blowing Rocks contains the remains of trillions of tiny sea creatures.

From March to September, Atlantic green, leatherback, and loggerhead sea turtles nest on the sandy beaches to the north of the rocky outcrop. At night the females come ashore to lay eggs.

During a Spring visit, the calm water offshore was here-and-there disturbed. At first glance, it appeared to be small sharks or perhaps dolphins. It soon became apparent, however, that Atlantic green sea turtles were mating offshore near dawn. Appearing to flounder at the surface, some seemed to wave their flippers in the direction of the watching humans.

The preserve's 75 acres are managed and owned by The Nature Conservancy, a private, non-profit, conservation organization. Since 1961, the Conservancy's Florida Chapter has helped protect more than 700,000 acres in the state's most

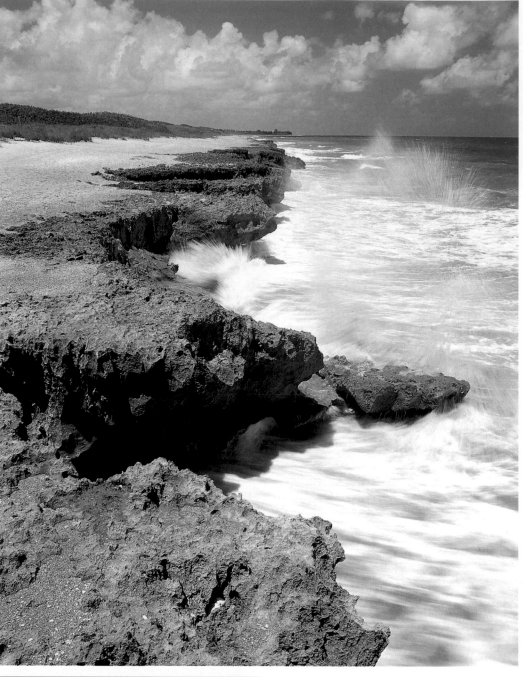

threatened natural areas, where the greatest natural diversity remains.

At Blowing Rocks there has been a pioneering effort to remove Australian pines and replace them with native plant and tree communities. Each morning, volunteers also search for baby sea turtles that may have become trapped in the limestone. They are then set free.

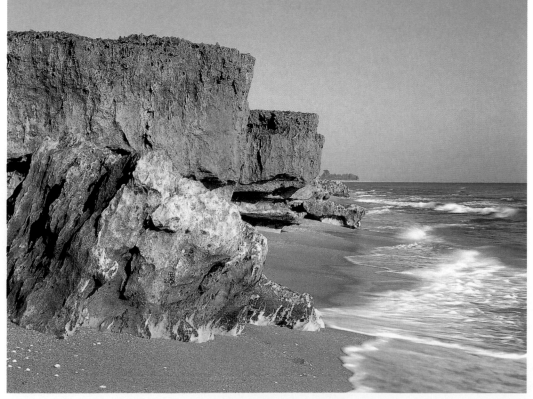

Opposite page, top: the surf erupts through the blowholes, sending plumes of water high into the air.

Opposite page, bottom left: lovers embrace at the end of a sandy path lined with sea grapes.

Oppposite page, bottom right: a former blow hole at sunrise.

On Jupiter Island in Palm Beach County. From US-1 go east to SR-708 then south on SR-707.

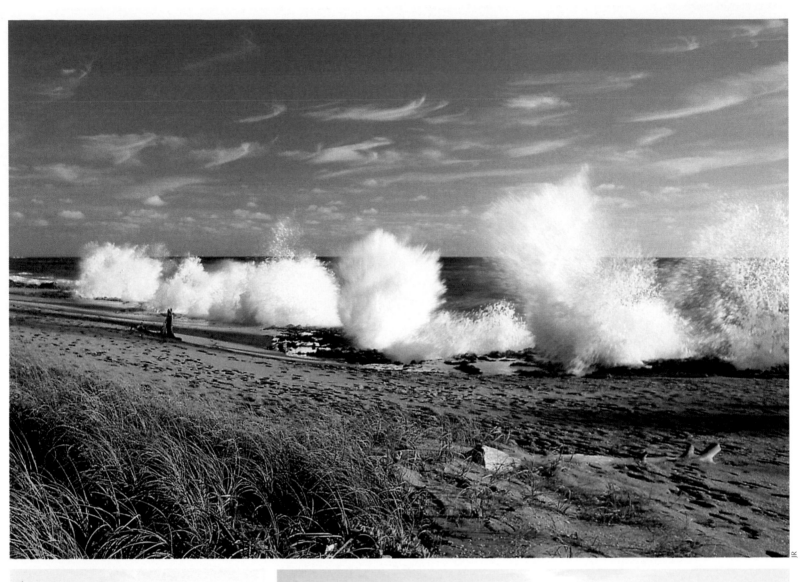

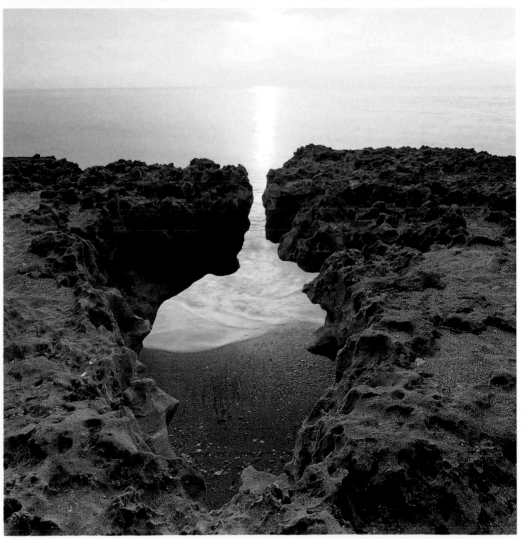

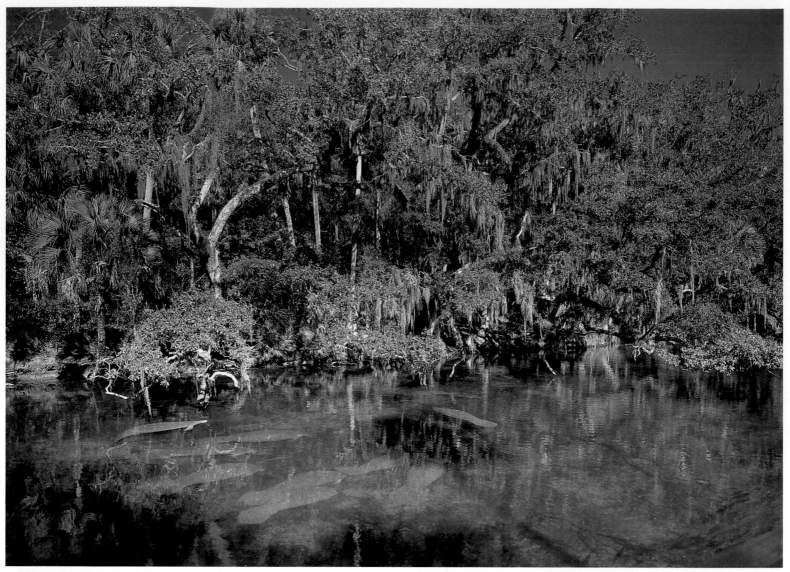

Blue Spring State Park

Blue Spring is a premier winter viewing area for manatees, with the largest concentration of these gentle creatures on cold winter mornings. They can be viewed from a half-mile boardwalk. They spend most of their time resting.

The manatee is one of nature's marvels, and is a distant cousin of the elephant. When manatees were plentiful, the adults helped to clear Florida's waterways, each one eating almost 100 pounds of aquatic vegetation daily.

Manatees were consumed by early Native Americans, including the Timucuan people who lived here. A manatee could feed a village for a week or more. They were also eaten by settlers. Boiling preserved the flesh almost a year. Museums paid high prices for manatee hides and bones. Yet manatees were plentiful and these human activities hardly affected their population. It was dredging and flood control which later devastated their breeding and grazing grounds. Today, almost every adult wild manatee bears scars from boat collisions.

In addition to the manatees, Blue

Above: **manatees share the spring with gargantuan longnose gars and plentiful bass.**

Opposite page: **morning on the St. Johns River.**

Spring has a four mile-in/four mile-out hiking trail which passes through flatwoods, hammock, marsh, and scrub. Canoe trips are possible on the St. Johns River. Diving, snorkeling, and swimming are allowed in the spring and in small portions of the spring run.

Exit I-4 north onto US-17/92 as close as possible to Orange City. US-17/92 has many I-4 exits, and some are quite far from the park. In Orange, turn onto French Avenue. The turn-off from French Avenue to the park is marked by signs. Located in Volusia County.

FLORIDA'S MANATEES

It is a race against the biological clock for Florida's manatees. Almost 5% of their population (around 90 animals) may die each year. How fast newborns are produced to offset the loss is not clearly known. Manatees are increasing, but high population estimates might be just the result of more people counting them.

The reproduction rate among manatees is slow compared to that of some mammals. Manatee mothers give birth to only one calf, not unusual among large mammals, but not exactly the way to re-

plenish a threatened population. The newborn is carried for a long time, 13 months. The calf is then raised by "mom" for two years and usually no pregnancy occurs during this period.

Adult manatees can weigh more than a ton, yet they glide effortlessly through the water. They are thought to be strict vegetarians, yet there are reports of manatees on occasion taking a fish. Some think fish-taking is merely accidental. These creatures may be as long-lived as humans, with life spans between 50 and 80 years.

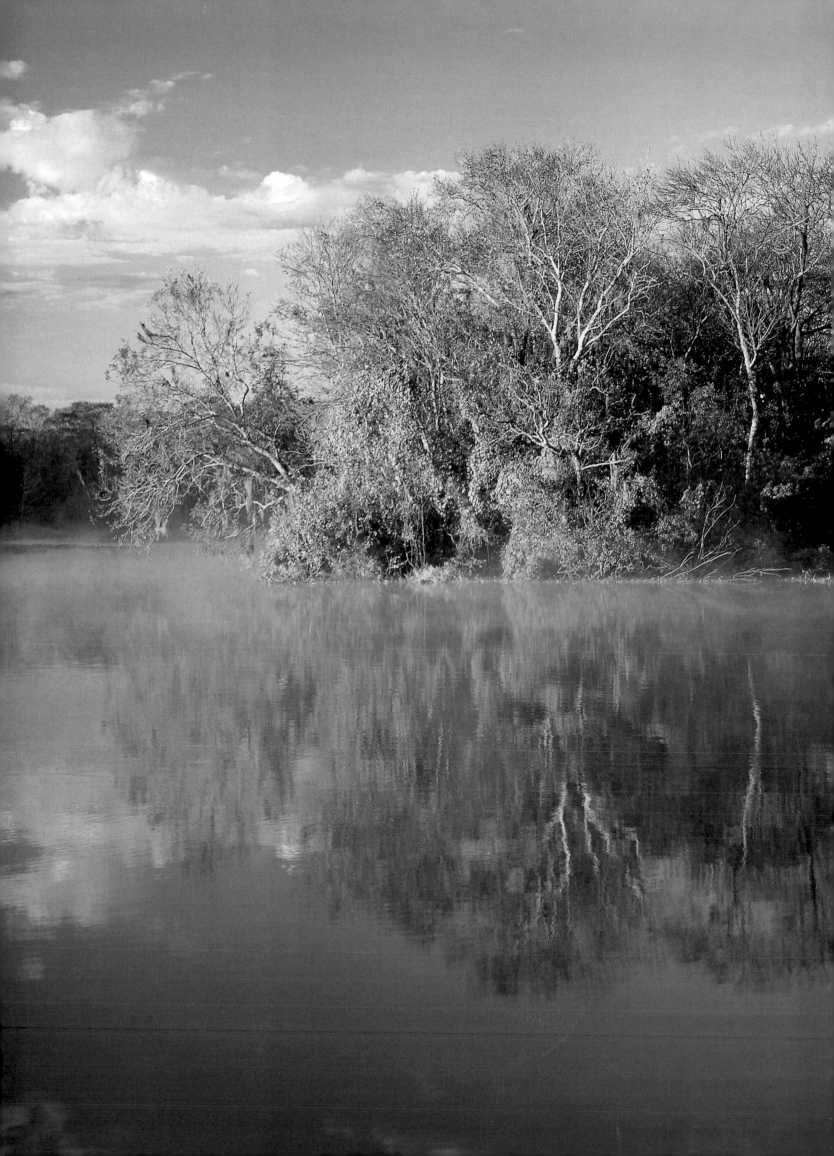

Canaveral National Seashore and Merritt Island National Wildlife Refuge

Spin-off benefits from the US space program include commercial products such as breakfast drinks, plastics, and new disease-fighting drugs. The Merritt Island National Wildlife Refuge and the Canaveral National Seashore are two natural spin-offs. Because of the nearby space program, these areas are kept wild as a buffer zone. They are occasionally closed for security and safety, especially during shuttle launches.

The Black Point Wildlife Drive is northeast on CR-406. This seven-mile nature drive is one that can be enjoyed from the comfort of a car. There is a stop near an observation tower, where there is a five-mile hike through the salt marsh. Birds appear here in great numbers in the cooler months. Over 100,000 coots alone have been reported in the Winter months. The late spring and Summer months belong to biting flies and the ever-present salt marsh mosquitoes.

The Merritt Island NWR headquarters and visitor center are on Beach Road (CR-402). There is a short trail along a turtle-rich pond through a hammock. Further east, on the north side of the road, are two relatively short hammock trails. The Manatee Observation Deck is located on the

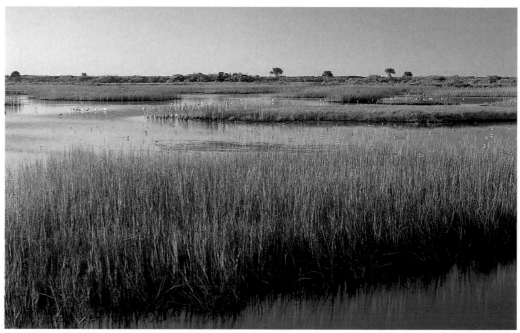

northeast side of Haulover Canal. There are several canoe and boat launches. Other than this, most of the 140,000 acres in Merritt Island NWR are inaccessible.

Canaveral National Seashore has several hard-to-find trails. It is best to ask for directions at the gate. The reason to visit here is not the trails, even if one of them leads to a fairly large Timucuan shell mound. Probably the greatest pleasure at

Canaveral NS is to walk along the 24 miles of uninterrupted, natural beach, and to swim in the surf. It is the longest stretch of natural beach on Florida's Atlantic Coast.

Nearby is Cape Canaveral, representing the pinnacle of man's engineering and daring. The assembly building, launch towers, and (sometimes) space vehicles poised for launch are clearly visible.

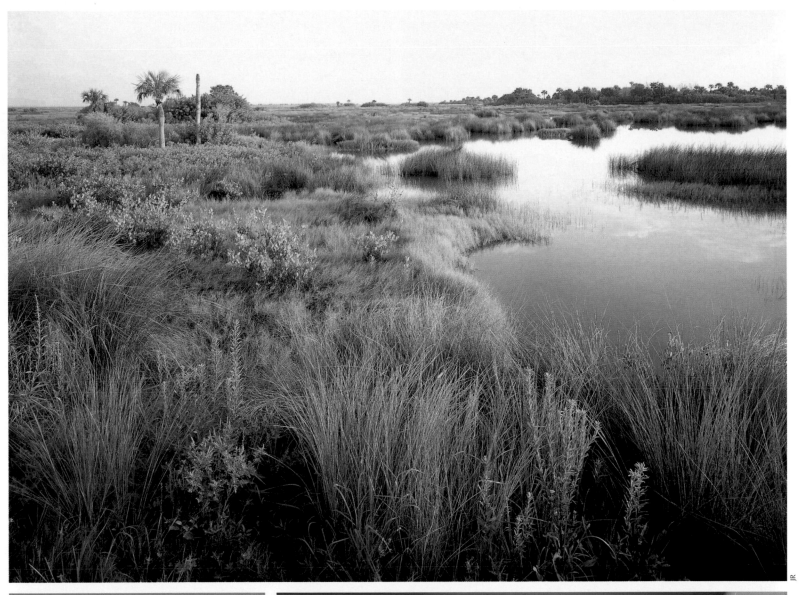

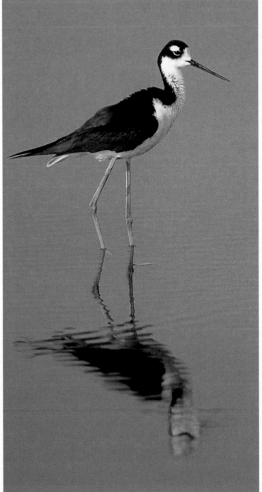

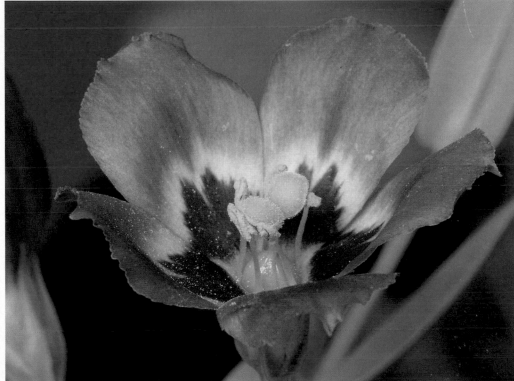

Opposite page, top: the beach at Canaveral National Seashore.

Opposite page, below: a saltwater marsh at Merritt Island NWR.

Top: a saltwater marsh at Merritt Island NWR.

Left: a black-necked stilt at Black Point Wildlife Drive.

Right: Florida seaside gentian at Merritt Island NWR.

Exit I-95 at Titusville. Go east through Titusville, then cross the Indian River on CR-406. Portions of both Merritt Island NWR and Canaveral NS are in both Brevard and Volusia counties.

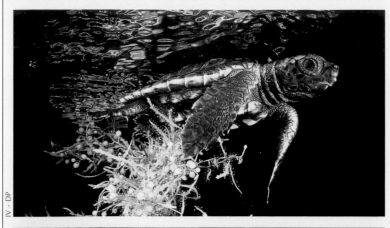

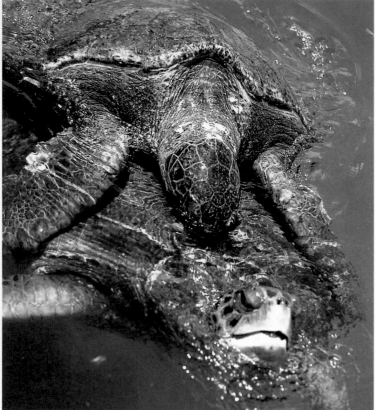

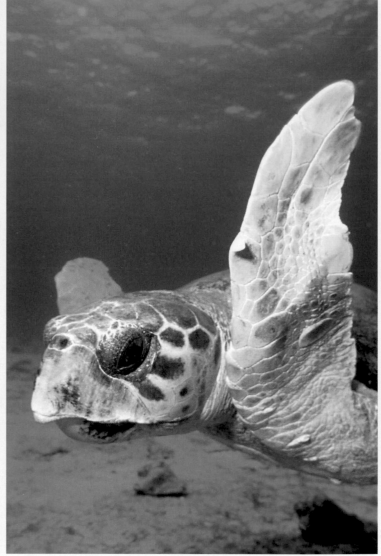

Top, left: a loggerhead turtle hatchling hiding in a floating clump of sargassum in the open ocean.

Left: green turtles mating.

Above: a loggerhead turtle showing its powerful swimming stroke.

FLORIDA'S SEA TURTLES

Watching sea turtles lay their eggs has become a new wildlife adventure. From Canaveral NS south through Brevard County, about four out of ten Florida female sea turtles lay their eggs. Most of the remaining sixty percent nest farther south on Atlantic beaches or on the Gulf Coast.

Humans come in small, regulated groups to watch the females come ashore. Places where turtle watches are conducted include Canaveral National Seashore, John Lloyd SRA, Merritt Island NWR, and Sebastian Inlet SRA.

Baby sea turtles have a difficult life. Raccoons, opossums, and dogs eat the eggs before they hatch. Cats and birds capture the little turtles on land, and birds, crabs, and fish may pluck them from the water. If the turtles get confused by bright lights on the beach, they may head away from the water and perish before reaching the safety of the surf. If they crawl out of their underground nest during daylight hours, they sometimes sit immobile until they die.

They are so vulnerable that they spend the first year of their life hiding to avoid being eaten. Perhaps it is no wonder that when grown they lead solitary lives, except for mating.

Nine out of ten turtles seen in Florida are loggerheads, easily recognized by their large head. Atlantic green sea turtles also lay eggs in Florida, as do leatherbacks, the tough-skinned turtles with a leathery shell. Both green and leatherback turtles are endangered, and observers are required to avoid them. Hawksbill turtles are known to swim around the reefs in the Keys, and there are records of their nesting in seven counties. The rare Kemp's Ridley turtle nests in Mexico, however some individuals have nested on both coasts of Florida. Peter Pritchard of the Florida Audubon Society, a foremost turtle expert, believes these may be from the approximately 2,000 yearlings released into Florida waters in the 1980s.

Male sea turtles almost never come ashore. There is much evidence that the female turtles return to the same beach where they were hatched to lay their eggs. They return to the same location each season to lay their eggs. Some experts have suggested that this is because of the turtle's remarkable sense of smell. When turtles come ashore, they do stick their noses into the sand. Peter Pritchard explains that this is because they are taking the temperature of the beach, not smelling it. He believes, along with many other scientists, that the turtles are able to navigate using the earth's magnetic field. Turtle hearing also comes into play, as beach sand sometimes shift, for example because of storms. While appearing almost stone deaf on land, in the surf they are able to tell the difference between water smashing against a cliff as opposed to a sandy beach.

The huge leatherback can weigh as much as 1,300 pounds and dive as deep as 3,000 feet. Surfers and swimmers will be delighted to know that its favorite foods are various jellyfish.

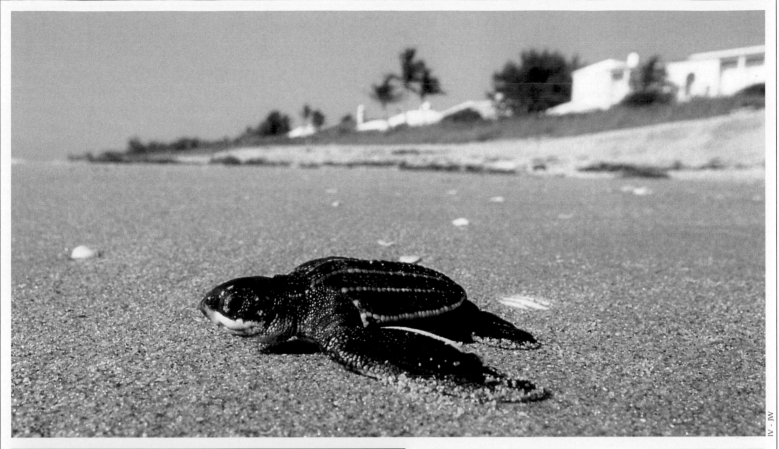

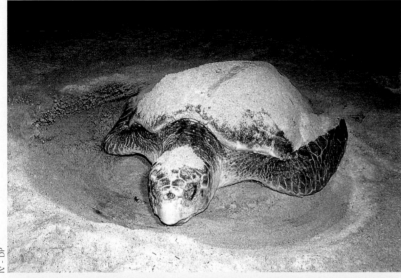

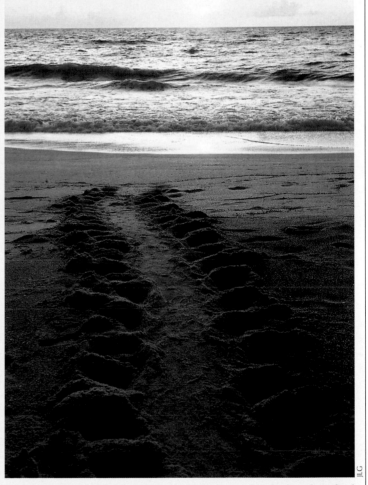

Top: a hatching leatherback turtle struggles across the beach to find its way into the surf.

Center, left: a female loggerhead turtle covering her nest on the beach.

Bottom, left: spectators watch a loggerhead turtle lay her eggs.

Above: the tractor-like tracks of a loggerhead turtle heading for the water.

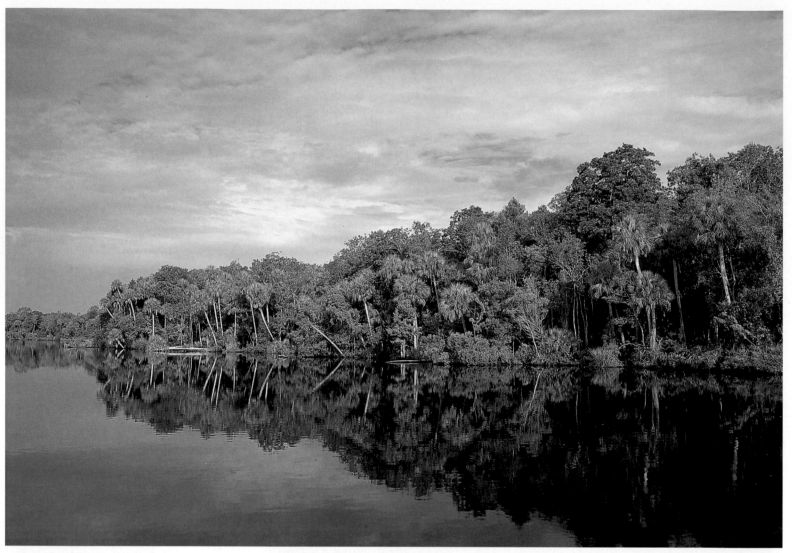

Chassahowitzka National Wildlife Refuge

This refuge was established in 1943 as a winter preserve for migratory waterfowl. Until the early 1970s, humans had encroached very little on the Chassahowitzka River. The only dwellings on the main river were stilt houses and Miss Maggie's Baithouse. A father could take his children fishing with the reasonable expectation of catching speckled trout near the Gulf of Mexico, and bass, bream, and catfish within the river. If the sun became too hot, skinny-dipping provided relief, and there was no one to peek except disinterested waterbirds. When photographers needed a beautiful photo for a cover of a corporate report or a phone directory, they came here for a sure shot of pristine Florida.

This has changed. As with much of Florida, however, it accomplishes little to lament what was lost. The only practical course is to celebrate and preserve what is left. In this case, what is left is 35,000 acres, including the Chassahowitzka and Homosassa River estuaries, many islands, 12 miles of river, salt marshes, and swamp. Within this area are 7,500 acres of wildlife sanctuary, which includes habitat for Florida black bear. The sanctuary is closed

to all public use from October 15 to February 15. Perhaps one of the loveliest rivers in Florida, the Chassahowitzka is only accessible by boat. It can be canoed, perhaps in one long day, with due caution for motor boats. Farther west on the river, after the remnant railroad trestle, is a spring run. The spring is perhaps 50 feet deep and is crystal clear to the bottom. There are other permanent springs in the river. Smaller springs boil occasionally and then disappear. Venturing out into the Gulf is not recommended because the water is shal-

low and the rocky limestone bottom can scrape a boat badly during rough seas in summer thunderstorms. Also, it is easy to lose the route back to the main river.

South of Homosassa Springs about nine miles. From the junction of US-19 and US-98, go west on the only road available. The river is in Citrus and Hernando counties.

Top: the Chassahowitzka River.
Above: vegetation along the shore of the Chassahowitzka River.

Crystal River National Wildlife Refuge

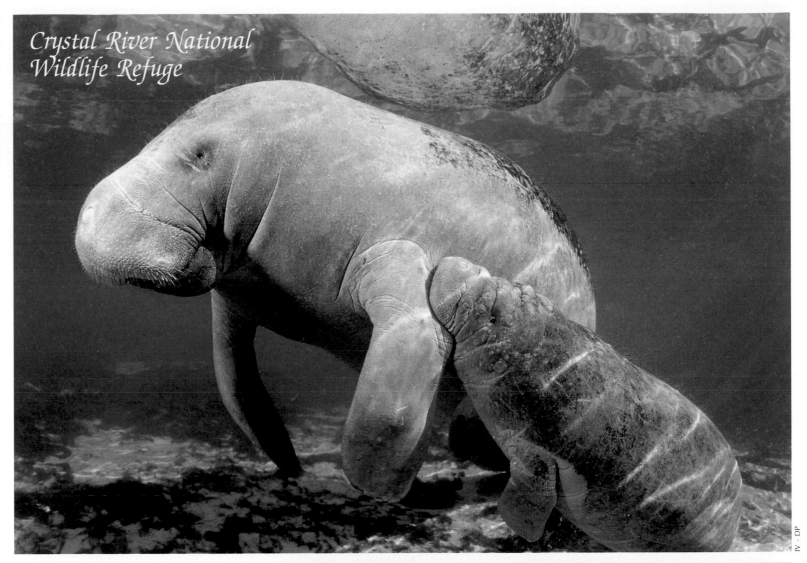

IV - DP

SI - PC

As of 1998, there were over 500 wildlife refuges in the US, 16 in Florida. Of these, this is the only federal preserve devoted to the endangered manatee. Once again, nature lovers can thank the Nature Conservancy. Its successful efforts led to the acquisition of the property that made this refuge a reality.

When heavy concentrations of manatees are in the river, certain "Manatee Sanctuary Areas" are declared and prominently marked off-limits to humans and are monitored by law enforcement officers.

At Crystal River, considerable commercial activity and tourism have arisen due to the presence of the Winter manatees. An AM radio station provides the latest manatee "news;" the frequency of this station is on signs along US-19. Two mammal aggregations seemingly grow in a direct ratio: the more manatees in the rivers, the more human divers are there to see them. Sometimes 100 or even fewer manatees can attract 1,000 or more divers on a weekend. There are at least six boat rental locations, one beside the main office. For less than $20, one can rent a wet suit and get a boat ride to dive with the manatees.

Some naturalists might prefer to first see Crystal River during April through October, when manatees are not plentiful. This would allow an appreciation of the river's beauty undisturbed by all the divers. A second visit could then be made during manatee season.

Manatees congregate in the warm waters that flow from the electric power generating plant at Crystal River as well as others in Florida. Such warm waters have perhaps created false Winter refuges, diverting the manatees from their more traditional migration farther south in Winter. Manatees cannot survive long when the water temperature falls below 68 F. The lure of the warm power plant waters is thought to have habituated manatees to areas they should have abandoned before the arrival of cold weather.

The refuge is composed of 46 acres of islands and water bottom in Kings Bay, the headwaters of Crystal River. Near the office is Banana Island, where Kings Spring pours forth. A map of the refuge is available at the visitor's station. The map includes the regulations necessary to protect the manatee.

Top: **a manatee nursing her calf. The mother's nipples are located under her flipper.**

Above: **a small boat on the scenic Crystal River.**

The main office with a few exhibits is located west of US-19 at 1502 Kings Bay Drive in Crystal River in Citrus County. The refuge is entirely in the river, accessible only by boat.

Green Swamp

The Green Swamp is a large wilderness area of approximately 544,000 acres of flatwoods, lakes, hammock, marsh, river, sandhill, and swamp. Much of the almost 900 square miles is under management by the Southwest Florida Water Management District (SWFWMD, pronounced as "swiftmud") and is not easily explored. Portions of it can be canoed from the rivers spilling from its headwaters: the Hillsborough, Ocklawaha, Peace, and Withlacoochee.

This area is defined by four "ridges," or areas of slightly higher elevation: the Brooksville, Lakeland, Lake Wales, and Winter Haven ridges.

A 30-mile bike path (also used by roller bladers and hikers) extends through the Green Swamp from Maybel in the north to Polk City in the south, with access at Bay Lake and Green Pond. This is known as the Van Fleet State Trail and is built over an old railroad. This is perhaps the most accessible portion of the swamp. It connects from Maybel on SR-50 to Polk City on SR-33.

Alligators, armadillos, gopher tortoises, swallow-tail kites, wild turkeys, and various types of snakes can frequently be seen. The typical Central Florida mammals are there, but harder to spot.

SWIFTMUD guards this precious resource. The authority tries to control the "water wars" between Hillsborough, Pinellas, and Pasco counties that affect the Green Swamp and all other drinkable waters in the region. These wars are often marked by political skirmishes among the "water-haves" and the "water have-nots." Less populous Pasco in general has the water while the more populous counties, particularly Pinellas, have not.

The Green Swamp is located in Lake, Pasco, Polk, and Sumter counties. There are some rugged, and not well-marked access roads from SR-471 north from US-98, and access from SR-33 on Green Pond Road. Contact the Florida Trail Association about their hard-won trails. The Southwest Florida Water Management District issues camping permits.

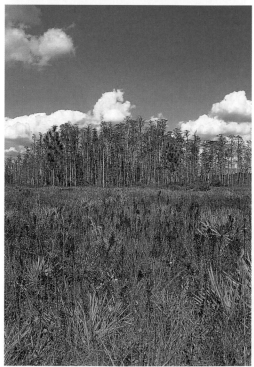

Top: **cypress in the Green Swamp Wildlife Management Area.**

Above: **wildflowers and one of the many cypress heads in the Green Swamp.**

Opposite page: **a pond near "Sanders Shack."**

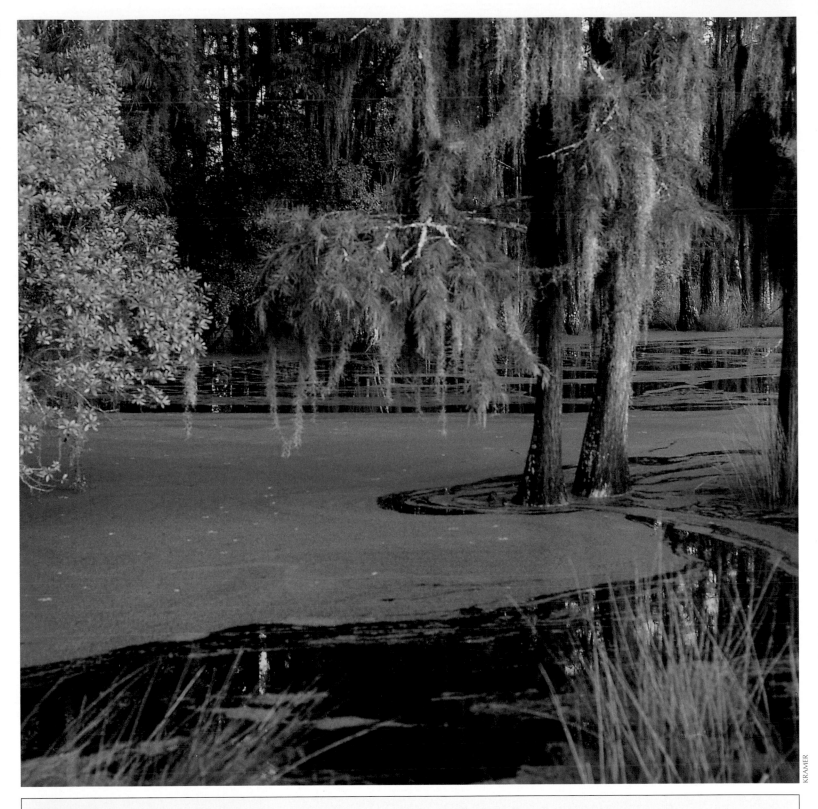

KRAMER

BONE-DRY?

Try telling the people of many desert and island lands that Florida may have a water shortage. Comparatively, Florida is drenched with water. Yet its water supply has become strained by the needs of expanding populations.

Some lakes have disappeared because of human consumption. There has been a drastic decline in the aquifer. Many parts of Florida impose sprinkling bans and other water regulation during the dry months or periods of drought. The greatest fear in drought conditions is that the underground aquifers will get so low that saltwater will intrude. Another worry is the threat of wildfire following a drought.

Desalinated sea water may be one long-term solution to Florida's water needs, and parts of the state are experimenting with it. Currently, it is three times as expensive as freshwater resources. Not many Floridians want to see their water bills go up 200%, even to save the environment. In 1997, however, the West Coast Regional Water Supply Authority was presented with an estimate for desalination that was only 50% more than current water sources. Fresh water is free, but it costs to purify and pump it. Perhaps in time, Floridians would accept their water bills increasing by half in order to save the natural wonders. On the other hand, desalination requires a great deal of energy

and has its own potential environmental problems, including disposal of the by-products.

Many naturalists feel that not enough has been done to conserve water. While commendable, stopping leaks is not the same as changing water use habits. Also much more could be done to contain and use the plentiful rains. However, the damming and impoundment of streams would not be a good option, as it is also very damaging. Water, like land, is comparatively cheap in Florida, and in the end it may take more expensive water rates to change damaging water-use habits which are draining the aquifers.

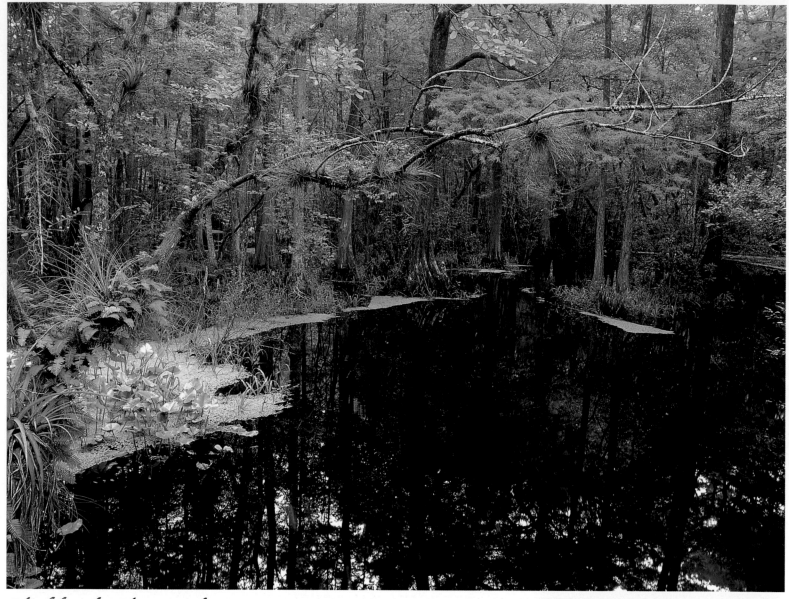

Highlands Hammock State Park

In this hardwood hammock are several trees approaching 1,000 years of age, and at least one is reported to be this old. A millennium seems like near immortality to short-lived mortals. The seedlings of these trees sprouted when Europe was a feudal society. They reached middle age about the time Spanish conquistadors arrived in the Americas. In a sense, visiting this park is like a trip back in time to see the terrain and vegetation that greeted and pre-dated the explorers.

In 1931, a time not particularly well-known for its ecological concern, grass-roots efforts resulted in the area becoming a park, which now is 5,440 acres. These efforts were spurred by the Roebling family, which purchased some of the land and donated it to the state. The Roebling family was also responsible for the establishment of Archbold Biological Station mentioned previously. Their generosity has preserved many valuable treasures for the state.

A road provides easy access to several trails and one boardwalk over a blackwater swamp rich with cypress trees. Blackwater swamps currently make up about five percent of Florida's forested wetlands. They take their name from the darkness of the water. Blackwater swamps have peat bottoms and are relatively low in nutrients and oxygen. The boardwalk over the swamp is at first broad, but soon becomes narrow with a low handrail on one side only.

The Ancient Hammock Trail passes under many enormous oaks, and by the trunks of fallen comrades that provide life and refuge to smaller creatures. Along other trails are bromeliads, ferns, cabbage palms, and hickories. White-tailed deer are plentiful.

Alligators and Florida cottonmouths are abundant in the park. On the paved road, it is often necessary to stop driving to allow an alligator to cross. On the boardwalk, visitors are sometimes startled by a loud roar, which they mistake for either a panther or a feral pig. It is usually a roaring alligator hidden in the nearby duckweed.

From US-27, turn west on CR-634 and follow the signs. Highlands Hammock is in Highlands County.

Top: **cypress along a creek at Highlands Hammock State Park.**

Above: **a 1000-year-old oak tree.**

Opposite page: **live oaks in a hammock.**

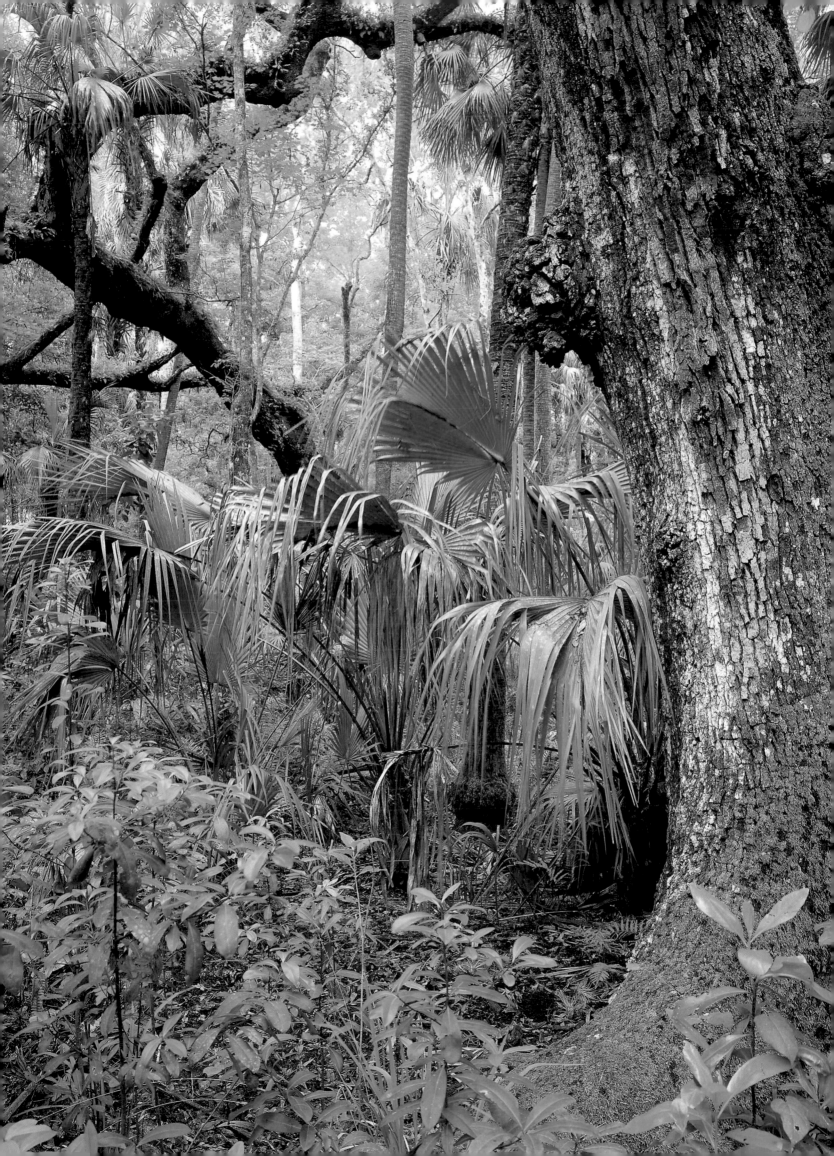

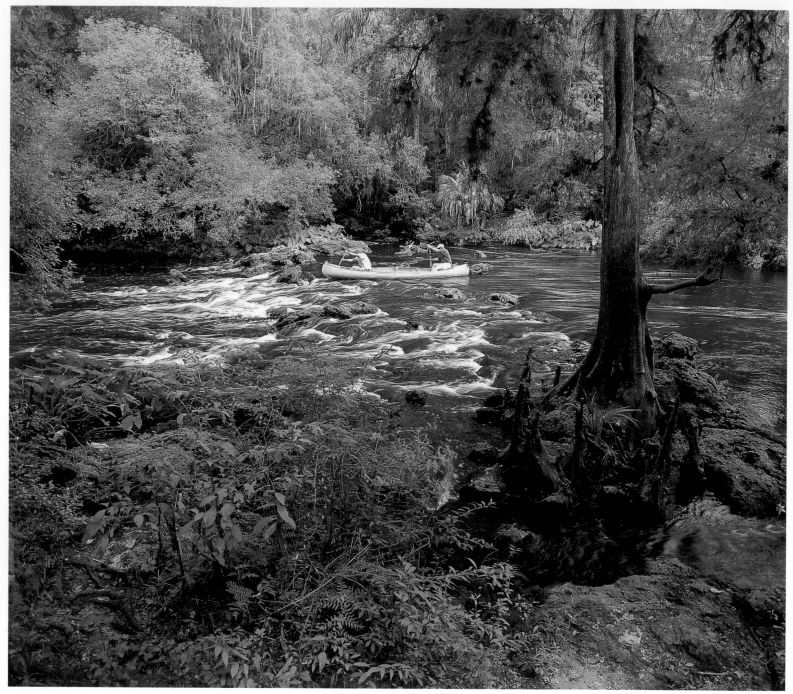

Hillsborough River Parks

Through private outfitters, canoes can be rented north of Hillsborough River State Park on US-301 near Zephyrhills. At times this upper portion of the river can be blocked by fallen trees, and the river has a small limestone rapids in the state park. Canoes are also available from concessions inside the park.

The portion of the river inside the park presents a hint of what the entire 56 miles might have looked like before agriculture, development, and flood control took over. Along the river, there is a lovely hiking trail that passes the rapids. For crossing the river there is a swinging bridge.

Further south, outside the park, canoes can be launched at Fletcher and Fowler Avenues, east of the University of South Florida. A boardwalk and an observation tower are located at Lettuce Lake, a county

park on Fletcher Avenue. Alligators, ospreys, herons, and turtles can be seen.

For hikers, there are several trails within the 3,400 acres of the state park, the longest a little over three miles. The trails lead through pine flatlands and sandhills to cypress swamps and the river. Otters are sometimes seen in the river or sunning themselves nearby. The area is rich in gopher tortoises, frogs, black racers, and an occasional eastern indigo snake. Hawks nest here every year, and bald eagles and sandhill cranes are sometimes seen.

The nearby Wilderness Park offers bicycle, canoe, and hiking opportunities in 16,000 acres of flatwoods, sandhill, and swamp. The Wilderness Park is along Fletcher Avenue and has several separate areas. The first, to the north on Fletcher Avenue just to the east of the bypass canal, includes access onto the top of the canal levee. Hiking and bicycling are permitted, but there is no shade, and only "mad dogs

and Englishmen" would try it under the summer sun in the middle of the day.

The most attractive of the entries is at the Morris Bridge section, farther east on Fletcher. Here, after a short boardwalk under the road, there is a primitive trail passing along the river. There is also a trail on an old railroad tram bed which leads through cypress on a canopy road, ending at a scenic overlook. In the scrubbier areas before reaching the cypress, look for gopher tortoises.

Hillsborough River State Park is 12 miles north of Tampa off US-301 exiting from I-4 . The Wilderness Park is east on SR-579 from I-75. Lettuce Lake is west on SR-579 from I-75. All are in Hillsborough County.

Above: canoeists paddling over the rapids of the Hillsborough River.
Opposite page: **another view of the rapids.**
Page 94: **along the Hillsborough River at Wilderness Park, Fletcher Avenue.**

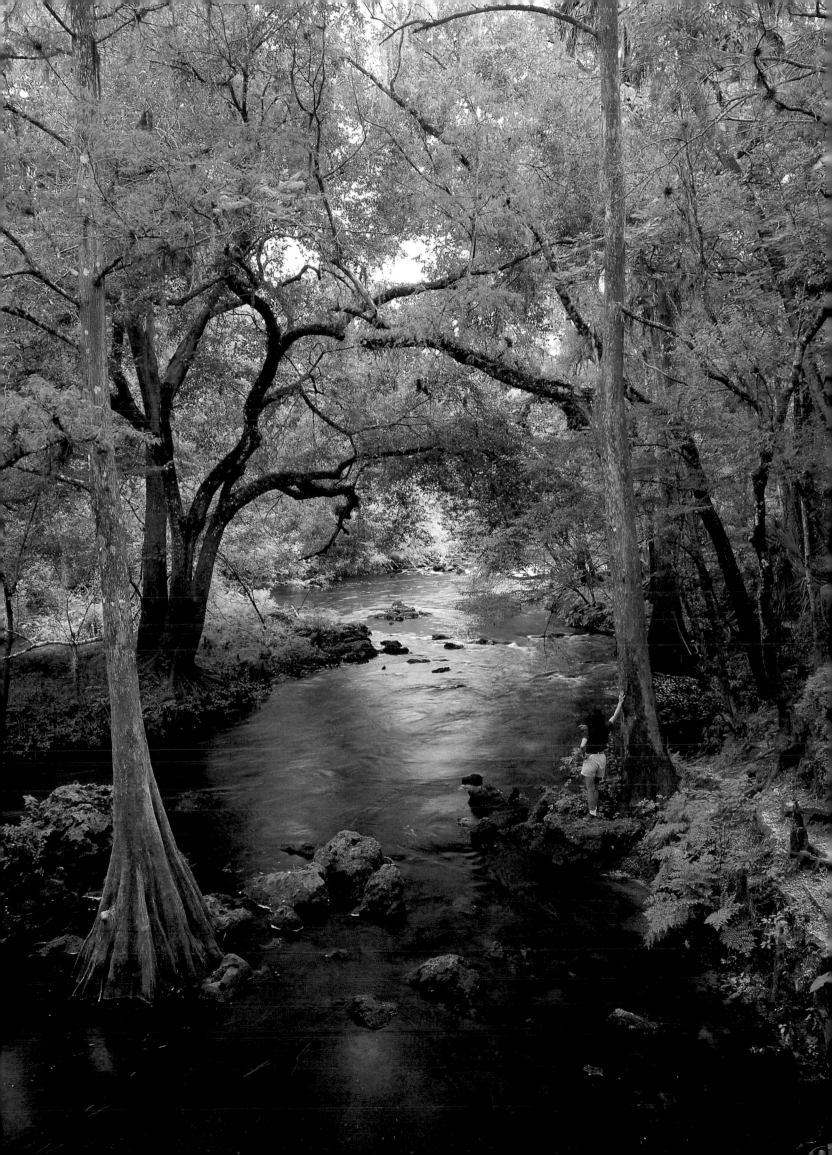

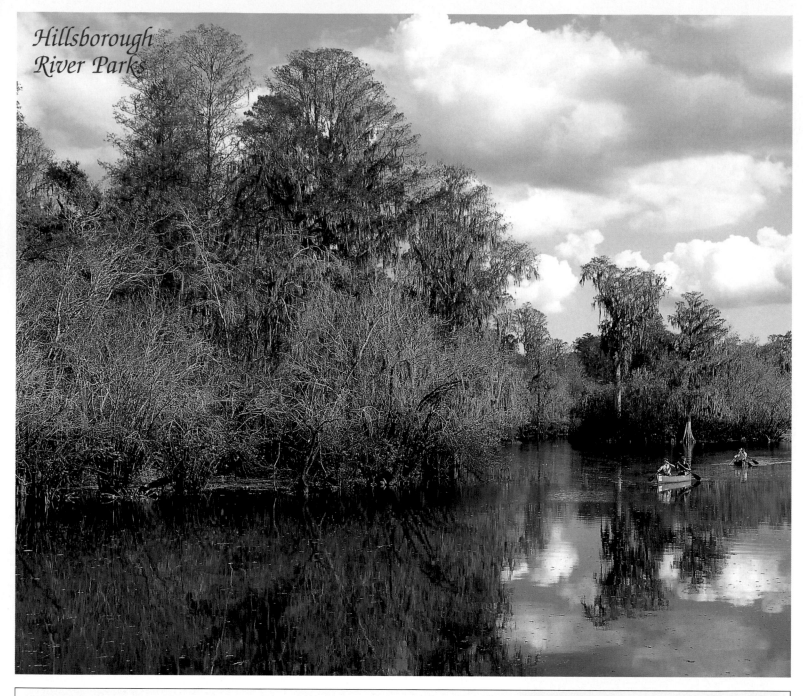

Hillsborough River Parks

GOPHER WORLD

Hillsborough and Pasco County have many sandy lands where once was an abundance of gopher tortoise and eastern indigo snakes. The two often live together in gopher holes, the burrows that tortoises dig in the earth. The burrows are also shared by many other creatures. Other reptiles commonly seen in Central Florida are skinks, and many kinds of snakes, including the southern ringneck.

It is a fairly common experience in this area to see gopher tortoises lumbering along, as well as black racers, easily confused with indigos. Black racers are extremely fast-moving snakes, and the naturalist rarely gets a chance to look closely. Same for indigos! It is often said that black racers have a white chin and indigos have a red or brown chin. There is much variation in chin color and this is not really a good indicator. Indigos are more robust, and as adults they are longer than racers.

Indigo and gopher tortoise numbers have been on the decline even though they can live comfortably with humans. Many farmers or ranchers have memories of a "tame" indigo that once stayed around their ranch holding down rodent and venomous snake populations.

Land clearing for development has done much harm to the gopher tortoises. In many areas, there are now requirements to relocate or to pay a fee when gophers are displaced by development. Habitat destruction is not the only reason for the decline of the indigo snake population, but it is the main reason. Humans have collected and often sold this valuable snake. Although there are laws that forbid the collecting or sale of indigos and gophers, there still exists an illegal trade which further diminishes their numbers. Indigos are a threatened species, and the gopher is designated a species of special concern.

Homosassa Springs State Wildlife Park

At first glance, Homosassa Springs State Wildlife Park hardly resembles a wild area of Florida. It seems more like one of the theme parks in Kissimmee/ Orlando. The entrance fee is around $8 for adults, more than other Florida parks, and there is a "tour boat" from the visitor center to the park. The extra entrance fee goes for feeding and rehabilitating injured wild animals. A boardwalk through the park passes a number of habitats containing rescued animals.

But there is more than meets the eye at Homosassa. Huge Homosassa Springs pours directly out of the aquifer. In the springs, fresh and saltwater fish mingle and circle endlessly. The freshwater varieties include plentiful bream and gar, while the saltwater fish can include jacks, mullet, sheepshead, and snook.

Manatees can be seen year round through an underwater observatory in the main spring. Along with Lowery Park Zoo in Tampa, this is the best place to observe manatees eye-to-eye without snorkeling or diving in one of their favorite rivers or springs. "Up close and personal" is always special with a manatee.

Important, especially for younger people, are the continuing educational programs which occur between 10 am and 4 pm daily. The park's wildness may be largely managed, but it nevertheless contains enough wonder to inspire many youngsters to take an interest in their natural surroundings. This can be the beginning of a great adventure of the mind.

Children of all ages can benefit by attending some of the park's educational programs. Homosassa Springs is perhaps a two-hour visit for the naturalist familiar with the Florida environment.

To the west on US-19 in the town of Homosassa Springs in Citrus County.

THE NOT SO LITTLE MERMAID

Manatees are classified in the scientific order Sirenia, meaning siren, or mermaid. Manatees are thought to be the source of mermaid legends, although the resemblance of these huge mammals to the lithe, goddess-like mermaids, is certainly unclear. Their common name may come from the Carib word, manati, *meaning breast.*

Top: children observing a manatee.

Right: a sheepshead is among the many fish that are easily observed at Homosassa Springs.

95

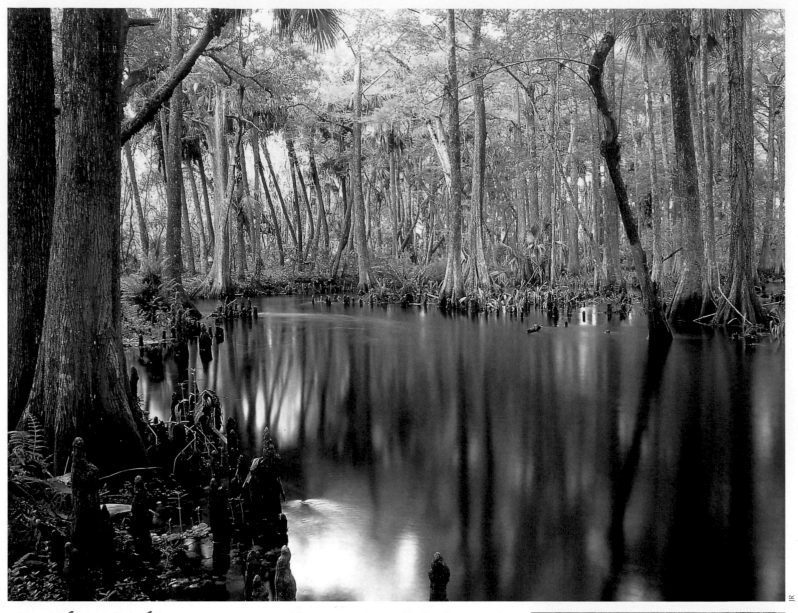

Jonathan Dickinson State Park

From the paved road into the park, the second right turn takes the visitor to an observation tower more than 50 feet tall atop Hobe Mountain, a high dune from an ancient sea. From the platform, Jonathan Dickinson State Park seems like an endless expanse of forest.

The park is named for a Quaker merchant who was captured by Native Americans in 1696 after a shipwreck at nearby Jupiter Island. With him were his wife, infant son, servants, and shipmates. Their story of suffering and adventure is told in *Jonathan Dickinson's Journal* which is sold at the concession.

The park contains 11,500 acres of flatwoods, scrub, portions of the Loxahatchee River, and over 20 miles of hiking trails. The river can be explored by canoe from several points (check with the rangers) or by a boat ride at the concession. The concession boat ride takes the visitor to the home and former zoo of "The Wild Man of the River," Trapper Nelson.

Trapper Nelson died of a gunshot wound in 1968. The coroner said it was self-inflicted, but some say it was not. A Polish immigrant, Nelson made his living trapping. He built every inch of his home, and frequently invited guests to spend the night in the wilderness. His holding cages became a sort of popular zoo until an injured visitor sued him. He was an individualist, and he looked like a body builder in his prime. The park rangers provide an excellent tour of his home.

The Native Americans named the Loxahatchee for its turtles. They are plentiful and can be seen sunning themselves on logs. Manatees, alligators, mullet, and tarpon can also be seen in the water. A canoe journey on this lovely river is one of the prime reasons to visit.

Top: the Loxahatchee River.
Bottom: Wilson Creek.
Opposite page, top: canoeists on Kitching Creek.
Opposite page, bottom: a saw palmetto and turkey oak forest.

Exit I-95 at Hobe Sound east to US-1, then south to the entrance on US-1, also called Federal Highway. The park is in Martin County.

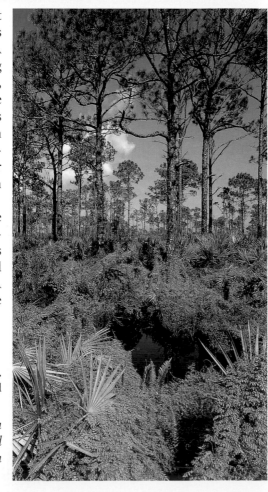

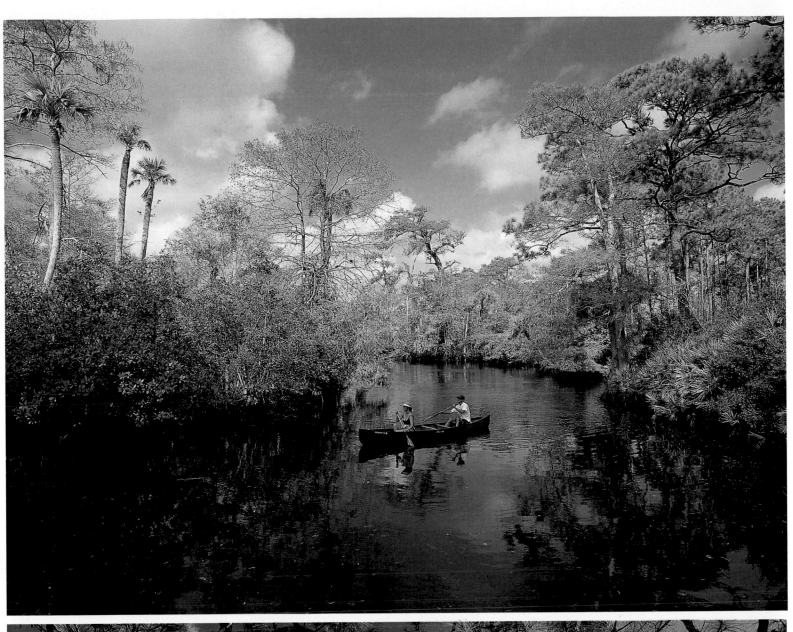

Lake Kissimmee State Park

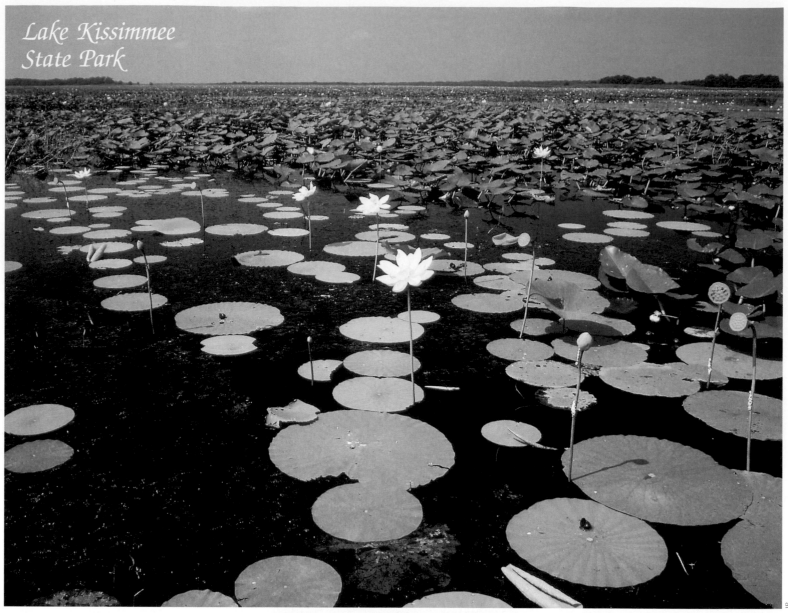

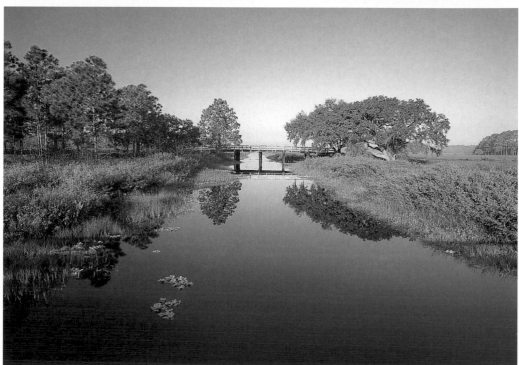

Two decades ago, visitors might have been lucky if they saw a deer during a week's stay in this park. When the state acquired the park, hunting was stopped. The deer are now plentiful, and it is not uncommon to see 20 does a day and, with a little luck, a buck. Does are even plentiful on the three-and-a-half mile drive from the entrance to the parking areas. Along with San Felasco Hammock Preserve, this is now one of the best places to observe deer in Florida.

Flocks of sandhill cranes also make their homes in the park. On many days, sandhill cranes are seen near the ranger office at the entrance, seeming to greet visitors.

There are several ecosystems within Lake Kissimmee State Park. Two trails total approximately 13 miles and lead the hiker through hardwood hammocks, swamps, marshes, pine flatwoods, prairie, and scrub.

A marina in the park has a channel that leads into both Lake Rosalie and Lake Kissimmee. Just as Lake Kissimmee is entered from the canal, Tiger Creek is on the right, and connects to Tiger Lake on a scenic waterway. A canoe could be used on this creek, but taking a canoe on Lake Kissimmee would be foolhardy, as there are frequent high winds and whitecaps.

On weekends there is a "living history site," called the "Cow Camp." After the Civil War, many Cracker cowboys made their living roping strays for the cattle industry. There is also a 40-foot observation tower where the visitor can overlook forest, lake, and prairie. As with other observation towers at nature sites, viewing will be most productive if it is long and leisurely.

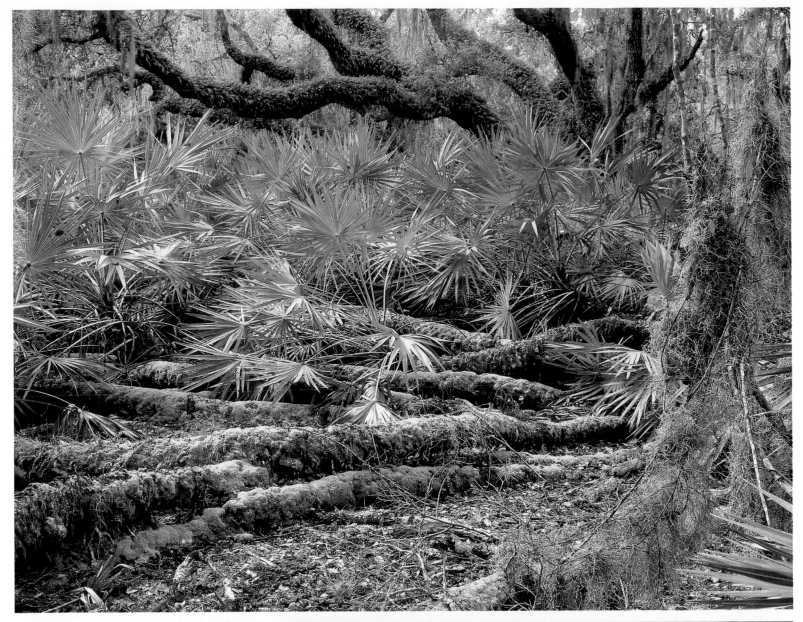

SI - GF

Opposite page, top: American lotus growing in a pond.

Opposite page, bottom: the bridge over the canal from Lake Rosalie to Lake Kissimmee.

Top: moss-covered roots and trunks of saw palmettos.

Above: the Kissimmee River, 15 miles north of Lake Okeechobee. In the distance the long ditch shows how engineers turned the twisting river into a canal. The Kissimmee River is now being restored to its natural state.

Right: plants with seed pods along the Buster Island Trail.

In Polk County, turn north on Camp Mack Road from SR-60 and follow the signs.

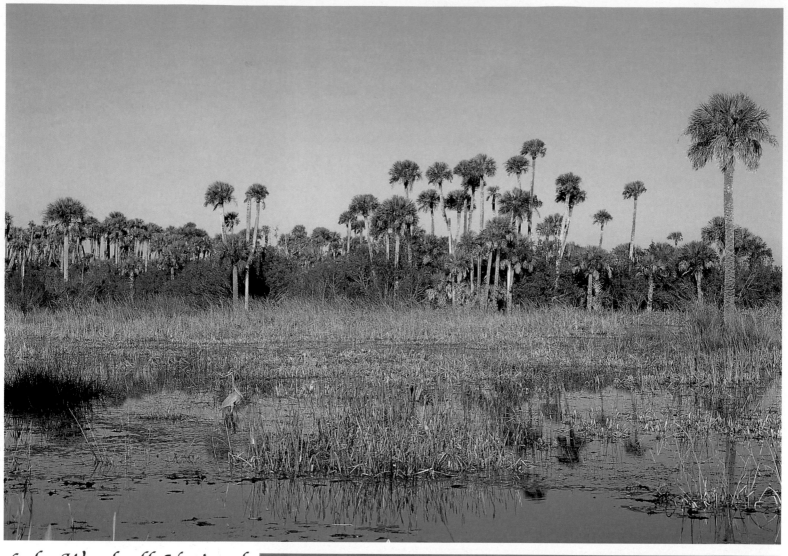

Lake Woodruff National Wildlife Refuge

Most of the 19,500 acres of this refuge are accessible only by boat since it encompasses canals, lakes, marsh, streams, and swamp. There are, however, over 1,000 acres of pinelands and hammock, and over 400 acres of dikes, from which some hiking can give rewarding glimpses of over 200 bird species and plentiful alligators. There are several trails, including one of six miles that starts at the entrance.

Canoes can be rented at DeLeon Springs State Recreation Area north of the NWR. Three lakes, runs, and the St. Johns River can all be accessed either in one very long canoe trip or in several shorter ones.

Among the birds are bald eagles, ospreys, sandhill cranes, and wood storks. The mammals include bobcat, deer, otter, round-tail muskrat, and a small population of Florida black bear, reported to live around Tick Island between Lake Dexter and Lake Woodruff.

In Volusia County. From US-17 go northwest of Deland on CR-4053. Also off SR-44, especially for canoe put-ins.

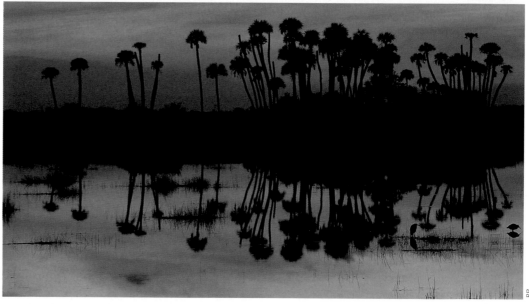

PERILS OF A NATURALIST: BITING THINGS

Precaution and prevention are the best plans for warding off the biting insects encountered in wild Florida. Repellent, or raw sulfur, can ward off many little beasties. (Check warnings on repellents, as some individuals may suffer allergic reactions.)

It is a popular joke that Florida's state bird is the mosquito. In South Florida, particularly in the summer, marsh mosquitoes are fierce. Mosquitoes only live as flying biters for a period of ten to 21 days. Only *female mosquitoes do the biting. Some mosquitoes need blood to reproduce. Others only need blood to produce stronger offspring. Normal precautions against these pests include long sleeves, long pants, and repellent. Other biting, itching things deserve mention. Deerflies, yellow flies, and horseflies are known to bite through a perspiration soaked shirt. Redbugs (chiggers) are probably the most unbearable biting insect in Florida.*

Myakka River
State Park

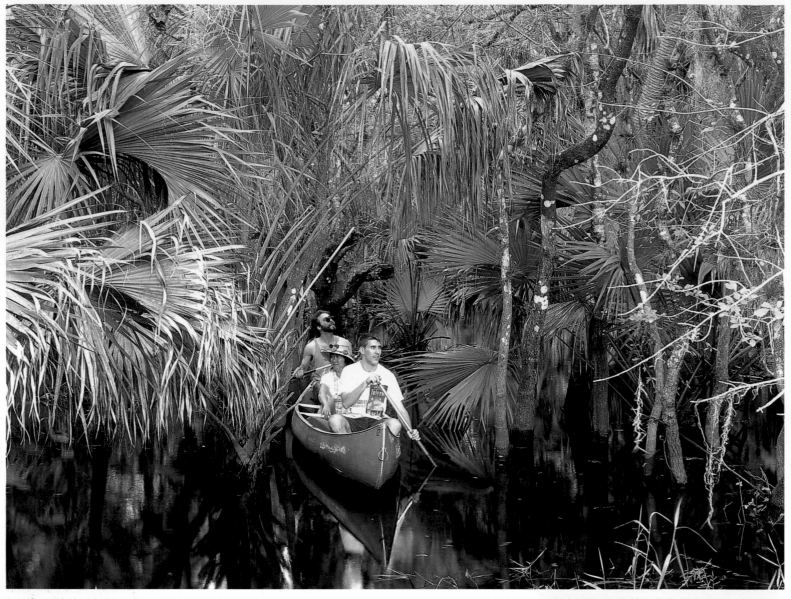

Myakka River State Park

Myakka Lake and River are primarily bordered by hammock and marsh. There is prairie with some patches of pine flatwoods, and hundreds of shallow ponds and grassy marshes. This blackwater river is 66 miles long, and meets the Gulf of Mexico at Charlotte Harbor to the south. Twelve miles of the river are within approximately 28,875 acres of the park, which makes for excellent canoe adventures. The adjacent Myakka Prairie tract is 8,250 acres.

Without being aware of it, the reader may already have seen many creatures from Myakka on the covers of nature magazines or within the pages of books devoted to insects and spiders. Myakka is home to amazing spiders, colorful beetles, bright blue darner dragonflies, multi-eyed horse-flies, and tens of thousands of other small creatures.

Most birders and other nature lovers, however, will associate Myakka with roseate spoonbills, sandhill cranes, and wood storks. In late Winter and early Spring,

sandhill cranes nest here. They produce usually two chicks, though one is sometimes lost to predators. The golden-brown chicks look nothing like their elders, and are six inches tall. The cranes that have not yet mated may break into their mating dance, which is as spirited and passionate as *salsa*.

There are twenty miles of service road in the park, and the paved road runs to the north gate, which is only open on weekends and state holidays. The river and lakes have large numbers of alligators. A distinct hiking trail goes about a mile along the riverbank, but the path is less clearly marked if one continues farther. A half-mile nature loop south of the river passes through palms, oaks, and occasional pines.

Within Myakka are 39 miles of hiking trails. These extensive trails allow for exploration of marsh and hammock. Canoes can be rented at the concession for exploring the river and lake. For a less strenuous trip on the lake, there is an airboat tour. In the Winter months, there is a tram trip which follows unpaved trails through woods and marsh. Tickets are available from the concession.

Top: canoeing through the flooded forest when the river water is exceptionally high.
Center: a painted lady butterfly.
Above: butterfly orchids.

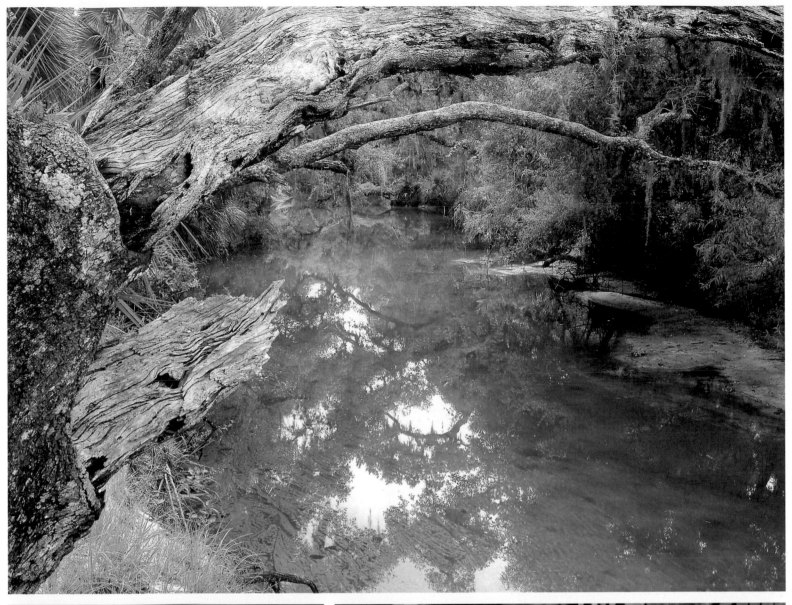

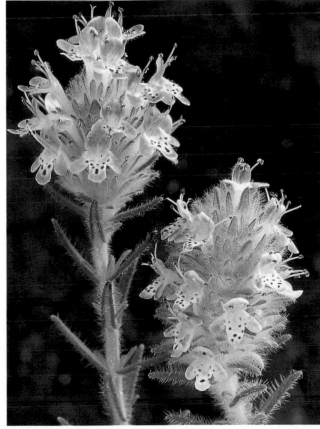

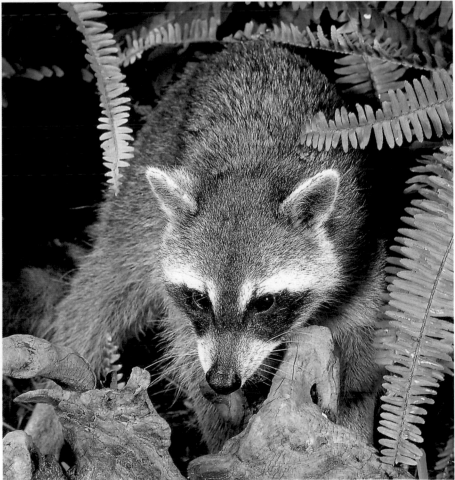

Top: Clay Gully Creek.
Bottom left: false pennyroyal.
Bottom right: a raccoon.

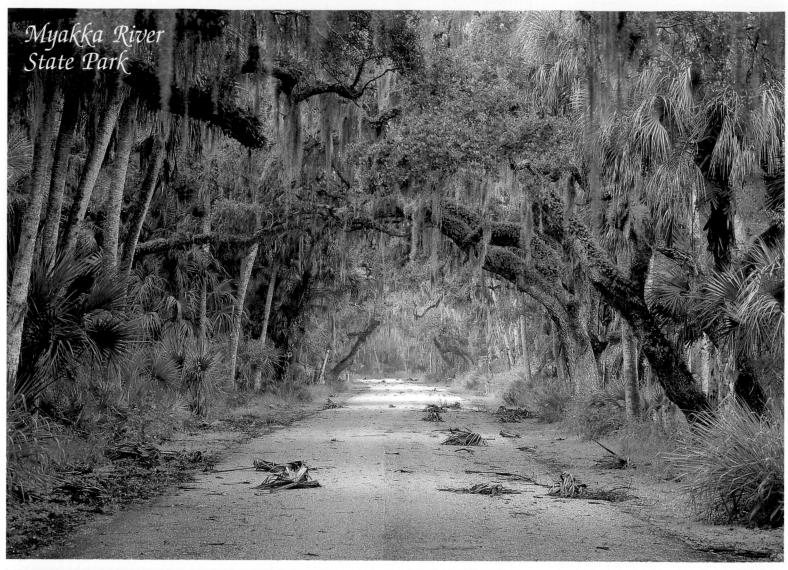

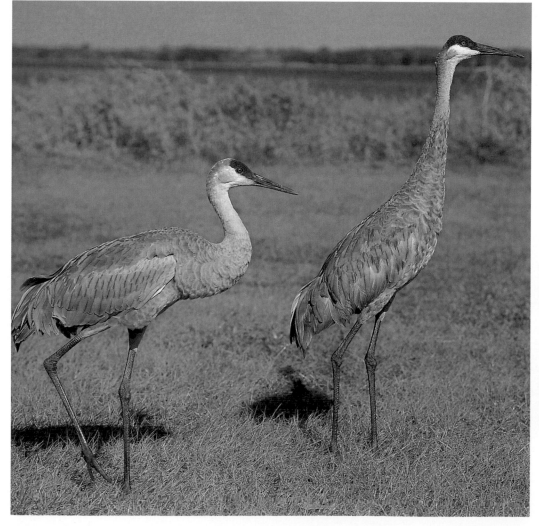

Top: the main road, canopied with oaks and palms (after a wind storm).

Left: sandhill cranes are a common sight at Myakka.

Above: a swamp scene.

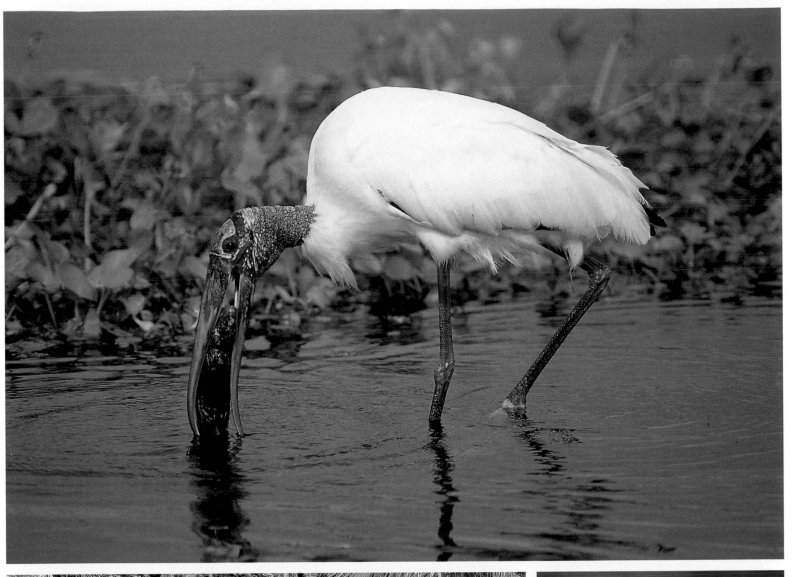

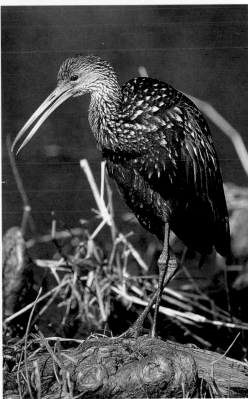

Top: a wood stork finds a meal.

Left: resurrection fern on an old oak tree.

Above: a limpkin.

Following page: a wooded scene with palmettos.

In Sarasota County, exit from I-75 on SR-72 and go east about nine miles.

Myakka River
State Park

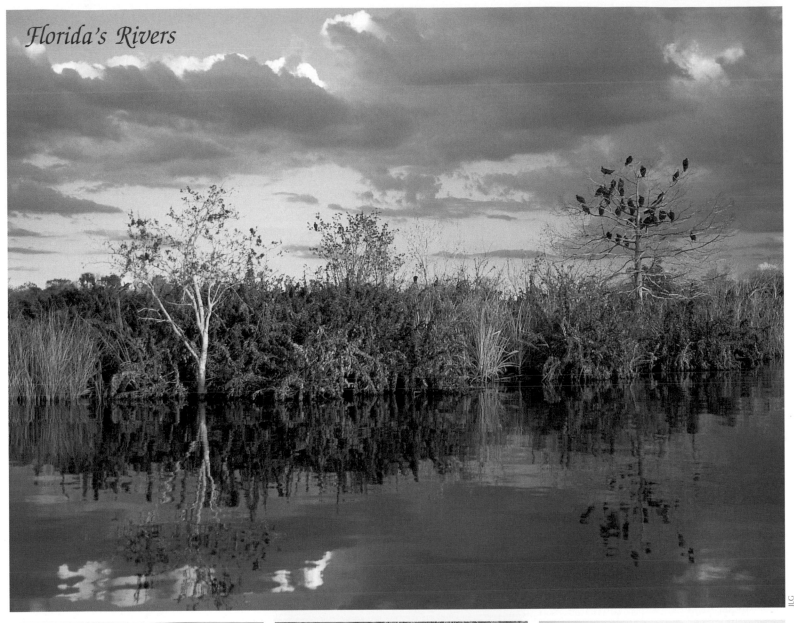

FLORIDA'S RIVERS

Of the more than 1,000 rivers in Florida, only a few remain in a pristine state, such as the Econfina, while many have been heavily impacted by humans, like the Peace River (shown here). These lovely scenes show that the Peace River is still very beautiful in places. Yet the Peace River has suffered a long history of phosphate mining along its banks, particularly in Polk County. Phosphate is strip-mined, and the residue includes a soggy, wet clay. Several times these clays have spilled over into the river, killing all living things in it.

Florida's rivers are usually classified as one of three types: alluvial, blackwater, and springfed. Alluvial rivers are rich in soil while blackwater rivers are clear, but darkened with tannin. Rivers can be a mixed type such as the Suwannee, which is blackwater, but springfed. The Peace River is a blackwater river, stretching from Central Florida south of Bartow to Port Charlotte. It takes its name from the Spanish *Rio de la Paz* (River of Peace).

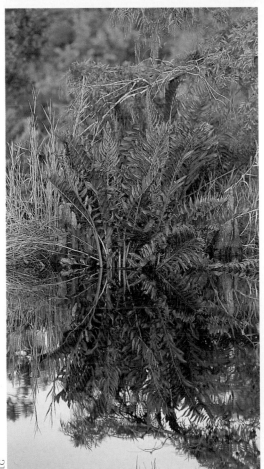

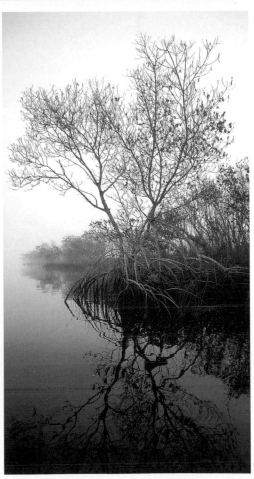

Tosohatchee State Reserve

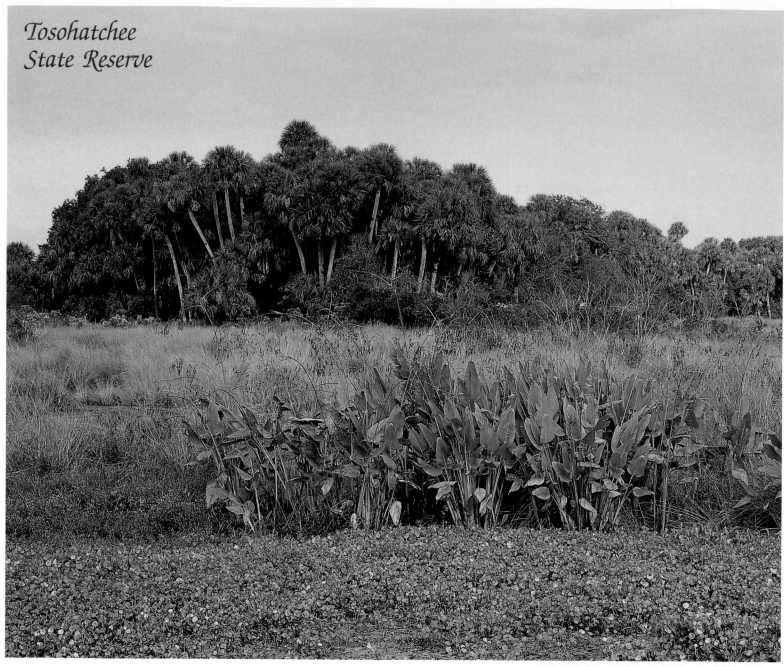

Nineteen miles of the St. Johns River flow along the east side of this little-known reserve. Tosohatchee Reserve contains 34,000 wild and primitive acres. Along Jim Creek is a strand of ancient cypress, and in the reserve is a stand of slash pine with individual trees older than 250 years. Habitats include hammocks, marshes, pine flatwoods, and swamps.

"Tosohatchee" is named for the nearby Tosohatchee Creek, which means either "chicken creek" or "fowl creek." Perhaps the Native Americans were referring to the turkeys that still attract hunters in the Fall. Native Americans dwelled in Tosohatchee before Europeans came to Florida.

Bobcats, white-tailed deer, and gray fox are some of the mammals that can be found. Bald eagles come to the woods to nest. The uplands have hawks and owls. The marshes are home to wading birds. In the winter, large numbers of migrating water fowl come to the marsh areas. The eastern indigo snake and the gopher tortoise are among the reptile inhabitants.

There are more than 60 miles of hiking trails, and 23 miles of horse trails, through ferns, orchids, and bromeliads. Biking is allowed on some of the trails. This reserve is little used, and often uninhabited, especially during the warmer months. The roads which run through it are usually passable by auto but become more difficult during periods of heavy rainfall. Although the reserve can be toured in part by car, there is still plenty of real wilderness.

Top: **sunset near the St. Johns River in Tosohatchee State Reserve.**

Right: **an ibis in a cypress swamp along Jim Creek.**

Opposite page, top: **reflections in Jim Creek.**

Opposite page, bottom left: **trees along the banks of Tosohatchee Creek.**

Opposite page, bottom right: **a cypress swamp in the lower part of Jim Creek.**

In Orange County on SR-50, 15 miles west of Titusville, south of the town of Christmas.

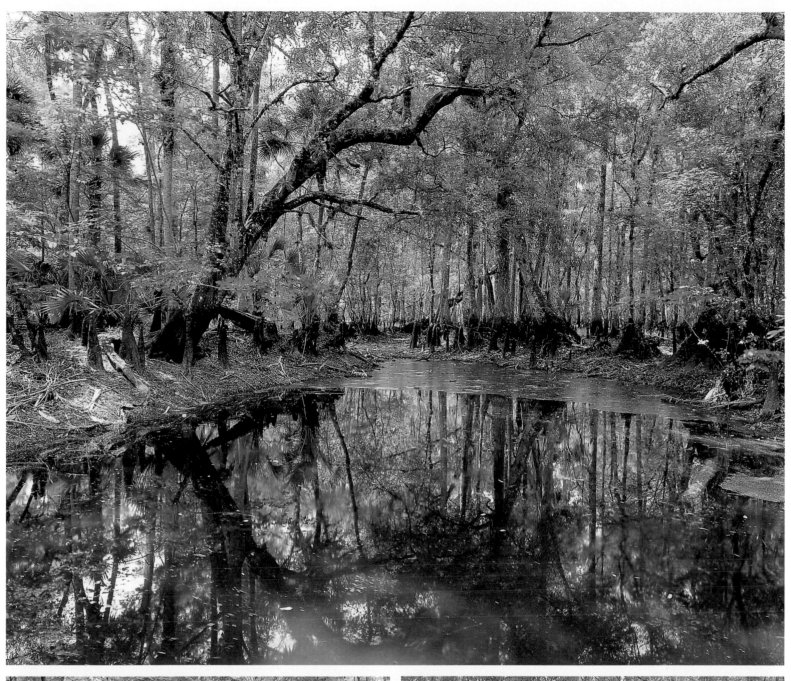

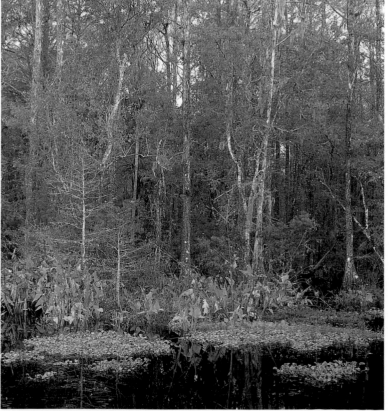

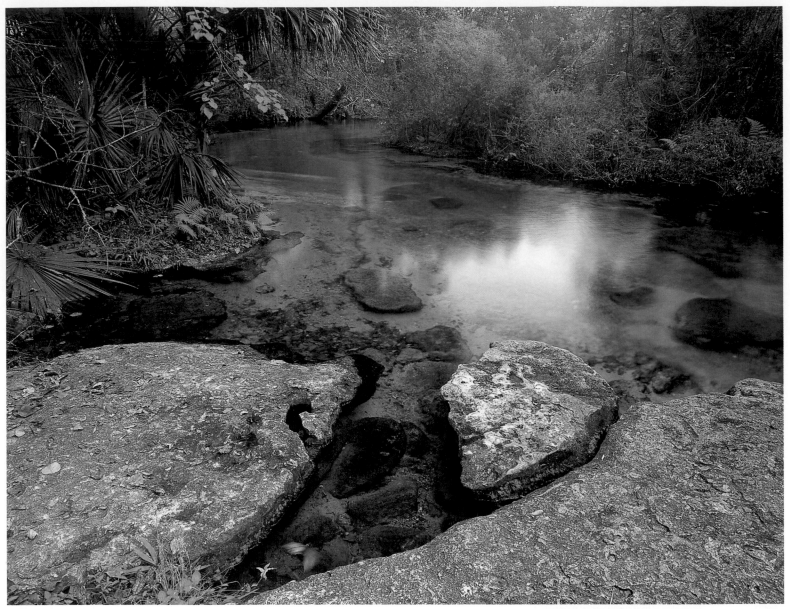

Wekiwa Springs State Park and Lower Wekiva State Preserve

At first Wekiwa seems not like a wild place but rather more like an old country swimming hole. A concrete wall encloses the spring. Boys in cutoff jeans are doing "cannonball" dives into the water. Sunbathers recline on the grassy slopes, even on some chilly days in January. The spring is a pleasant place to swim and cool off after a day of canoeing or long hikes.

Away from the spring, the number of humans declines and the natural wonders increase. This park is about 7,000 acres, and the adjacent Lower Wekiva State Preserve has about 5,000 acres. The Wekiva River runs through them. There is a hardwood hammock in the park. There are flatwoods, marsh, ponds, sandhill, and scrub in both areas.

Note that the spring is spelled Wekiwa while the river is spelled Wekiva. According to some, these confusingly similar words are derived from different Creek language words, but more likely, one spelling is simply a corruption of the other.

State park naturalists are trained at Wekiwa because of the diverse habitats that are so close to one another. Within a few minutes, a hiker can pass from swamp and spring, to damp hammock, and to flatwoods and high pine areas.

A boardwalk passes through a hardwood hammock. Along the 13 miles of trails there are sinkholes. The river can be canoed northward into the Lower Wekiva State Preserve. Canoe rentals are available inside and outside the park.

East of Orlando, exit from I-4 at SR-434 and go west to SR-46. The exit for Wekiwa Springs State Park is clearly marked. The preserve is on SR-46 about nine miles west of Sanford for auto access, but can be reached by canoeing down-river from the park. Located in Orange and Seminole counties.

Top: a view of Rock Springs Run.
Right: white flowers at dawn along the Sandhill Trail, Lower Wekiva State Preserve.
Opposite page, top: oaks, pines and fog along the Sandhill Trail, Lower Wekiva State Preserve.
Opposite page, bottom: a canoe on the Wekiva River.

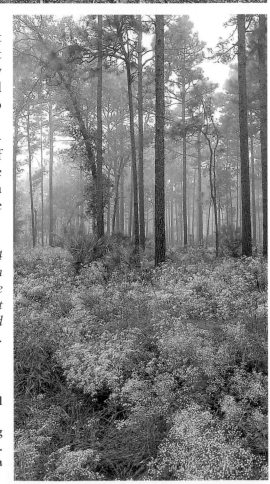

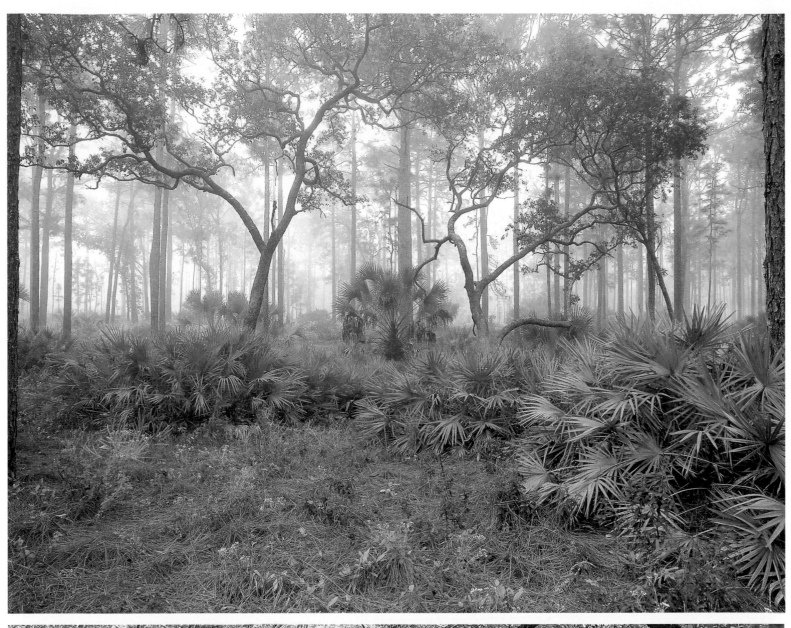

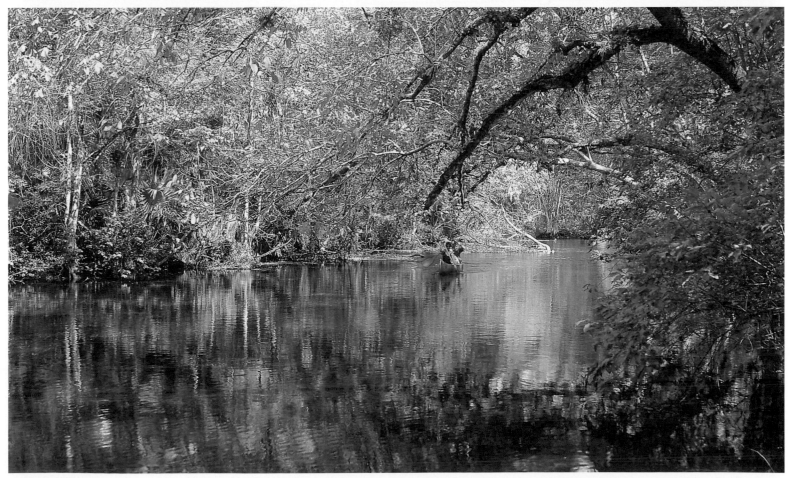

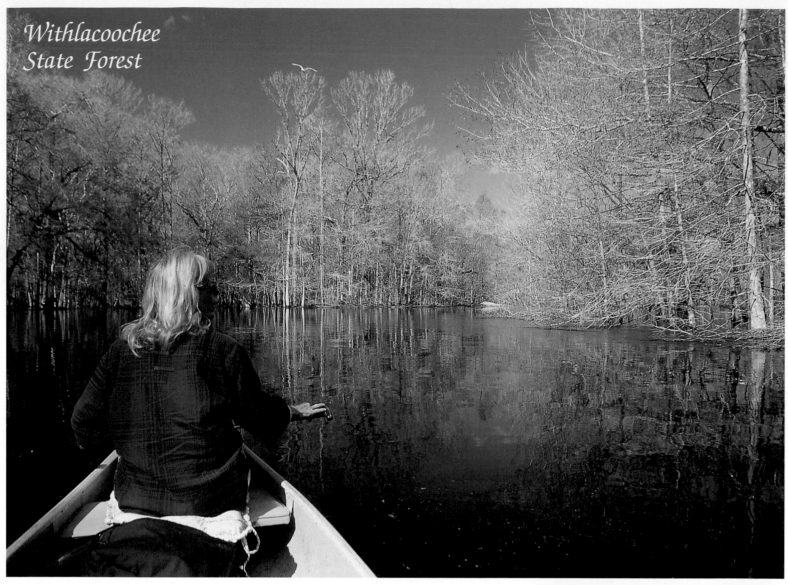

Withlacoochee State Forest

This expansive forest takes its name from the Withlacoochee River. This is an 86-mile, springfed, blackwater river which begins in Polk County and flows into the Gulf of Mexico near Yankeetown. It is often called the Withlacoochee South to avoid confusion with Florida's other Withlacoochee that begins in Georgia. It is perhaps more logical to think of this as four separate areas which altogether contain more than 120,000 acres.

THE CITRUS TRACT

Located in Citrus County, this section contains 43,000 acres of the forest, the second largest portion. Forest roads and horse trails crisscross a terrain which seems more like the pine flatlands of northern Florida (Apalachicola National Forest). The area has abundant gopher tortoises and many long hiking trails.

THE CROOM TRACT

This popular recreation area contains over 30 miles of hiking trails and a motorcycle trail. Silver Lake is a prime spot for swimming and canoeing. Canoes are an excellent way to experience the river and lake. Families usually prefer this portion of the forest for camping and swimming.

THE JUMPER CREEK TRACT

This area of over 10,000 tangled acres is in a wild, primitive state. As of 1998, there were two short roads and one barely detectable trail. Jumper is a Seminole name, and for the most part this area is as untouched as it was in Seminole times. When visited in 1998, the trail was largely unused, blocked with golden silk spider webs, heavily populated with ticks, and not well-marked. This is a tract for those who like their nature experiences wild and remote, and who have no fear of the woods.

THE RICHLOAM TRACT

At over 49,000 acres, this is the largest of the tracts, and the one dedicated to forestry. This tract runs into the Green Swamp in the southeast, and has days' worth of hiking trails. Such a beautiful forest, so close to metropolitan Tampa, gets much recreational use. Nevertheless, it is large enough that one feels solitude.

OTHER AREAS

The McKethan Lake Nature Trail has a two-mile loop. The Colonel Robbins Area also has a small trail of about two-and-a-half miles. Both are located on US-41 north of Croom and to the south of Citrus.

Top: a canoe on the Withlacoochee River near Brooksville, during high water.

Above: along the Withlacoochee River.

Opposite page: American lotus on McKethan Lake in the Withlacoochee State Forest.

Near Brooksville. Exit I-75 at US-98. The forest is spread out in four counties: Citrus, Hernando, Pasco, and Sumter. For the best use of this area, a forest map is very helpful. This can be requested in advance by writing or it can be picked up at the Forestry Headquarters Office on US-41, north of Brooksville. US-41 is parallel to I-75.

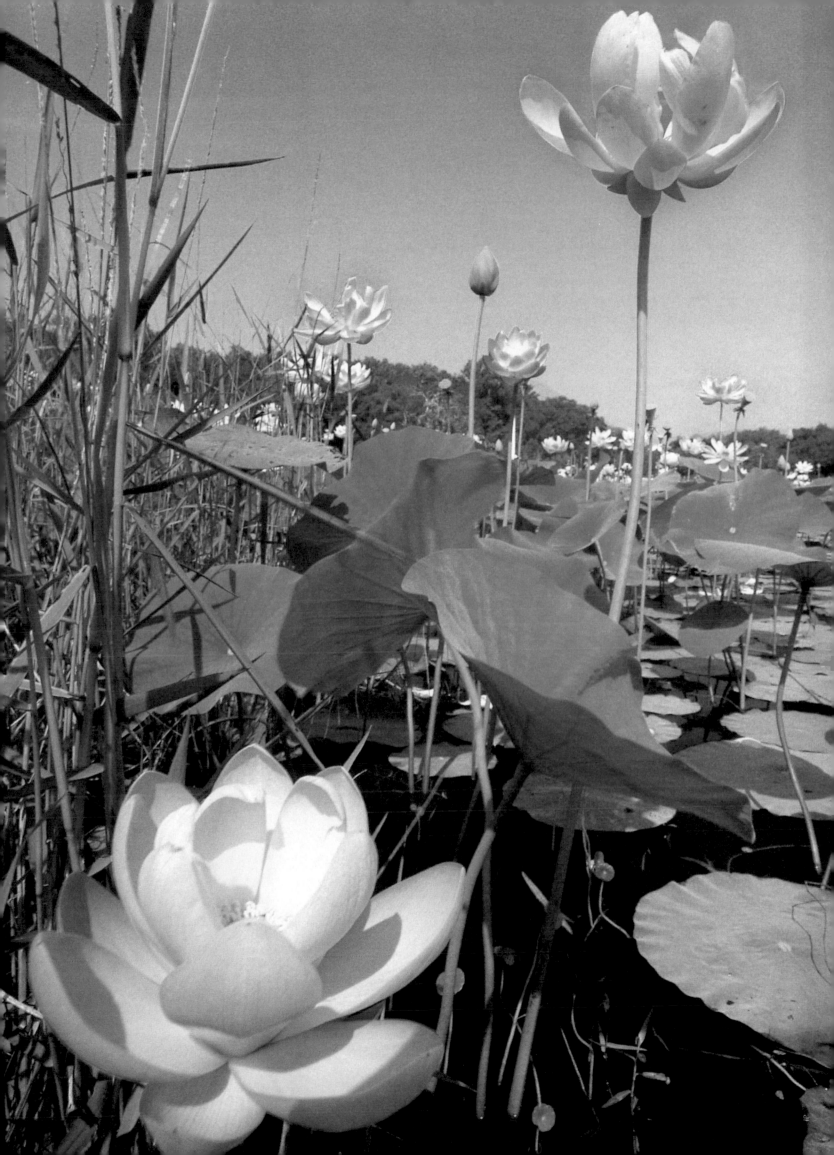

Other Central Florida Adventures

ARCHIE CARR NATIONAL WILDLIFE REFUGE

To the east of A1A. South of Melbourne and north of Vero Beach. This is the only national wildlife refuge dedicated to sea turtles.

CATFISH CREEK STATE PRESERVE

Between Lake Wales and Haines City. Take CR-542 for eight miles from the city of Dundee. There are trails through scrub habitat with about 4,000 acres altogether.

CARLTON RESERVE

Exit I-75 south of Sarasota on Jacaranda Boulevard and proceed to Border Road, then go east two-and-a-half miles. There is a nature trail in a series of loops through flatwoods, hammocks, marsh, and swamp.

DELEON SPRINGS SRA

Next to Lake Woodruff NWR. Go northwest of Deland on US-17 to CR-3. Six-hundred acres including a beautiful spring, a nature trail, and canoe rentals. Also, fishing, swimming, and scuba diving.

HOBE SOUND NWR

Almost "across the street" from Jonathan Dickinson State Park on US-1 between Hobe Sound and Jupiter. This is sea turtle territory with great dunes.

OSCAR SCHERER SRA

On US-41 south of Sarasota. Includes 1,384 acres of estuary, lake, flatwoods, marshes.

PRAIRIE LAKE WMA/THREE LAKES WMA

On US-441 near the small town of Kenansville south of Kissimmee. A place to see burrowing owls, caracaras, bald eagles, and sandhill cranes.

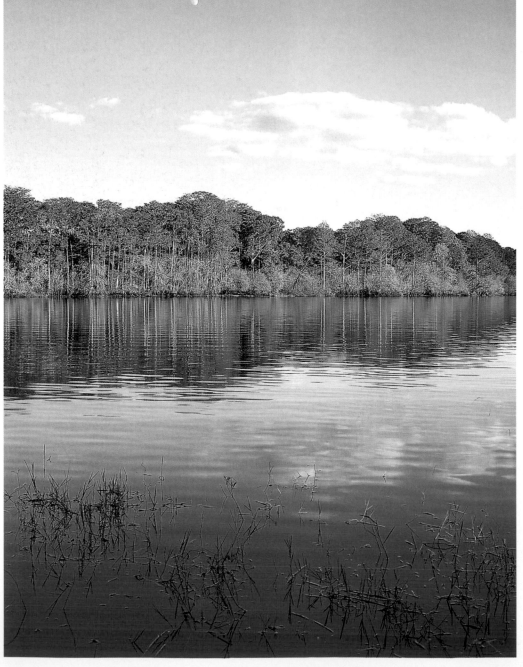

Left: moonrise over Silver Lake, Withlacoochee State Forest (Croom Tract).
Top: the Florida Trail through a hammock at Myakka River State Park.
Above: a caracara, symbol of the wide open spaces of Central Florida.
Opposite page, top: a swimmer with a manatee at Blue Springs.
Opposite page, bottom: a blue jay with an acorn.

GP

South Florida

South Florida is often referred to as subtropical because it has only occasional freezing temperatures. For meteorologists, a tropical area is one that never has freezing temperatures. On the other hand, South Florida is also described as tropical because it has a large number of tropical species of plants and trees and, to a lesser degree, other tropical forms of life.

Many of the tropical trees, like mahogany, reach their northernmost limits a little above Miami. South Florida is rich in bromeliads, or air plants, which in parts of the Big Cypress seem to grow profusely on every tree, often in crate-size clusters. Other "tropical" plants prominent in the region include about 75 species of orchids and 100 species of ferns.

The Big Cypress encompasses a large area that has been substantially modified by human activity. Historically it reached north to Corkscrew Swamp and eastward for a considerable distance. This is the land of the endangered Florida panther.

Along the southwest coast, the Ten Thousand Islands are mostly mangrove clusters that slowly accumulate soil around their saltwater roots. The Big Cypress, named for its large area rather than for the height of its trees, is generally slightly higher in elevation than the Everglades. Its waters make their way slowly to the Ten Thousand Islands and the Everglades. The waters do not flow as efficiently to the Glades now because of roads, canals, and flood control structures.

A unique wilderness, the Everglades, which formerly extended from Lake Okeechobee southward to Florida Bay, is a complicated part of the South Florida ecosystem. Its center is a huge, periodically-flooded marsh.

Most Americans have heard of the Everglades and most probably think that this natural place has always existed. But the natural world is not always so permanent. Only in the last few thousand years has the climate changed so that the Everglades could exist. Before current climatic conditions, most of South and Central Florida were either under water during times of high seas, or dry during times when much of the ocean's waters were trapped in glaciers.

Lake Okeechobee is the second-largest freshwater lake (after Lake Michigan) contained wholly within the US. It stretches from the central region into the south. From outer space, it looks like a large meteor-impact crater, however it was formed by gentler means. It is a natural depression that filled with water over time. The lake is now largely encircled by a system of dikes and levees, and its waters are controlled through dams and locks.

While Ft. Myers and Naples are the largest cities on the Gulf Coast, the east coast metropolitan complex of Miami-Ft. Lauderdale dominates in population.

Opposite page: **cypress trees with red lichens at Loxahatchee National Wildlife Refuge.**

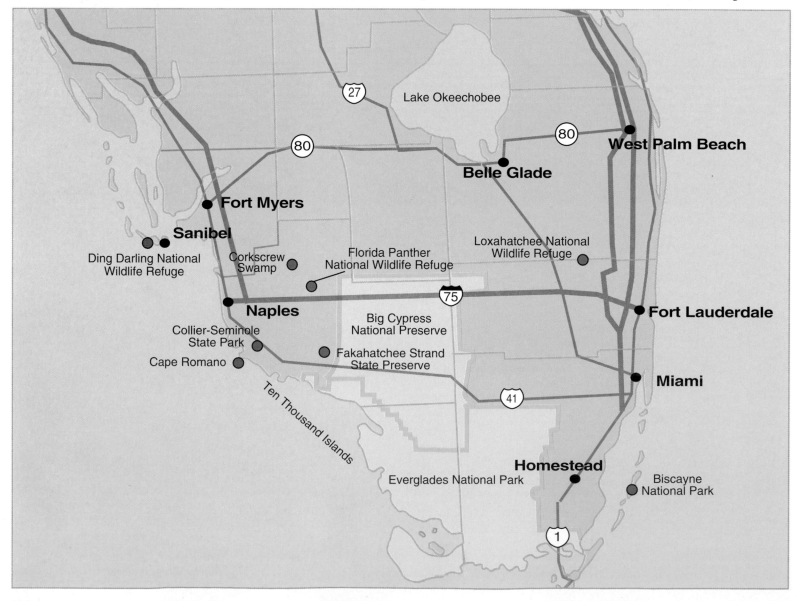

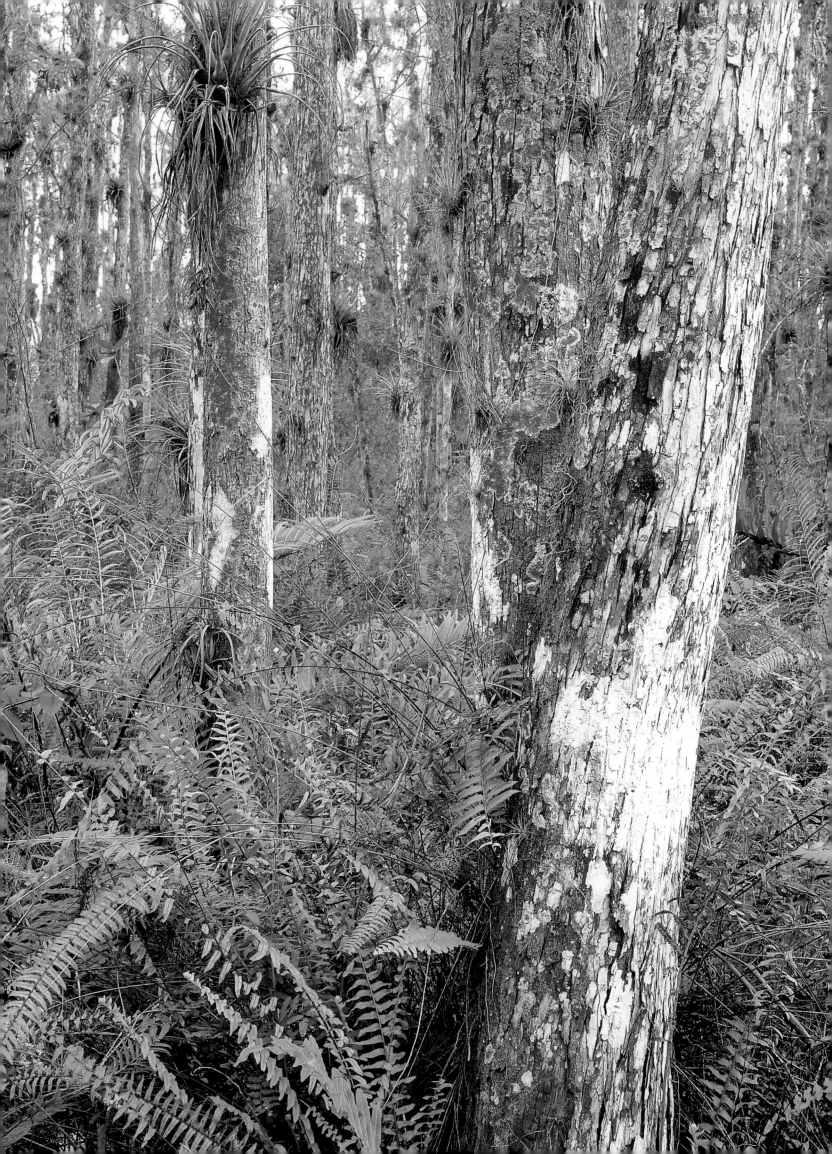

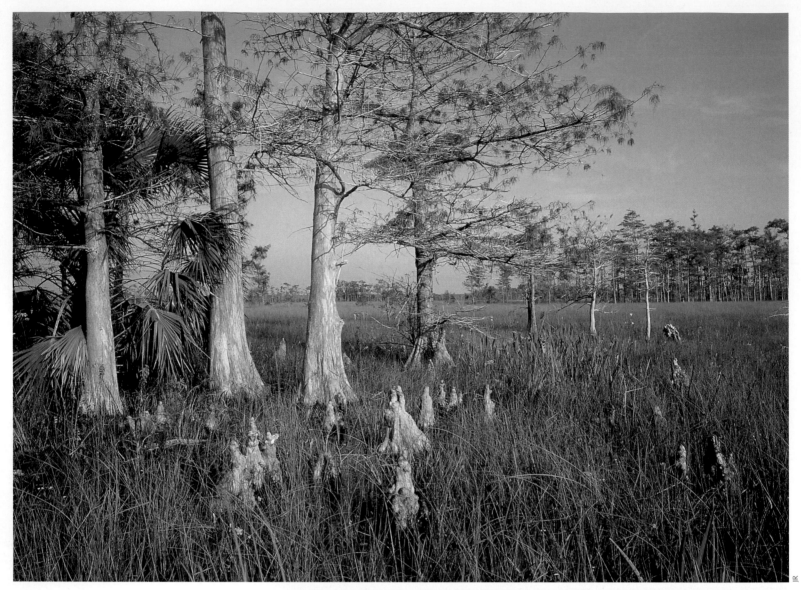

Big Cypress National Preserve

To many travelers, the Big Cypress Preserve is a name on a sign they happen to glimpse as they flash by on I-75 or US-41 during a hurried trip. This is truly unfortunate. Not far away, deer beat the earth with their hooves. Foraging raccoons rustle the brush. Surprised alligators crash into the water. Insects are busy buzzing and pollinating flowers and trees. Many varieties of birds are singing their songs. Large pig frogs (the usual source of Florida frog legs) grunt out hoarse, loud barks. Such are the animal sights and sounds of the Big Cypress that go unnoticed by travelers listening to radios in their air-conditioned, 70-mile-per-hour missiles.

The Big Cypress is a large wild area with trails, but with no interpretive, leisurely walks. It includes more than three-quarters of a million acres. Endangered species of the Big Cypress include the Cape Sable seaside sparrow, the snail kite (also found in the Everglades), and the Florida panther. Red-cockaded woodpeckers live in remote areas.

BEAR ISLAND

Bear Island can be accessed from US-41 by going north on the Turner River Road. There is a ranger check point at the entrance to Bear Island as well as a primitive camping area. Authorities have sought to address the issue of off-road vehicles (ORVs), which can damage and scar the earth, by constructing separate roads and areas for responsible use. The roads can be hiked or bicycled, and there are some trails limited to pedestrian use.

The ORV road directly north from the check point leads several miles past marsh and swamp to an area known to the locals as Reedy Creek, or to park rangers as The Black Hole. Here the road dips into the marsh for a length of about 180 feet, depending on the season, and the water varies between waist and chest deep. Bicycle riders carry their bikes over their heads as they wade through.

Why would sane people go through The Black Hole? To see what's on the other side. In this case the reward is a remarkable hardwood hammock. Here,

Top: **pond cypress and cypress knees.**
Above: **an alligator-inhabited marsh.**

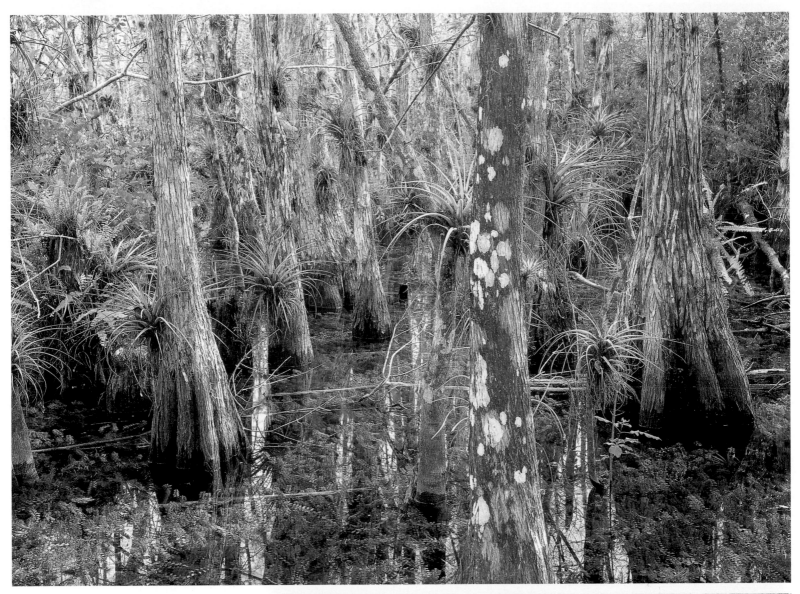

north of I-75, are tropical gumbo limbo trees, mastic, and wild coffee. Oaks and pine are interspersed with a variety of other trees, including wild orange.

To the west of Big Cypress is Florida Panther National Wildlife Refuge, to which entrance is restricted. While rare, panther sightings are not unknown at Bear Island, which indeed gets its name from the occasional presence of bears.

RANGER-GUIDED ACTIVITIES

During part of the year, rangers lead canoe trips through the mangroves, as well as hiking trips into the Big Cypress. Because of weather and mosquitoes, ranger-guided tours are limited to Winter and early Spring. However, braver souls can go whenever they dare!

Top: a stand of cypress tree festooned with bromeliads.
Bottom: a hiker following a portion of the Florida Trail through the Big Cypress.

The visitor center is on US-41, the Tamiami Trail, to the east of SR-29. The preserve is in Collier and Hendry counties.

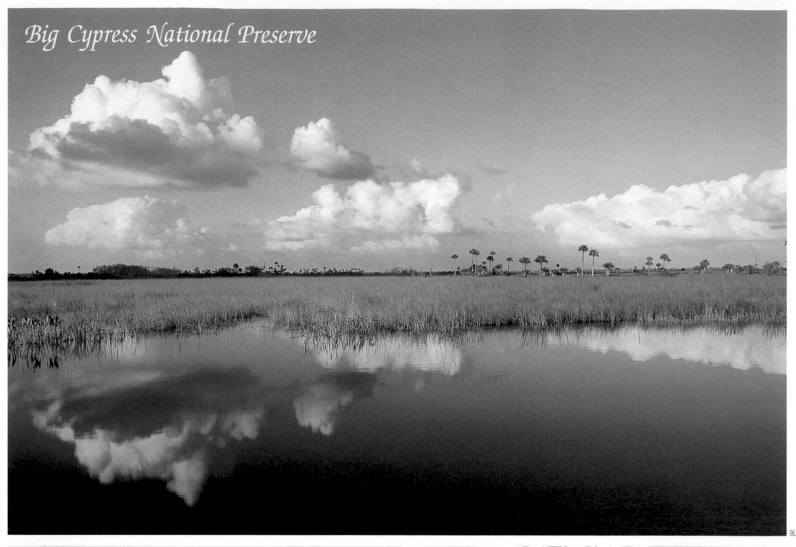

Top: extreme high water in a freshwater marsh of Big Cypress.

Left: swamp lilies and marsh in early morning.

Above: one of the beautiful bromeliads that bloom in early winter in Big Cypress.

Opposite page, top: a rare double rainbow at Ochopee in the Big Cypress.

Opposite page, bottom left: an alligator crossing Loop Road.

THE FLORIDA TRAIL

As of early 1999, the Big Cypress portion of the Florida Trail was not yet complete. It will eventually extend from I-75 in the north and run 28 miles to its southern end near the visitor center on US-41. Conditions on the Trail should be discussed with center personnel before an expedition.

LOOP ROAD

Loop Road is 26 miles long, to the south of US-41, with access near Monroe Station. It is mostly full of potholes, although a car can travel it with caution. It passes many shaded canals, creeks, and cypress ponds. Otters are often seen along the loop, sunning themselves on the road, or frolicking in the ponds and streams. Panthers are occasionally seen, as are behemoth alligators, which sometimes lumber across the road in front of vehicles.

LIGHTNING IN FLORIDA

Summer thunderstorms come from towering cumulonimbus clouds. These giants of the sky start as typical puffy cumulus clouds, but are fed by warm, moist air until they reach monster size. Updrafts at times can reach 100 mph and hold the moisture in the sky, giving these clouds their dark appearance. Some Florida storms may approach 1,000 strokes of lightning per hour.

The sound of thunder travels at about one mile every five seconds. So, it is easy to judge the distance of an electrical storm in miles by counting the seconds between the flash and the crash, and then dividing by five.

Popular accounts call Florida the lightning capital of the US, and according to some sources, the world. It is not unusual for a Florida home to temporarily lose power or to suffer some appliance damage from lightning strikes. Aside from their destructiveness, Florida lightning storms are also dramatic events that can be enjoyed as spectacular displays of nature's power and beauty. They are especially impressive in Spring and Summer.

Biscayne National Park

Most of this park is underwater, including coral reefs and small, circular patch reefs. Over 40 islands have been set aside from development. Diving and snorkeling trips can be taken to the reefs, and a glass bottom boat is available for those who do not choose to enter the water.

Watching underwater documentaries cannot match the excitment of personally experiencing a reef. Florida reefs contain 40 to 50 species of coral, which live in colonies. Corals are not rocks, but animals, living creatures that often die when touched by humans. Many of these corals are lovely in color, or fantastic in shape. They are surrounded by an undersea "forest" of fans, sea plumes, and whips that wave in the currents. Fish abound with hundreds of species, including angel, butterfly, parrot, and trigger fish. This is home for the barracuda and the spiny lobster. Even sea turtles swim leisurely by.

Seven-mile-long Elliot Key offers the most hiking. A trail extends the entire length of the island, and there is a one-and-a-half mile loop trail, including a boardwalk along the beach.

Canoes can be rented to explore the 14 uninterrupted miles of mangrove shore-line within the park. Paddling the canoes far out into the sea is foolhardy, although unfortunately done often. A sudden storm can easily capsize a canoe. For boat rentals, it is best to make reservations. The phone contact numbers are on page 158.

Many divers feel that the reefs here are superior to others in the preserve system. This is because of the fine water quality and because there are fewer divers.

Top: the eye of a stoplight parrotfish. **Bottom:** a Spanish hogfish. **Opposite page, top:** a midnight parrotfish. **Opposite page, bottom left:** diver with giant brain coral. **Opposite page, bottom right:** diver with giant barrel sponge.

In the water, to the east of Homestead in Dade County, accessed from US-1 or the Florida Turnpike. Tours begin at the National Park Center at Convoy Point, east of Homestead.

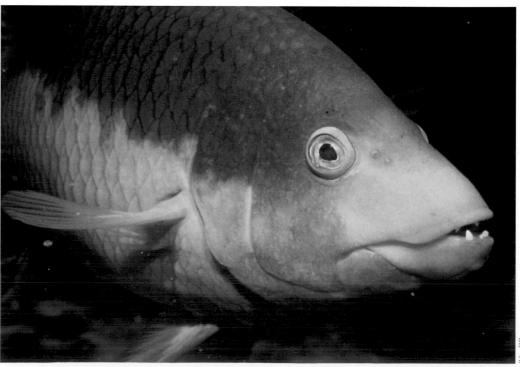

IV - MU

IV - DP

IV - DP

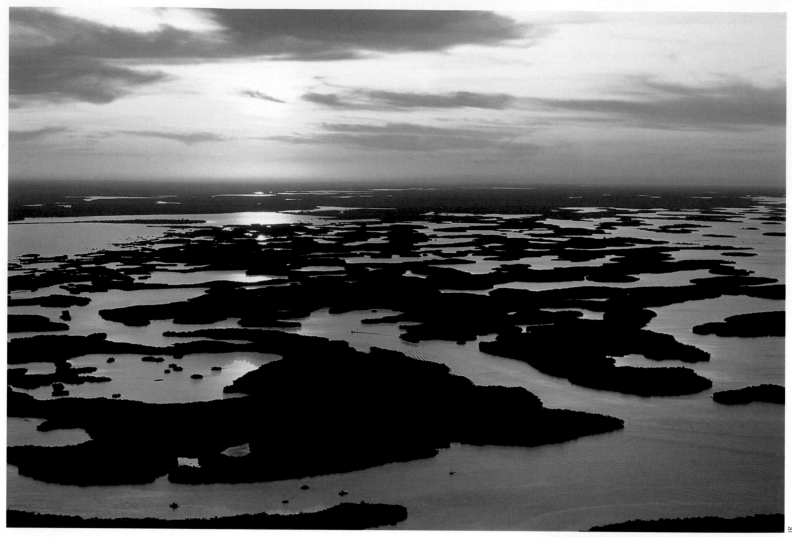

Cape Romano and the Ten Thousand Islands Aquatic Preserve

Seemingly endless, the small mangrove islands and occasional clumps of land that compose the Ten Thousand Islands cover a vast area. They stretch from Collier-Seminole State Park (just south of Naples) south to Florida Bay. Where this area begins and ends is not clearly marked by any signs. New, nameless islands are constantly being created. Older islands can be altered or eliminated by hurricanes or changes in salinity or water quality.

A large portion of the Ten Thousand Islands is in Everglades National Park. But other portions are in Big Cypress NP or assigned to Florida Panther National Wildlife Refuge. While access into the Florida Panther NWR is almost impossible (limited to occasional, small educational groups), the Ten Thousand Islands can be accessed by anyone with a boat. A compass and a radio are strongly advised, since it is often impossible to tell one mangrove island from another. It is possible to canoe into the Ten Thousand Islands from both Collier-Seminole State Park and the Big Cypress area. Rangers of the Big Cypress Preserve lead canoe trips in the cooler months.

Much mangrove habitat has been cleared along Florida's west coast for development. The remaining mangrove ecosystems need serious protection as they are vital in the aquatic food chain, which includes the seafood consumed by humans. Mangroves represent the most energy-rich of all natural ecosystems, and they are spawning grounds for many species of fish.

Besides sheltering many birds, such as roseate spoonbills and brown pelicans, mangrove estuaries and swamps provide ideal growing conditions for crabs, fish, lobster, and shrimp. Some of the fish are human favorites, whether for sport fishing or dining, including mangrove snapper, mullet, and snook. If these mangroves were to disappear, it would be a severe threat to the survival of many aquatic species.

Cape Romano is a spit of land at the south end of Cape Romano Island, just south of populated Marco Island. It has been inhabited at various times. Several abandoned and storm-damaged homes now decorate the Cape's tip.

Red mangroves flourish in salt water and are able to survive in fresh water. Their roots exclude saltwater. Two other mangroves, black and white, absorb and eliminate salt. In addition to the red, black, and white mangrove, buttonwood is also considered a mangrove. "Mangrove" is an im-

precise term which refers to several plants that are not in the same families, and also refers to the type of habitat. What people usually mean by "mangrove" is a collection of similar-looking, salt-tolerant plants found along the shoreline.

The red mangrove propagule (seed) is most noticeable for its size. It can be as long as one foot and is slightly curved like a long, fat green bean. When released from the tree, the propagule floats until it anchors itself in nearby mud.

Accessible by water from Chokoloskee, Collier-Seminole State Park, Everglades City, Goodland, and many other points. In Collier and Monroe counties.

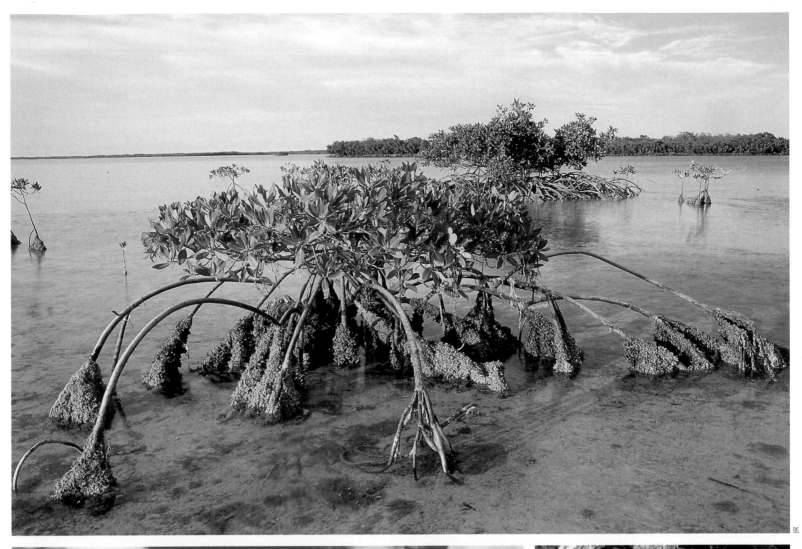

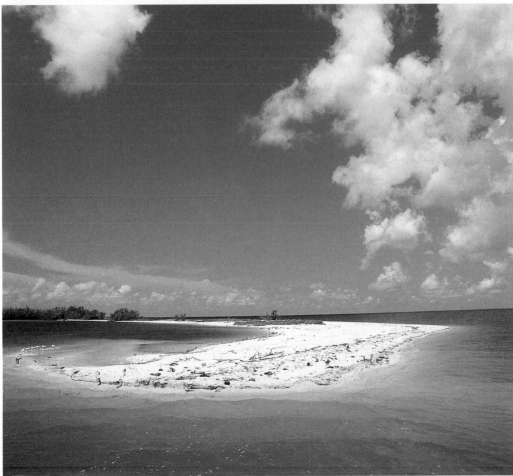

Opposite page, top: a sunset view of a few of the Ten Thousand Islands.

Opposite page, below: a flock of white pelicans follow the leader over one of the islands.

Top: red mangrove at low tide shows its impressive prop roots.

Above: a lovely beach on one of the islands.

Right: red mangrove roots and leaves.

Collier Seminole State Park

Collier-Seminole Park offers two hiking trails which pass through a tropical hardwood hammock and a saltwater marsh. There is also a boat ride through the mangroves at the north end of the Ten Thousand Islands. The mangroves are also accessible by canoe and small boat, but a float plan should be filed with the park authorities before embarking. It is easy to get lost in the endless expanse of mangroves. In a normal year, someone gets seriously lost here at least once.

With luck, American crocodiles and alligators can be seen swimming in the waterways. This is one of the few places in Florida where American crocodiles (also mistakenly called saltwater crocodiles) are frequently seen. In the park's hammocks, among lush ferns, are many tropical trees. These include the copper-colored gumbo limbo, a tree that will readily grow if a branch is whacked off with a machete and stuck into the soil. In South America, living fences are made from gumbo limbo in just this manner.

The machine that helped to build US-41 across the Everglades is on display near the entrance to the park. It is called the "walking dredge."

In Collier County, eighteen miles south of Naples on US-41 west from I-75 from any Naples exit.

Top: royal palms in their natural habitat.

Bottom, left: a Gulf fritillary butterfly feeding on lantana.

Bottom, right: a brown pelican.

Opposite page, top: the lush vegetation along one of the hiking trails.

FLORIDA'S FERNS

The photo, above left, shows the underside of the leaves of a leather fern and the photo above right shows strap ferns growing on an uprooted tree. Florida is rich in a variety of ferns with possibly as many as 100 species. Perhaps 60% of these are tropical in origin and, on the US mainland, are found only in Florida. Ferns do not produce seeds, but reproduce through spores which are formed on the underside of their leaves.

Corkscrew Swamp

Less than a century ago, there were extensive stands of ancient bald cypress in South Florida. Some of the trees may have been 1,000 years old. They were cut down by lumber companies. By the 1940s, the cypress left in the Big Cypress and the Fakahatchee Strand were mostly young trees. Corkscrew Swamp contains the oldest remaining stand of cypress in the state. Some of these trees may be 500 years old. The National Audubon Society saved the swamp from lumbering in the 1950s.

Corkscrew Swamp can be viewed from a two-and-one-quarter mile boardwalk. The walk passes first by a sawgrass pond, then to a wet prairie, a type of marsh that is prairie-like in appearance, has a peat bottom, and is not filled with sawgrass.

The plants in the wet prairie include blue flag iris, buttonbush, sand cordgrass, St. John's-wort, and water dropwort. An excellent guide book is available from the visitor center that describes each plant and tree commonly encountered in the different ecosystems within and around Corkscrew. Next, the visitor passes through dense strands of pond cypress. The sun streaming through these trees in the morning produces beautiful shafts of light. Pond cypress that are 100 years old may not reach great heights since they live on poor soil. Much smaller than bald cypress, its bark is lighter in color, and its needles point upward.

Reaching as high as 130 feet, the bald cypress tower over the swamp. The common reaction among visitors reaching the area of the bald cypress is to stand and stare upwards in awe. Bald cypress drop their needles in the winter and so appear "bald" until March. Befitting a first-class Audubon project like Corkscrew Swamp, birding is a major activity. The largest colony of wood storks in the US winters and often nests in the sanctuary. Turkey vultures soar overhead at all times of the year. Corkscrew is refuge to many other birds, including limpkins, bitterns, herons, red-shouldered hawks, painted buntings, and barred owls.

In Collier County, east of Naples. From I-75 exit at CR-846 and go east 15 miles.

Top: Lettuce Lake, so named for the water lettuce plants that usually cover its surface.
Bottom: the boardwalk through Corkscrew.
Opposite page, top: some of the lush vegetation.
Opposite page, bottom left: a small alligator walking on top of water lettuce floating on the lake surface.
Opposite page, bottom center: a barred owl.
Opposite page, bottom right: scarlet hibiscus, a rare native plant.

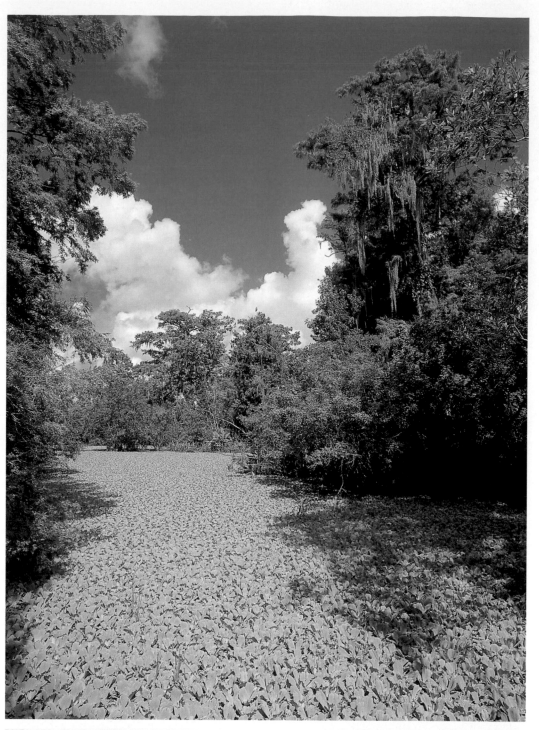

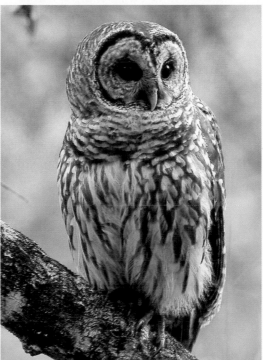

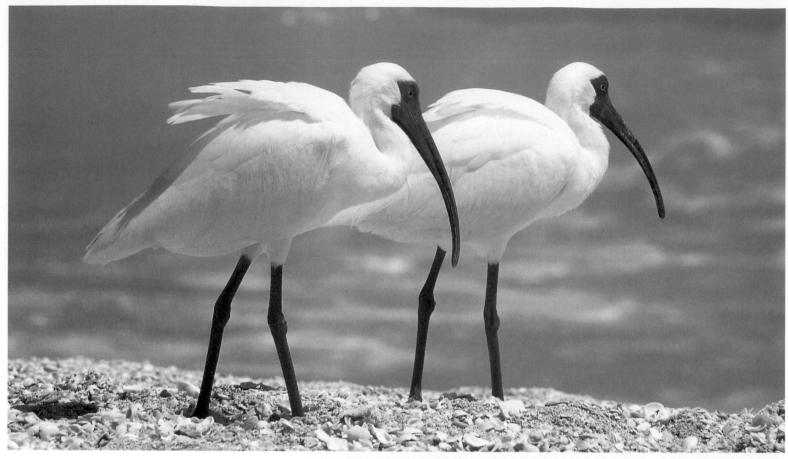

Ding Darling National Wildlife Refuge

The 6,350 acre refuge is named for J. N. "Ding" Darling, the nationally famous cartoonist, founder of the National Wildlife Federation, and a force behind the creation of the Duck Stamp. The refuge's sights and sounds can be experienced in comfort while driving along the four-mile Wildlife Drive, a shell road built on old dikes originally used for mosquito control.

Birds are the stars of Ding Darling. Cormorants may be seen diving and swimming underwater like Olympic champions. In the mangroves, white and pink dots turn out to be egrets, roseate spoonbills, ibis, and herons. Wood storks are often seen. Peregrine falcons, white pelicans and many migratory birds are visitors in the Fall and Winter months.

Reptiles offer some prime viewing also. There is a famous American crocodile, and many large alligators. Black racers often scoot across the path in front of hikers on the two-mile Indigo Trail, which is named for the rarer eastern indigo snake.

Sanibel and Captiva are barrier islands that have become incredibly popular winter vacation spots. In the winter, the traffic on Periwinkle (the only north-south road) grinds at the pace of downtown New

Top: a pair of white ibis foraging on the beach.

Bottom: a pileated woodpecker with its nest hole in a dead palm.

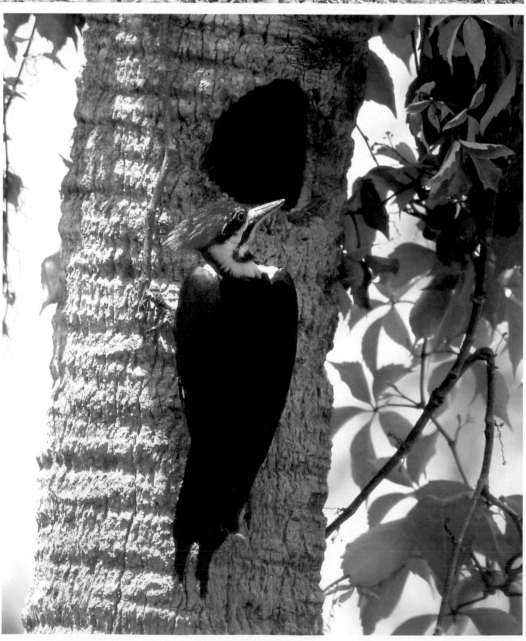

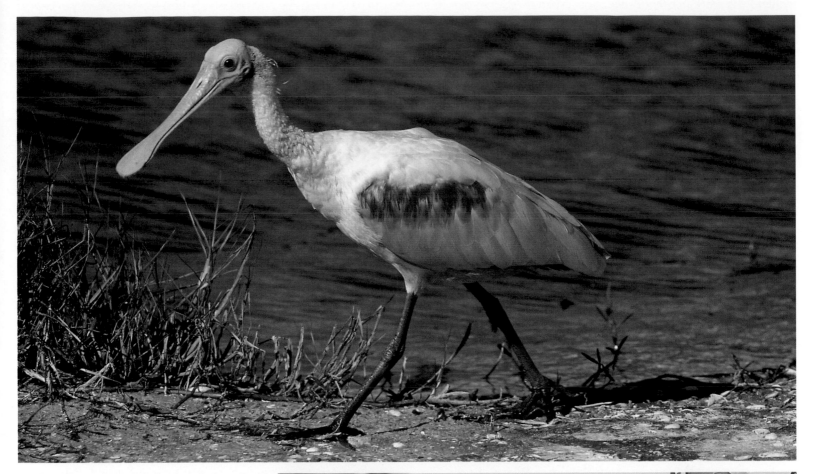

York City at five o'clock. Sanibel, one of the shelling capitals of the world, is the home of the Bailey-Mathews Shell Museum, conceived by the late Tucker Abbott, a renowned shell expert, and Raymond Burr, the late actor.

The Sanibel-Captiva Conservation Center has a four-mile hiking trail. Boating is popular around these islands, including those between Sanibel, Ft. Myers, and Pine Island. There are scores of wild islands in the bays and around the passes.

In Lee County south of Ft. Myers. From I-75, exit west on Daniels Parkway and go to 6-Mile Cypress Road Parkway. Go south on 6-Mile Cypress Road across US-41, and follow the signs to the beaches. Do not take the Ft. Myers Beach exit but continue straight to Sanibel Island.

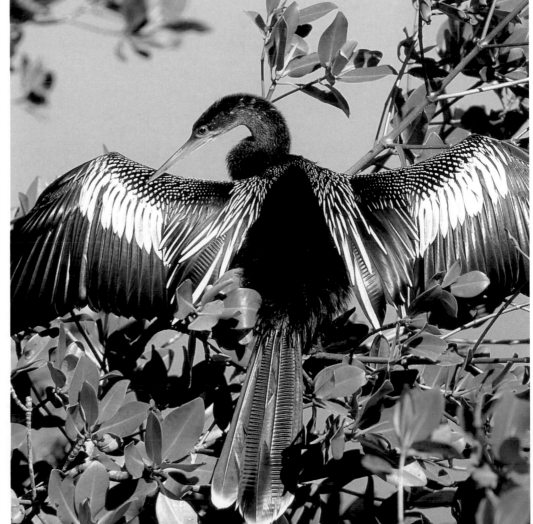

Top: a roseate spoonbill. These birds feed by swinging their spoon-shaped bill from side to side in shallow water.

Bottom: an anhinga preening its feathers. These fishing birds dive to catch their prey underwater. They are often seen with their wings outstretched, drying their feathers in the sun.

Everglades National Park

"There are no other Everglades in the world. They are, they have always been, one of the unique regions of the Earth, remote, never wholly known."
Marjory Stoneman Douglas
River of Grass

The Everglades is the most publicized natural treasure in Florida, and perhaps in the entire Southeast. Only about 25% of the original Everglades lies within the national park. Its original size of over 4,000 square miles has been greatly diminished over the last century.

North of US-41 is the portion of the Everglades that has been dedicated to water conservation. Farther north, adjoining Lake Okeechobee and extending southward, is a section set aside for agriculture, mostly sugar cane. South of US-41, most of the area that is not in the Big Cypress Preserve is part of the national park.

The entire park contains much more than the so-called "river of grass." It also includes large portions of the Ten Thousand Islands (mostly mangroves) and most of Florida Bay, which reaches the Keys. The southern mainland of the Everglades is mostly mangrove swamps.

There are several explanations for the name "Everglades." It might be a shortened form of Forever Glades, since they seem to go on forever. A likelier source was an English map maker who referred to them as the River Glades. This name was changed before printing to Ever Glades.

Many marshes, and especially the Everglades marsh area, look prairie-like when viewed as a panorama. A glade is an open space in nature. The Native Americans called the Everglades *Pay Hay Okee*, a grassy river, because of the slow movement of water across it to the sea.

Originally the Everglades received water from the overflow of Lake Okeechobee. Water flowed south abundantly during the wet season, and almost disappeared during the dry season in Winter. Water overflow from Lake Okeechobee is now controlled by locks. The Everglades have become dependent on rainfall and the benevolence of water managers.

The vast central marsh system slopes very gradually to the sea, no more than two inches per mile. This, and the blocking of water movement by vegetation, account for the slow flow. The base of the Everglades is a large sheet of limestone covered with relatively thin layers of peat

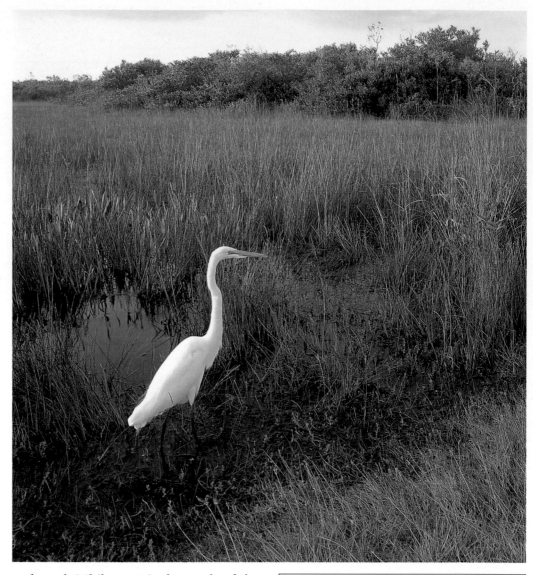

and marl. While peat is the result of decaying vegetation, marl is made from decaying periphyton. Periphyton is composed of many forms of algae growing together, and is the basic element of the food chain in the Everglades. Periphyton is as conspicuous in the water as the sawgrass is above it.

First-time visitors are often quite surprised by what they see. There is a preconceived notion that the Everglades is a sort of wild, tropical jungle. Instead, visitors see sawgrass extending endlessly into the distance, with clumps of trees growing only on islands, on raised hammocks, or around "gator holes."

Gator holes are depressions into which aquatic life retreats during the dry season. They are so named because gators clear them out by wallowing and later hunting in them. A low tree called the coastal plains willow grows around the gator holes and serves as a marker. Alligators perform an important task for the ecosystem by excavating these holes, in which aquatic life survives during the dry season.

Top: **American egret in a sawgrass marsh of Shark Valley.**

Opposite page, top: **black vultures perched in dwarf cypress trees.**

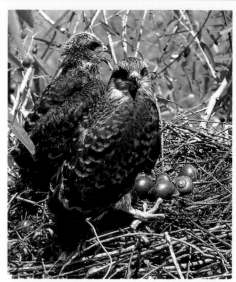

THE SNAIL KITE

The snail kite, or Everglades kite, is a bird of prey that eats mostly apple snails. Its beak is curved to assist in ripping the snail from the shell. These kites are an endangered species with perhaps as few as 1,000 left. They do not migrate, and they depend on the rise and fall of waters in the Everglades and surrounding areas to support an apple snail population. As the Everglades are reduced, or the quality of the water degraded, so is their ability to survive.

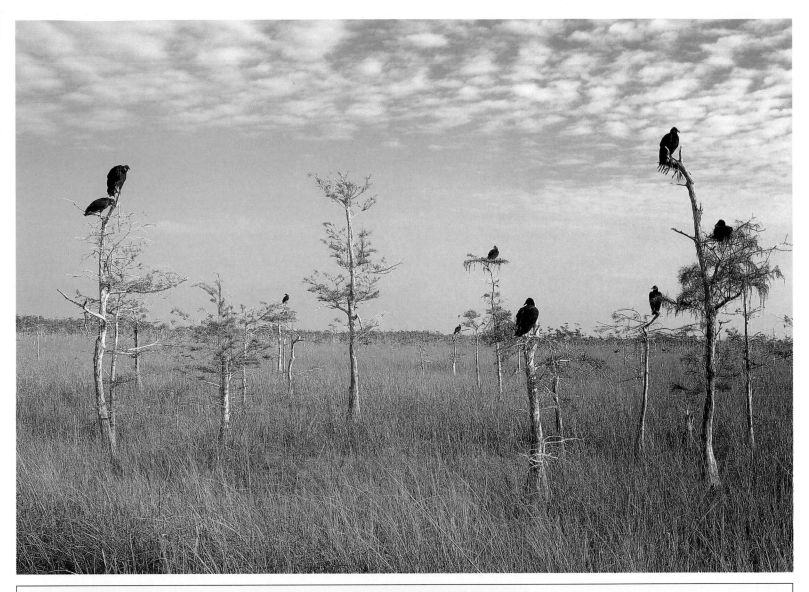

VU-GF

GLADES AIR BOATING

The noise is hard to endure and wind in the face forces eyes almost shut. Riders are advised to put cotton in their ears and to make sure their caps are on tight.

Air boats skim over the grasses and water at speeds around 35 mph. The boats are capable of much more speed, perhaps 60 mph, but according to the Miccosukee guides there is an unwritten code of holding back on the throttle. (One suspects these "unwritten" rules are broken once in a while, and that it must be quite a thrill to fly at 60 miles an hour across a shallow sheet of water.) The boats are capable of turning in narrow spaces, roaring across water only a few inches deep, passing harmlessly over obstructions such as floating logs, and making breathtaking sliding turns.

Only a few decades ago, it could be said that no one (not even the Seminoles forced into refuge during the Seminole Wars) had truly crossed the Everglades. With the advent of airboats, a lone individual can flit across the remaining Everglades in a day. As one Miccosukee guide put it, "Sometimes my friends and I just get up and go on as far as we feel like."

I 75 from Naples to Ft Lauderdale is known as Alligator Alley, and the older road, US-41, is known as the Tamiami Trail because it joins Tampa and Miami. Along US- 41, the Miccosukee offer airboat rides that take tourists to small villages that still exist on hammocks in the open Glades.

The Seminoles speak two dialects, Mikasuki and Muskogee. The Miccosukee Tribe should not be confused with the Mikasuki dialect just because the two words sound alike. The Miccosoukee are composed of people who speak both dialects. They split from the other Seminoles over matters of politics, not language.

The forty-five minute rides provided by the Miccosukee seem too short. They make the adventurer yearn to be a Seminole guide who can "just take off" on a whim across what seems an endless expanse.

Airboat damage to the sawgrass is an issue of study and concern among ecologists. Too many trips over the same path can cause "ruts" in the sawgrass that will then give way to encroaching cattails, a plant that is a sign of the alteration of the Everglades environment.

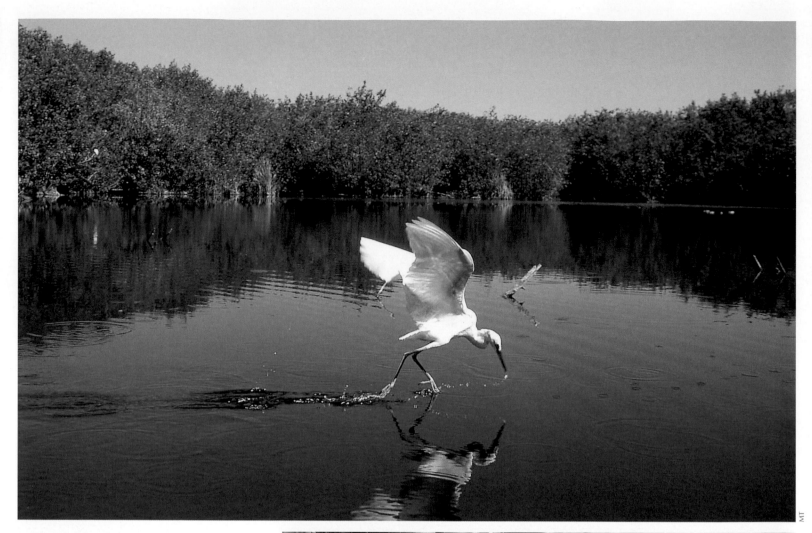

Everglades National Park

SHARK VALLEY

Shark Valley leads to the Shark River and the sea. It is so flat that the term "valley" seems inappropriate. The land ridges to the east and west are merely a few feet higher in elevation. In this flat, wet land, small elevation changes make a significant difference.

The first time visitor should take the tram ride to the tower. The two-hour ride on a paved road passes many alligators. The tour guides are highly informative, presenting the ecology and history of the Everglades in a way everyone can understand. The mid-point and high-point is the arrival at the huge concrete tower. A spiraled ramp leads the visitor to heights from which the "forever" glades (and some gargantuan alligators) can normally be admired. On a second trip, and probably thereafter, most visitors prefer to hike or bike the approximately seven-and-a-half miles so they can observe at their own leisurely pace.

ON THE ROAD TO FLAMINGO....

ANHINGA TRAIL

Winter birding at Anhinga Trail is leg-

endary. When conditions are right, not only anhingas, but bitterns, herons, ospreys, and many other birds congregate around the boardwalk. The boardwalk is about one-half mile long, passing over marsh near deeper Taylor Slough. The ponds here were dug artificially, but this deeper water attracts the anhingas, cormorants, and other birds.

GUMBO LIMBO TRAIL

The Gumbo Limbo Trail is a half-mile trek through a tropical hardwood hammock. This trail is named for the copper-

colored tree with the peeling bark (reminiscent of a sun-burned tourist). Expect to see wild tamarind, strangler fig, poisonwood, orchids, bromeliads, cocoplum, pond apple, and willow.

LONG PINE KEY

This area is pine rockland dominated by slash pine and marsh. While this is a camping and recreation area, in it are almost 45 miles of hiking trails, which are also used for bicycles. Much of Long Pine Key is pock-marked with limestone solution holes.

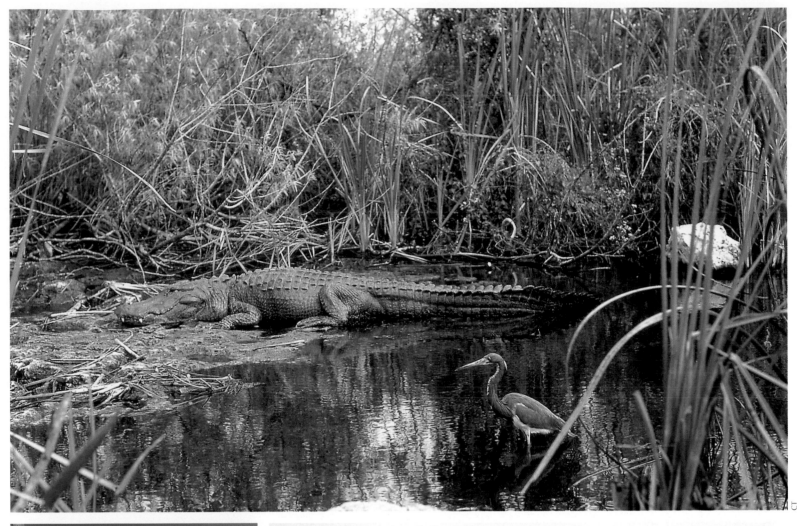

PA-HAY-OKEE OVERLOOK TRAIL

Do not expect much exercise on this trail (unless you travel it a few hundred times). It is a short walk on a short boardwalk to a slightly elevated platform where a large expanse of the Everglades can be viewed. It is a great location for leisurely scanning the horizon and observing birds.

MAHOGANY HAMMOCK

The one-half mile boardwalk leads into dense hammock where the largest mahogany trees in the US grow. Paurotis palms fringe the hammock. These palms

Opposite page, top: a snowy egret (note the golden slippers) fishing in Mrazek Pond.

Opposite page, below: the peeling bark of the gumbo limbo tree.

Top: A tricolored heron fishing in an alligator hole as the gator watches.

Above, left: a pair of tree snails.

Above right: dwarf cypress (note that the limestone base of the Everglades is visible in this photo).

Left: mats of periphyton (an algal community) floating in a sawgrass glade. Periphyton is at the base of the food chain in the Everglades.

135

Everglades National Park

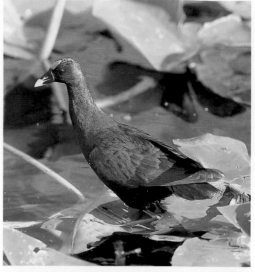

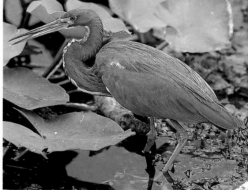

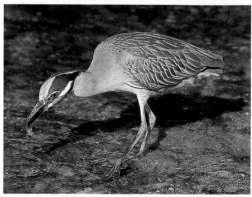

are found in the US only in the south tip of Florida and in the Keys. In the mahogany and live oak there are bromeliads, ferns, and orchids. Barred owls are sometimes seen here (but more often only heard) in Mahogany Hammock.

WEST LAKE

This brackish lake is the start of a canoe trail. Nearby, a short boardwalk goes through the mangroves. There are several other canoe trails along the road to Flamingo, and all are clearly marked.

SNAKE BIGHT TRAIL

During the tourist season, a tram also runs on this trail, complete with mosquito netting. The road is a little less than two miles, leading to a boardwalk from which Florida Bay and its variety of birds can be observed. There are many other short and long, clearly-marked trails within the park,

with their locations noted in park literature.

What is a bight? Many people think this trail is the snake "bite" trail but it is not. A bight is a bend, a hollow, or a curve in a river or coastline.

MRAZEK POND/COOT BAY POND

In the Winter dry season, Mrazek Pond attracts birding enthusiasts hoping to see ducks, egrets, herons, roseate spoonbills, and pelicans, among other birds. If the water level is too high, they may be disappointed. Otherwise, the bird population is usually very heavily concentrated here. There is a short trail around Mrazek Pond. Just beyond it is another favorite spot to observe birds, Coot Bay Pond.

FLAMINGO

Flamingo is the end of the road, where the visitor looks over Florida Bay. The fa-

Top, left: the observation tower at Shark Valley.

From top right, downward: purple gallinule, tricolored heron, common moorhen, and yellow-crowned night heron.

mous Flamingo Lodge is located here, along with a marina, campgrounds, and an excellent restaurant. Near the motel and camping facilities at Flamingo is Eco Pond, an excellent spot for birding.

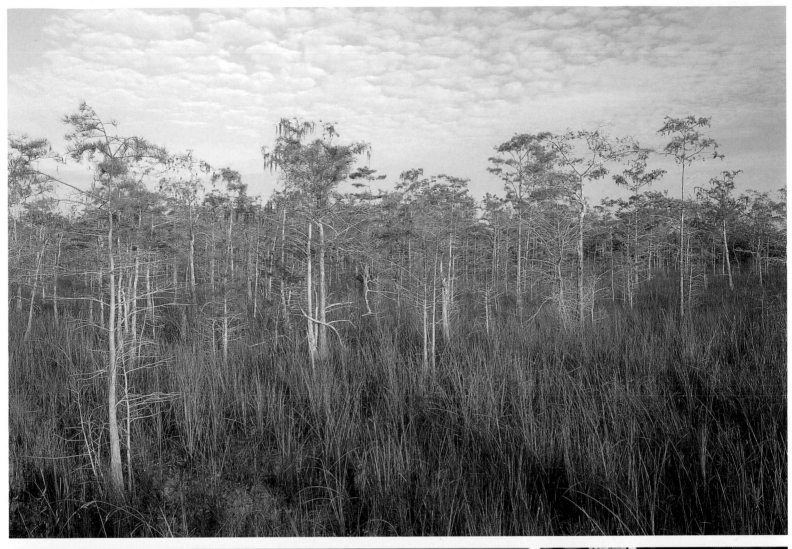

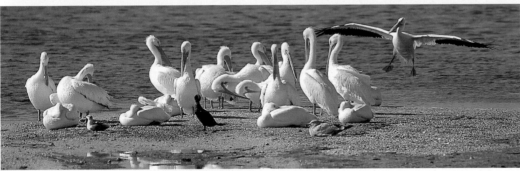

ROMANCE IN THE GLADES

Valentine's Day in the Everglades is in the season of anhinga love. Females with "halos" about their eyes have head plumage that stands on end to signal their availability. Lady anhingas have white on their chests, while the males are black.

These powerful divers and expert fisher birds unfortunately often take both the fish and the hook from Florida fishermen. If this happens, it is best to reel the bird in, and remove the hook. This is often impossible, and cut lines can ensnare and kill unfortunate birds. In the worst case, fishermen should reel the bird in, and cut the line as short as possible. To leave a long line is likely to give this majestic bird an untimely and unpleasant death when the line becomes tangled in vegetation. It would be better to remove the hook or to take the bird to a wildlife rehabilitation center to have the hook surgically removed.

In the mating season, these birds are abundant in the Everglades. They are common throughout Florida but are most approachable here. In the spring, they are seemingly in every other tree along US-41.

Top: dwarf cypress at Rock Reef Pass.
Above, left: a flock of white pelicans.
Above, right: an Everglades rat snake.

The Shark Valley Entrance is on US-41 to the south. The main entrance is west of Homestead, on SR-9336. The park is located in three counties: Collier, Dade, and Monroe.

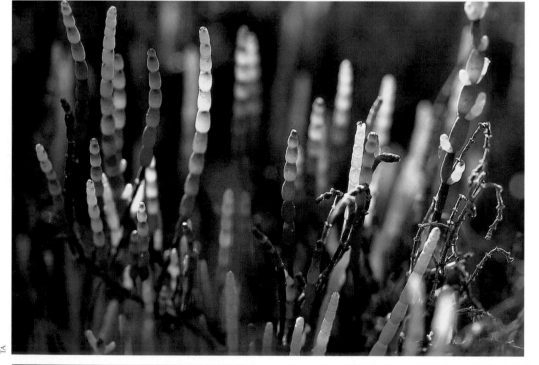

Above: an aerial view of a freshwater slough in the Everglades.
Left: colorful glassworts on Nest Key in Florida Bay.

THE PROBLEM WITH SUGAR

About one-third of the historic Everglades was set aside for agriculture. The other two-thirds were divided between water conservation and the national park. The need for an agricultural area in the Everglades is questionable in current times. The main crop is sugar. However, a plentiful supply is available on the world market at much lower prices. Many naturalists would like to see government support for the sugar industry withdrawn. Activists believe this support is based solely on large political contributions. Agriculture in the Everglades presents a long-term threat to the water conservation and national park areas. Runoff from the agricultural areas containing fertilizers flows first into the water conservation area and then into the national park. This runoff enriches the Everglades with nutrients beyond its natural limit. A sign of this is the appearance of cattails in place of sawgrass. As the level of nutrients climbs, a point could be reached when the Everglades would be changed, perhaps irreversibly. Also, sugar farming exposes the peat which oxidizes and gradually disappears.

FIRE IN THE EVERGLADES

At first, the idea of fire in a marsh might seem unlikely. Yet the Everglades, and other marshes, depend on fire. In the summer, thunderstorms bring lightning which can start natural fires. These fires may begin and end rather quickly because of drenching rains.

Such fires are often beneficial, especially in the sawgrass-dominated Everglades. Nutrients are released, and vegetation cleared. The roots of many of the plants and grasses are not harmed, and life is renewed from the ashes.

Winter fires, coming during the dry season, are another matter. At this time, fire can rage out of control. It can reach even into the peat. If the peat burns, the earth itself is on fire, and roots will be damaged. These fires can cause respiratory problems miles away as the smoke is carried by wind.

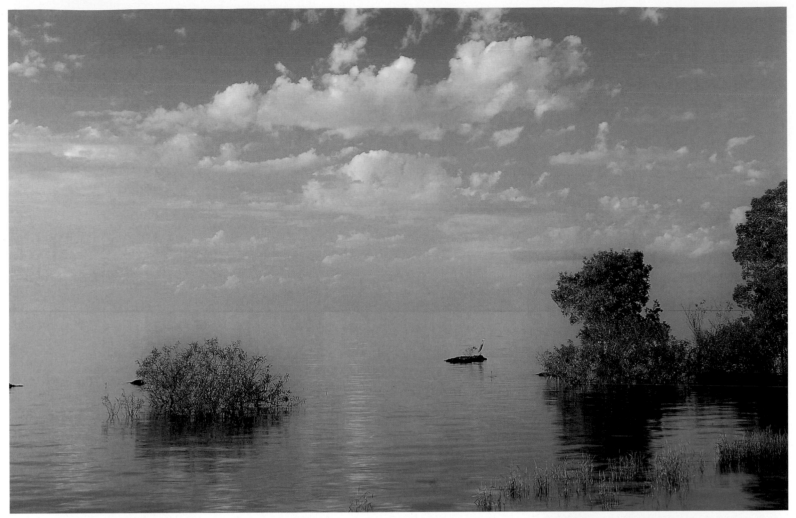

Lake Okeechobee

A young mother from Poland had brought her son to see Lake Okeechobee. They had already seen many of the natural sights in the US, including the Grand Canyon. Now they wanted to see the second largest freshwater lake in the US (Lake Michigan is the only larger freshwater lake which is completely in the US). They could not see it even though it was only 100 yards away

"Where is the lake?" she asked. "It's on the other side of the dike," a local replied, with a hand gesture to go up the steps with the handrail.

It isn't possible to immediately see Lake Okeechobee from the county park on SR-80. But once on top of the 34 foot high dike, after a hike of less than one-half mile, the expanse of the lake is visible. A 27-mile portion of the Florida Trail is largely along the dikes built around the immense, but shallow lake.

"Why did they do this to the lake?" the visitor from Poland wanted to know.

For several thousand years at least, Lake Okeechobee was free. It rose or fell with rains. Hurricanes whipped its waters. The overflow fed the Everglades. Native Americans lived with this flooding hazard.

Pioneers settling this area were repeatedly menaced by floods driven by hurricanes. They often drained the swamps, and put their dwellings in vulnerable places. The little town of Moore Haven, to the east of Ft Myers, built a dike, but in 1926, the dike broke during a hurricane. Some reports claim that more than 300 people drowned. Just two years later, another September hurricane struck, with fatalities reported at over 1,800 humans. Some dispute these numbers, but certainly there was significant loss of life.

In today's ecologically aware era, the 110 miles of dikes around Lake Okeechobee would probably never have been built. More likely, the area would have been declared a preserve, and the construction of human dwellings restricted to a safe distance. Instead, President Herbert Hoover, himself an engineer, appointed a commission to decide what to do about the "problem" of Lake Okeechobee. The commission decided to put the lake in jail.

In the dike are granite blocks trucked into a state dominated by limestone. The granite reinforces the dikes. The earth was dredged from the shore to supply the fill. Begun in 1930, and completed in 1937, it didn't solve all the problems. The Everglades was permanently changed, and engineers decided to "straighten" the beautiful Kissimmee River for flood prevention. Freshwater flow was diverted into the Atlantic and into the Caloosahatchee River. The Corps of Engineers is still at work

maintaining the dike around Lake Okeechobee, and probably always will be. Should these dikes break now in a hurricane, with a much larger human population living nearby, there might be a significant loss of human life and great damage. Freeing Lake Okeechobee from its prison is not an option any longer, but efforts are underway to return the Kissimmee River to its original meandering course.

The lake can be circled on SR-80, US-441, and SR-78. The lake is so large that parts of it extend into five counties: Glades, Hendry, Martin, Okeechobee, and Palm Beach. There are various access points onto the dike. Boating is allowed, but canoeing far from shore can be dangerous because of high waves during storms.

Top: Lake Okeechobee at sunset near Canal Point, Florida.

Above: **tall grasses surrounding the lake.**

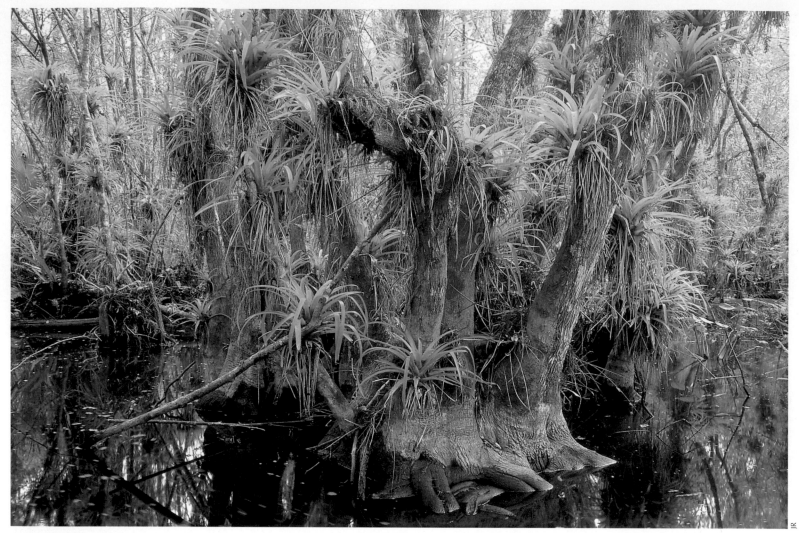

Fakahatchee Strand State Preserve

A strand swamp is a shallow, elongated channel within a flat, limestone plain dominated by bald cypress trees. The channel allows water to accumulate, creating a habitat which is safe from fire except during extreme droughts. Sloughs are even deeper channels within a strand. The high water and humidity levels of the slough help to moderate the temperature, thereby providing a frost-free habitat for tropical epiphytes such as orchids, ferns, and bromeliads.

One entrance into the Fakahatchee is via a 2,400 foot boardwalk that begins at Big Bend, about five miles west of Carnestown. This is a spectacular boardwalk on which black bears sometimes stroll. The boardwalk passes under ancient cypress trees. The Norris family once owned 215 acres at Big Bend, through which the boardwalk allows access to most visitors. Since this family did not want their property logged, this small portion of the Fakahatchee Strand can be seen in its original pristine beauty. Loggers removed most of the largest cypress trees from the rest of the Preserve in the 1940s and early 1950s. Strangler figs grow to the

sky around some of these ancient cypress. The strangler fig is no real threat to cypress that is sturdy enough to support it.

The preserve headquarters is located one mile from SR-29 on Janes Memorial Scenic Drive. A railroad track for lumbering was built in the 1940s, extending about 25 miles deep into the strand. There are about 160 miles of railroad spurs. The main track is now the 11-mile Janes Scenic Drive, which can be toured easily by car. The spurs, marked only by gates, can be hiked. There are about 125 square miles of wild swamp in the Preserve.

Trees at least 500 years old, and perhaps older, were harvested during the lumbering years. Fresh growth is repopulating the strand, but it will be five more human generations before the cypress grow as large as they once were.

Perhaps three to four panthers are present in the strand at any one time. More are found farther north in Florida Panther National Wildlife Refuge. The panthers (along with the bears, bobcats, and minks) are rarely seen.

The stars of the Fakahatchee are the plants. This is one of the few places in Florida where royal palms grow naturally. The population of royals in the preserve is estimated at 5,000 trees. Thirteen species of bromeliads can be found, including *Guzmania*, a tropical genus. Botanists

come here often to study the wide variety of ferns, orchids, and other plants.

There is an area east of Janes Scenic Drive known as "The Cathedral" for the beauty of its pond apple and profuse bromeliads. To reach it requires an arduous one-mile hike through swamp, in which it would be easy to become lost without help from a ranger, or a compass and a cool head. Seminole Indians successfully hid in the Fakahatchee during the Seminole wars, so a trip into it "ain't no disco." Rangers lead a small group into the swamp about once a month. Bill Boothe's Natural Encounters from Sarasota also takes groups into the Fakahatchee.

For most people, a walk into the strand is intimidating. A short hike into the swamp might not be too arduous, but longer journeys can be tough. There are sudden holes, roots to trip over, alligators, sometimes Florida cottonmouth snakes, and treacherous footing in the peat, which in some places is more than three feet deep.

The water in the strands flows slowly, as it does in the Everglades. But here, unlike the Everglades, large trees dominate.

The boardwalk: seven miles west on US-41 from SR-29. SR-29 is an exit on I-75. The strand: along Janes Scenic Drive from SR-29 about three miles north of US-41 near the small town of Copeland in Collier County.

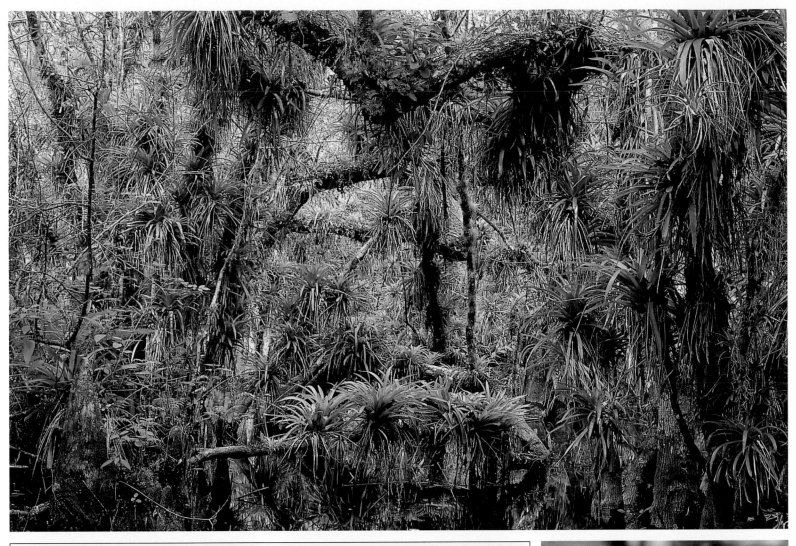

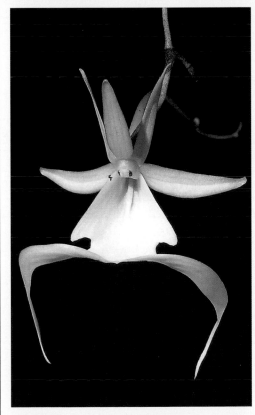

FLORIDA NATIVE ORCHIDS

Orchids are abundant in the Fakahatchee Strand, especially many small ones. The biggest concentration of ghost orchids in Florida is found here. This beautiful flower (shown above, left) is pollinated by a night-flying sphinx moth which has a very long feeding tube needed to probe the long nectar tube of this flower. There are more than 75 species of orchids in Florida and more than 40 are present in the Fakahatchee, including the beautiful mule ear orchid shown above, right.

Opposite page, top: pond apple and *Guzmania* air plants

Top: trees covered with *Guzmania* bromeliads.

Above, center: a detail of the *Guzmania* flower.

Above: a strangler fig embraces its host tree, an ancient cypress.

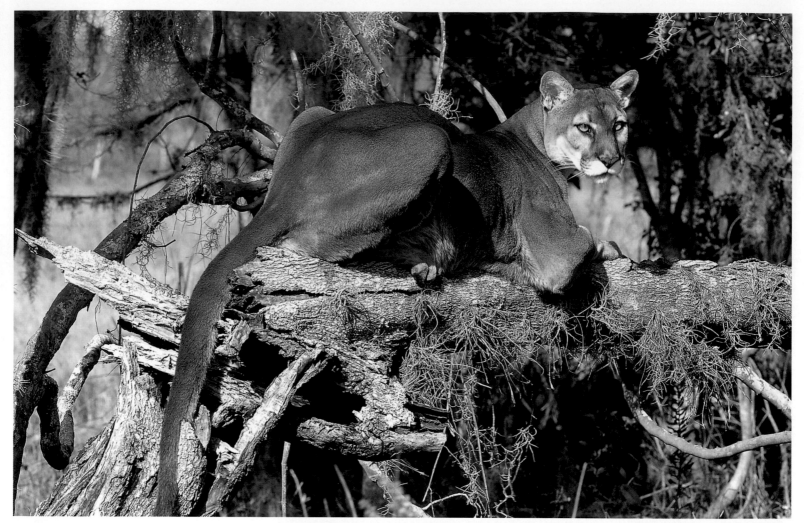

Florida Panther National Wildlife Refuge

There are warning signs to "watch out" for panthers in many parts of the Big Cypress. Underpasses have been created beneath major highways to help spare panther lives. The personnel of the panther refuge are on duty to protect and preserve Florida's most regal feline.

Once a year the refuge holds an open house. A fortunate few are shown the absolutely primitive wilderness. It is doubtful that a casual visitor would be able to see any of the few Florida panthers that roam the refuge. These radio-collared panthers are tracked from the air, and if one of them stops moving, wildlife biologists investigate, and sometimes undertake a rescue. Small educational groups are allowed in the refuge on rare occasions.

The plight of the Florida panther is sad, though it is a well-publicized tale. The Florida panther was hunted for most of the last two centuries, with bounties offered by the state as late as the 1950s. Panthers require large ranges, and human development has encroached on these territories. The panthers that remain face the risks of dying as road kill or being shot, although shooting a panther is against the law. Some male panthers die from fighting among themselves while protecting their

territories.

Florida's panther population has been judged to be too small to be genetically viable. For this reason, female Texas cougars have been brought into South Florida in hopes of keeping the panther population healthy with diverse genes (Florida's big cats are a subspecies of cougar). This program has reestablished a tiny panther presence in Everglades National Park.

Some naturalists are opposed to this program, believing it will breed the Florida subspecies out of existence. Others argue that if the subspecies is not able to reproduce, it will become extinct anyway, and that the state is better off with some form of cougar than none at all.

What are the Florida panther's chances of a comeback? No one is sure. Many hope that the panthers will reestablish themselves soon, but they could vanish within the next ten years without further help.

An encounter with a panther in the wilderness is a rare event. Many of the refuge staff have yet to see the big cat in the wild because of its solitary and secretive nature.

Top: a Florida panther.

Above: school children touring the Refuge in a swamp buggy.

In Collier County, but closed to the general public, except as noted.

Arthur R. Marshall Loxahatchee National Wildlife Refuge

The refuge is named for Art Marshall, a passionate advocate of wilderness preservation. Here in the early morning, flocks of waterbirds, often in line or in V-shaped formations, soar over the impoundments near the headquarters. Each of the ten diked rectangles is approximately eight-tenths of a mile around. Hiking the dikes provides views of softshell turtles and alligators. Birds seen often include wood storks, roseate spoonbills, ibis, heron, ducks, bald eagles, limpkins, and snail kites, among others.

Behind the visitor center is a one-quarter mile boardwalk. Young Florida cottonmouths with bright bands, and adults whose bands can barely be noticed, can often be seen below the boardwalk. Otters often frolic here, relieving any depression a city visitor might have brought. The bark of many of the cypress is decorated with red lichens.

A canoe trail of more than five miles starts at the headquarters. However, this trail is frequently clogged and closed, so it is best to call ahead. There are no canoe rentals.

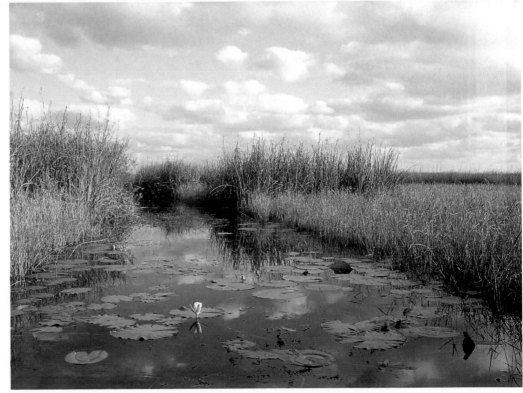

About half of the nearly 221 square miles of the Headquarters Recreation Area, in which the nature center is located, is closed to the public, and much of it is inaccessible. The Department of the Interior is attempting to purify agricultural runoff from the water before it flows into the rest of the Everglades.

The Loxahatchee River, like the St. Johns, flows north and empties into the Atlantic. The vast majority of the rivers in Florida flow into the Gulf of Mexico.

Top: **cypress trees and ferns along the boardwalk.**
Above: **a canoe trail at Loxahatchee NWR.**

The entrance is on US-441 west of Boynton Beach. US-441 parallels I-95 and the Florida Turnpike. The preserve is in Broward and Palm Beach counties.

Other South Florida Adventures

CAYO COSTA STATE PARK

Accessible by boat from Punta Gorda. Over 2,000 acres on three wild islands: LaCosta, North Captiva, and Punta Blanca. Some cabins, primitive camping, bird-watching, fishing, and lonely beach walks.

CORBETT WILDLIFE MANAGEMENT AREA

On SR-710, 25 miles northwest from West Palm Beach. Over 60,000 acres of flatwoods, hammock, marsh, and swamp which can be experienced on 14 miles of the Florida Trail.

DUPUIS RESERVE STATE FOREST

On SR-76, in Martin County. Almost 22,000 acres in which there are 40 miles of hiking, and 24 miles of horse trails. Flatwoods, marshes, and swamps.

MACARTHUR BEACH STATE PARK

On A1A in North Palm Beach. There are a nature center and several nature trails, but the two features are the beach and the mangroves. On the Atlantic side is a beautiful, seemingly untouched beach. On the shore-side are mangroves populated with foraging raccoons and black mangrove crabs.

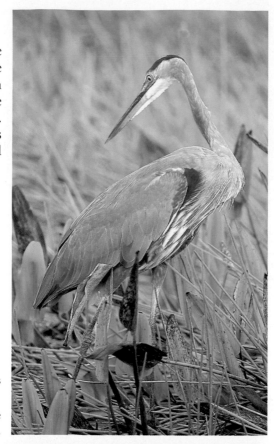

Right: a great blue heron

Below: the beach at Cayo Costa State Park.

Opposite page, top: an American alligator.

Opposite page, bottom left: the colorful leaves of sea grapes at Cayo Costa.

Opposite page, bottom right: a group of white ibis perched on bromeliads in the Big Cypress.

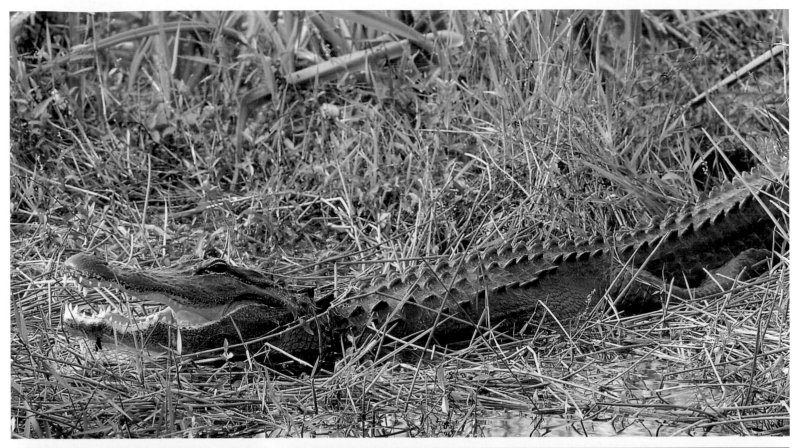

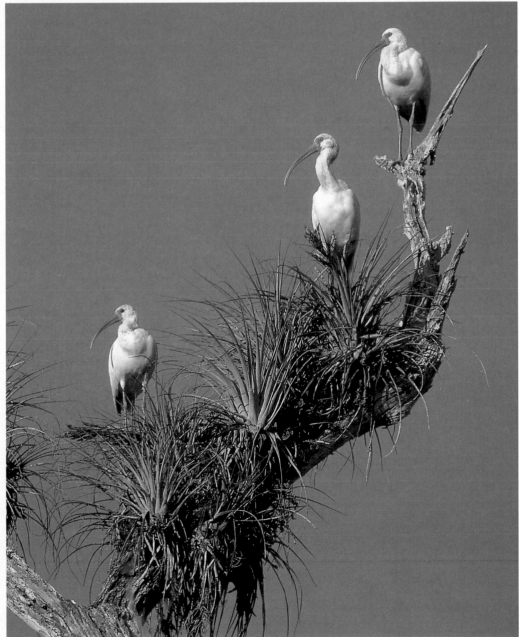

The Florida Keys

The Spanish word for an offshore barrier island is *Cayo,* which has been anglicized as Key. In the powerful, swirling Florida Current (an extension of the Gulf Stream) are the inhabited Keys. The lower Keys are oolitic limestone (produced from sediments in a warm ancient sea, containing round or egg-shaped bodies). The upper Keys are coral with an accumulation of sand and a thin layer of soil.

The inhabited Keys are the larger, limestone-based islands that follow an arc southwestward from near Miami, ending at Key West. They are different from the islands in Florida Bay to the northwest, which are accumulations of mud and mangroves, or mangroves that have claimed ground from a sandbar.

The Keys stretch from the end of the southeastern mainland into the Straits of Florida. US-1 connects the Keys with bridges from which can be seen the constantly changing face of the sea and sky. From US-1, the waters appear Caribbean and are often described as azure or emerald.

Hurricanes are severe threats to the human population of the Keys because there is nowhere to run on the exposed Keys. When storms come, the population must escape via a mostly two-lane road. Throughout the rest of Florida, barrier islands and shorelines take the brunt of the big storms, but the small islands of the Keys have no such protection.

Much of the little wilderness remaining in the Keys is on the offshore islands and particularly in the water. Around the Keys are coral reefs made up of living animals together with their accumulated skeletons. The reefs have two main forms: the circular patch reefs, and the elongated spurs which may have sandy "grooves" between them.

Coral reefs are not only lovely to the eye, but are home to hundreds of creatures. Humans have done great damage to the reefs. Because of this, both the state and federal governments have created marine sanctuaries for the protection of the reefs and the creatures that live around them.

Because the Keys are connected by a single road, the few remaining natural places in this section are not presented in alphabetical order but in the order they are encountered driving from north to south. The Dry Tortugas can only be reached by seaplane or boat.

Most of the large trees on the inhabited islands were harvested long ago. The Keys have constantly been exploited for their resources, including their lobster, turtles, and fish. The natural places in the Keys are all special and potentially imperiled.

The Keys are entirely in the tropical weather zone. Tropical hardwood hammocks are found in the islands. The tree species which make up the hammocks are mostly of West Indian origin and were originally carried to the Keys by storms. Their roots do not go deeply into the earth, which is rocky and inhospitable, but run along the ground, allowing the trees to take advantage of the shallow layer of soil.

Key West takes its name from its location. It is described in a number of important works of literature including *To Have and to Have Not,* by Ernest Hemingway, and *Key West Tales,* by John Hersey, among others. People in the Keys are known for their independent spirit and consider themselves as a group apart from the mainlanders. This idea is reflected in their nickname for Key West, the "Conch Republic."

Opposite page: **diver with loggerhead turtle.**

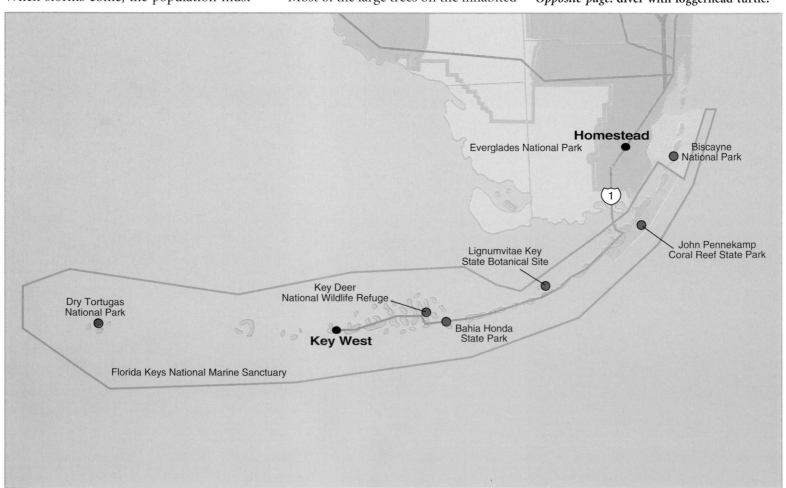

Everglades National Park

Homestead

Biscayne National Park

John Pennekamp Coral Reef State Park

Lignumvitae Key State Botanical Site

Key Deer National Wildlife Refuge

Dry Tortugas National Park

Bahia Honda State Park

Key West

Florida Keys National Marine Sanctuary

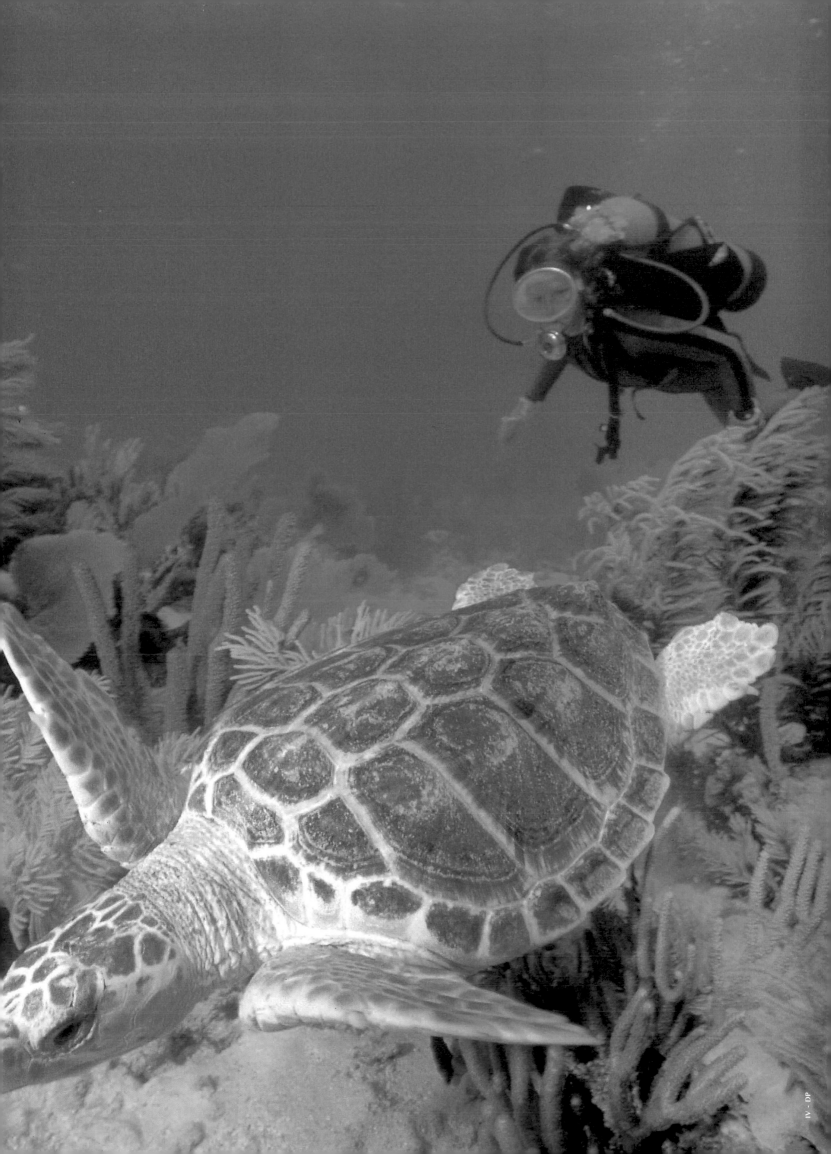

John Pennekamp Coral Reef State Park

Upon entering this park from US-1 on Key Largo, visitors are greeted at the Ranger Station, where questions about boat tours and schedules can be answered. Nearby there is one trail through dense, tropical hardwood hammock, another through mangrove. There are also swimming areas and canoe rentals, but the real adventure at John Pennekamp is out on the coral reef.

Visitors flock to John Pennekamp each year, mostly to see the work of tiny polyps that have built the coral reefs over tens of thousands of years. Call ahead for boat and camping reservations. The phone number is in the index. There are a number of private charters available around the park. Boating within the waters is reported to be tricky and potentially hazardous, so caution, experience, and a good set of charts should be employed.

At the visitor center is a 30,000 gallon aquarium, smaller tanks, and educational displays. In the 90 seat auditorium are continuous videos, films, and slide shows

about the reef and local wildlife. These give excellent educational background for subsequent reef trips.

The creation of the coral reef parks and marine sanctuaries was a response to human attacks on them. Coral was harvested for commercial reasons. Broken pieces were sold to tourists as curios or used in lawn ornaments. Salvagers dynamited coral reefs looking for treasures and wrecks. Now the threats are less obvious but just as real. John Pennekamp Coral Reef State Park was the first area protected. It is named for an environmentally active associate editor of the Miami Herald, who helped bring the park into existence.

Water quality is of primary concern to the health of reef ecosystems. Agricultural and storm-water runoff carrying fertilizers, eroded soil, industrial emissions, pesticides, and sewage are the predominant concerns. Large ships discharge oily bilge waste and dump litter at sea. Smaller boats provide their own pollution, and boats running aground have scarred reefs and blown damaging silt over them. Careless use of anchors, human diving, fishing and

Top: **Transparent shrimp on a pink anemone.**

Opposite page, top: **an example of a spur and groove reef described on page 146.**

Opposite page, bottom: **blue-striped grunts and longjaw squirrelfish sheltering under brain coral.**

spearing chip away at reefs. Much of the human damage can be lessened through education. The problems of too many boats and declining water quality require harder solutions.

Florida's coral reefs are as wonderful as any natural spectacle in the state. They attract divers from all around the world who spend much money in Florida as tourists. Reefs provide aquatic species with a rich habitat, which once destroyed takes many human lifetimes to recover, if it can recover at all.

How species-rich are these reefs? Over 650 species of fish are found on reefs in the Keys. Thousands of other marine species dwell on or about coral reefs. Diving or snorkeling among these riches can be rewarding to a person of any age, a treasure of the spirit and memory.

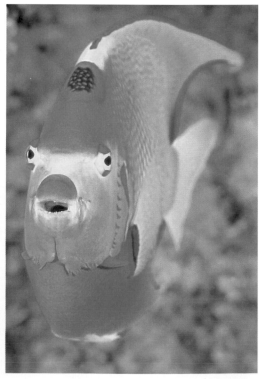

Top: this famous underwater landmark is called Christ of the Abyss and is dedicated to sailors who lost their lives in waters around the Keys.

Bottom, left: a Caribbean reef squid.

Bottom, center: a longsnout seahorse.

Bottom, right: a queen angelfish.

On Key Largo on US-1 at Mile Marker (MM) 102.5 oceanside. All the Keys north of Key Largo are in Dade County. The others in Monroe County.

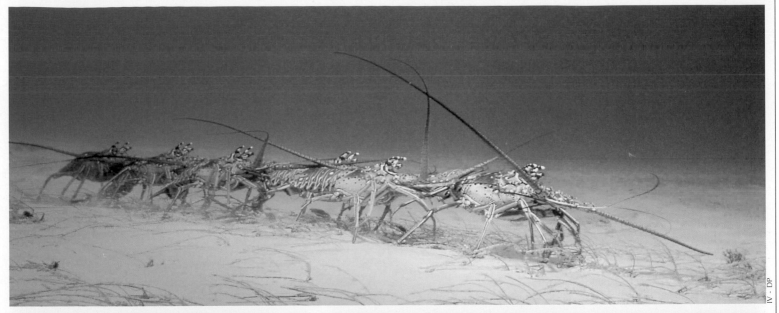

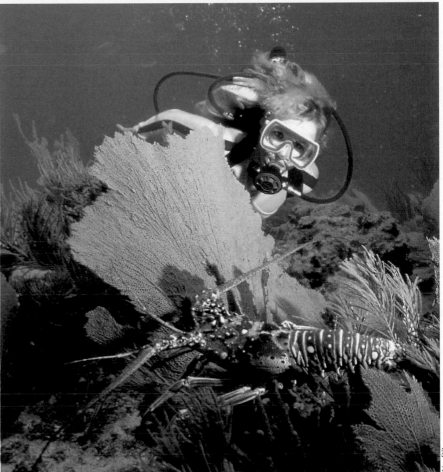

LOBSTER "SEASON" IN THE KEYS

Unlike lobsters in New England, Florida's spiny lobsters lack claws. They are protected instead by their spines, for which they are named.

The lobster "harvest" for both commercial fishermen and sports divers is from August 6 to March 31. It is preceded by a two-day mini-season for sports divers in July during which a free-for-all, carnival-like atmosphere prevails. The frenzy to get the biggest and most lobsters leads to increased boating accidents. Almost every year, deaths result from boat collisions or the running-over of divers. Boat operators who are unfamiliar with the reefs often run aground. Coral heads are sometimes intentionally overturned in pursuit of the prize. Many divers harvest lobsters smaller than allowed by regulations.

Lobster regulations change from year to year. Many areas have restrictions. No lobster-taking is allowed in Coral Reef State Park during the mini-season. The harvesting of lobsters is banned entirely in Everglades National Park. Full-grown lobsters can weigh as much as thirty pounds. However, this weight is rarely achieved due to the over-harvest of young adult lobsters. Many naturalists decry the two-day mini-season.

Brochures with current regulations are available upon request at the entrance to most coastal parks. They can also be obtained by mail from the Florida Marine Patrol and National Marine Sanctuary. Stiff fines are assessed against those caught violating the regulations.

Top: spiny lobster marching along the sea bottom on their annual migration from juvenile to adult habitat.

Above, left: a spotted spiny lobster.

Above, right: a diver spots a spiny lobster behind a sea fan.

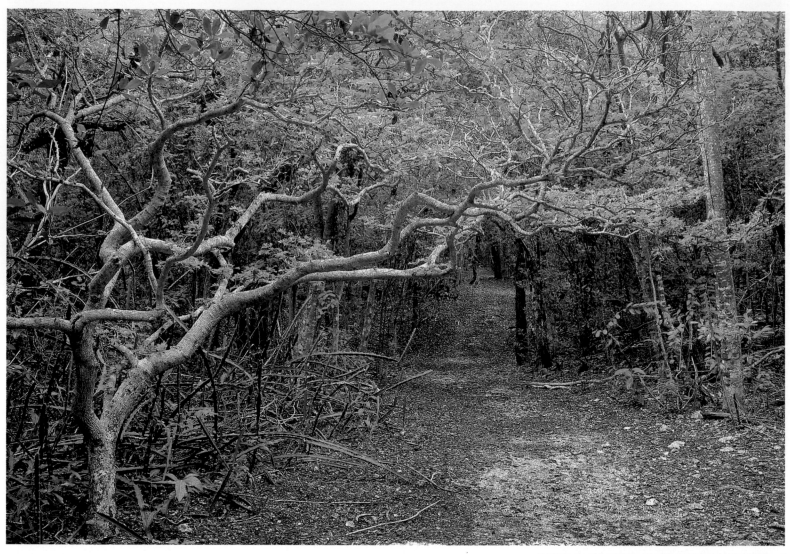

Lignumvitae Key

Named after the lignumvitae tree, this is one of a very few pristine limestone keys remaining. One hundred thousand years ago, it was a coral reef. "Stepping back in time" is a trite phrase, but there is nothing trite about applying that to Lignumvitae Key. Here are the Keys as they were when they were wild and natural. This Key, too, was almost developed, but it was saved thanks to the Nature Conservancy and the wisdom of the state.

There are approximately 2,000 lignumvitae trees on the island. But they are only a small part of the story. Approximately 50 species of trees grow here. Some of these include gumbo limbo, Jamaican dogwood, mahogany, and mastic. In all this richness, lignumvitae is an understory tree.

Lignumvitae is a remarkable wood that is exceptionally hard. It is said to be the second hardest wood in the Americas. It has the advantage of being self-lubricating because of its resin, guaiac gum. The name lignumvitae means "wood of life." It is so strong that it was used for propeller shaft bearings during World War II. Enthusiasts say it is the wood that beat Hitler.

There are presently two tours per day of Lignumvitae available, Thursday through Sunday. The rangers have their offices in the Matheson house, built on the island by a wealthy chemist in 1919. Horse trails were once cleared on the island, and it is along these trails that the rangers conduct the tours.

Because of the number of visitors and the horrendous mosquitoes, the tour normally is a short, one mile. The trail, however, actually extends for two miles, and visitors in Winter, when there is less mosquito activity, may wish to take the longer hike. At the midpoint of the longer trail is a stone wall, apparently dividing the island into three sections. No one knows who built the wall or what its purpose might have been. Traveling beneath the canopy on Lignumvitae is a rich experience of color and light.

The mosquitoes here are said to be so bad that boat loads of visitors sometimes turn around at the dock. Because the temperatures in the Keys are so moderate, mosquitoes appear year round after rains. There is usually repellent available in the ranger office for a donation. The mosquitoes illustrate what a challenge life on the Keys must have been when they were in their natural state, when there was no air-conditioning, and when humans had not yet applied tons of pesticide onto the land.

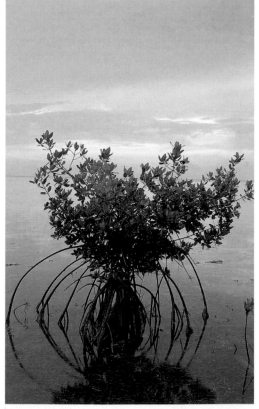

Top: a lignumvitae tree overhanging a hiking trail.

Above: a lone mangrove tree at sunset.

US-1 at MM 78.5. Access is by boat. Tours to Lignumvitae Key State Botanical Site can be arranged from Upper and Lower Matecumbe keys.

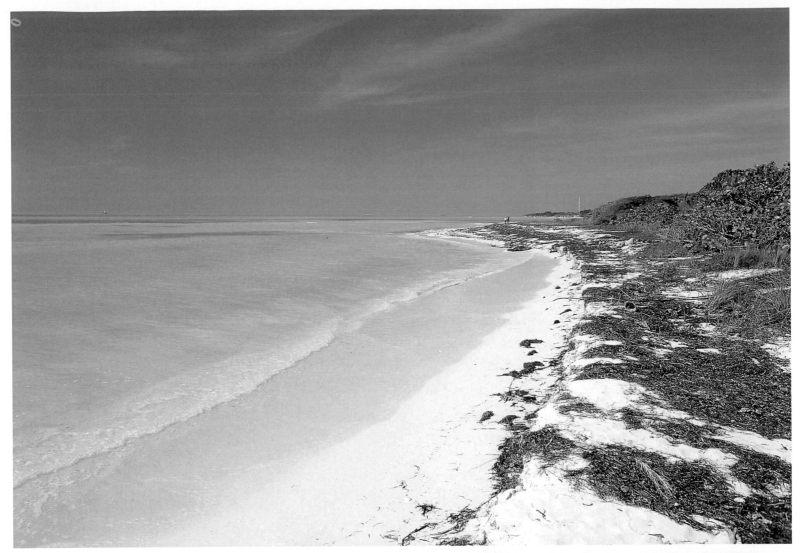

Bahia Honda State Recreation Area

One of the loveliest islands in the Florida Keys is largely preserved at Bahia Honda. Anyone who enjoys being at the sea's edge will want to plunge into the water or walk barefoot along the white sand. Beautiful shores such as this are a part of the real Florida experience, and Bahia Honda is the only significant, undeveloped beach left in the Keys.

Canoes and kayaks can be rented at the concession kiosk. Also, there is a marked nature trail that leads through some of the remaining hammock and along the beach, passing many burrows of large, colorful land crabs. The island is home to the Florida Keys mole skink, a shy, rare lizard. Few visitors catch sight of it because it is a secretive burrower.

In addition to the nature trail, visitors can walk onto the remains of the old railroad bridge at the west end of the park to admire the surrounding aquamarine waters, and to watch the white-crowned pigeons flying among the gumbo limbo and palm trees near the bridge.

"Bahia" is popularly mis-pronounced *Bay-ah* rather than the traditional Spanish pronunciation *Bah-ee-ah*. In Spanish

the words "Bahia Honda" mean "deep bay."
On US-1, 12 miles south of Marathon.

Top: the beach at Bahia Honda.
Above: the colorful bark of Florida poisonwood.
Above, right: the flowers of wild cotton.

THE RAILROAD THAT FLAGLER BUILT

Among pioneer Henry Flagler's railroad lines, he was most proud of the one that connected the Florida Keys. He called it "The Eighth Wonder of the World." It was built on bridges connecting the Keys. Parts of the old bridge can still be seen at Bahia Honda.

The bridges could not stand up to powerful hurricanes, however. On Labor Day Weekend in 1935, 200 mph winds and surging seas damaged the line. Over 400 people died, including rescuers whose train was blown into the sea. The railroad was never rebuilt, but portions of it can still be seen and walked on.

153

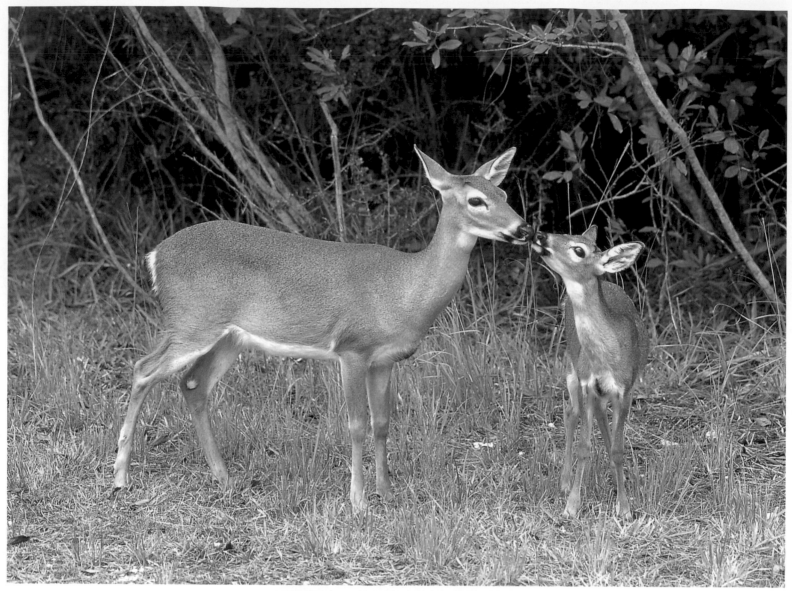

National Key Deer Refuge

Found almost exclusively on Big Pine and No Name Keys, the famous Key deer is a miniature version of the familiar Virginia white-tailed deer. A full-grown individual of this rare Keys race weighs between 45 and 85 pounds, and is the size of a German shephard.

Key deer once numbered in the thousands, but, due to hunting, their population was later reduced to a low of about 50. Even now, after years of protection, their number has only rebounded to about 600. Many of these "toy" deer have become very tame, wandering through yards and along roadways, even allowing people to pet them. For this reason, large numbers are killed each year by automobiles, especially during the winter tourist season. A sign sadly announces the number killed to date each year.

Aside from the Key deer, the refuge offers other natural attractions. There are many birds, and a pale sub-species of raccoon that has no mask about its eyes. Off Key Deer Blvd., north of Watson Blvd., is

the 2/3 mile Jack Watson Nature Trail featuring silver palms, thatch palms, and wax myrtle, among other species. There is also the Blue Hole which was once a rock quarry. It is habitat for alligators, wading birds, fish and turtles. It has saltwater (which seeps in through the limestone) in the bottom, but a lighter layer of freshwater (from rainfall) rides on top of it, a condition called a lens.

US-1 to Big Pine Key, turn onto Key Deer Blvd. for 1 1/2 miles. Turn right on Watson Blvd.

FLORIDA'S SMALL, ENDANGERED DEER

The fate of the Key deer is far from certain. Its existence is tenuous at best. While the population appears genetically viable, some abnormalities have appeared which could be the result of too small a gene pool.

Their plight is the result of habitat loss, highway fatalities, and other miscellaneous causes. Besides land being taken from them, the Key deer have abandoned some apparently suitable habitats. It is not understood why they abandoned these areas. This would need to be determined before reintroducing them there.

Captive breeding is one possibility for increasing their numbers. Refuge management will consider it if the Key deer numbers plummet, or if genetic changes are observed in the herd which make it necessary. However, human tinkering with nature can often have unexpected results.

Top: a mother Key deer with her young.

Above: a light-colored raccoon that is found in the lower Keys.

Opposite page: Spanish moss and buttonwoods in the National Key Deer Refuge.

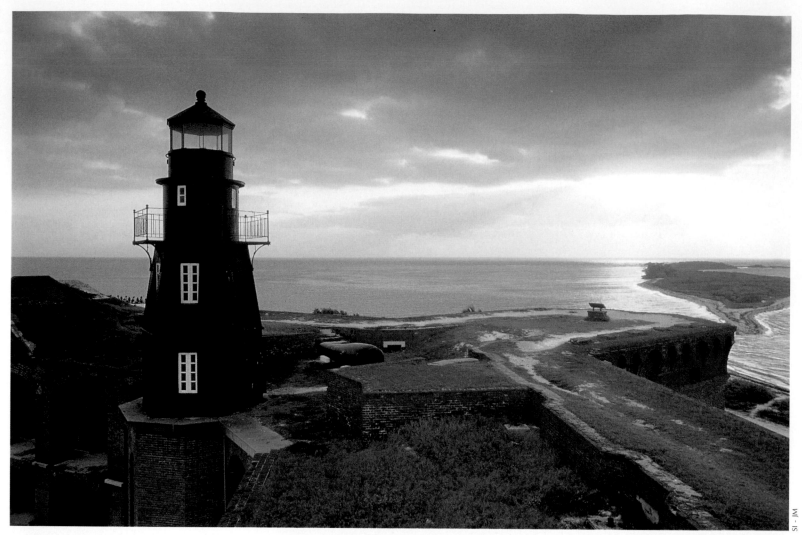

Dry Tortugas National Park

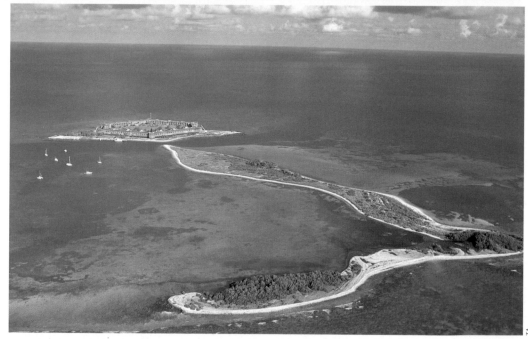

The Dry Tortugas are known for primitive camping, total isolation, lots of birds, and splendid diving. The name raises curiosity because it wouldn't seem that a series of islands in tropical seas would be dry. Storms occasionally cross the islands and bring rainfall. However, these islands do experience frequent drought. Also, there is no fresh water source on the islands. This was a very important consideration to early mariners. *Tortuga* is a Spanish word for turtle. In earlier times, there were abundant turtles in the waters around these islands

Salty soil and unpredictable rainfall restrict plant growth. Thus, these inhospitable islands are hot, isolated, and mostly barren. Such a place must have seemed perfect for a federal prison.

Historic Ft. Jefferson was named for Thomas Jefferson. During the Civil War, Union deserters were sent there for imprisonment. The watery isolation served to prevent escape. Ft. Jefferson's most famous prisoner was Dr. Mudd, the doctor convicted of aiding the escape of John Wilkes Boothe, the assassin of President Lincoln, by setting his broken leg. Many present day historians believe that the doctor was innocent of any crime and did not know that his patient was fleeing from federal agents at the time he rendered his assistance. However, in the passion of the moment, he was convicted. Years later, when yellow fever struck the fort, Dr. Mudd distinguished himself medically and was pardoned.

There are beautiful coral reefs surrounding the islands and in Spring there are large numbers of nesting birds, including boobies, frigatebirds, and roseate turns. The Dry Tortugas are also important to birders because they are located along an important bird migration route and at times, large numbers of migrating birds stop there to rest. Sea turtles nest on the beaches.

Top: a view of the lighthouse at Ft. Jefferson at sunrise.

Above: an aerial view of Ft. Jefferson on Garden Key.

These islands are located seventy miles west of Key West and can be accessed by boat or seaplane from Key West.

Other Adventures in the Keys

KEY LARGO STATE BOTANICAL SITE

Just east of US-1 on CR-905. There is a self-guided nature trail through hammocks dominated by West Indian trees, Jamaica dogwood, gumbo limbo, mahogany, poisonwood, paradise tree, and others.

Right: snorkelers near Molasses Reef Light, Key Largo, in the Florida Keys National Marine Sanctuary.

Below: Blue Hole at National Key Deer Refuge on Big Pine Key.

Center, right: a silver palm on Big Pine Key.

Bottom, left: a great white heron, found only in extreme South Florida and the Keys.

Bottom, right: a rare Würdemann's heron, a specialty of the Keys.

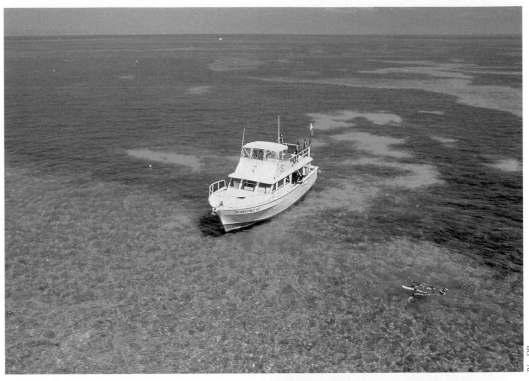

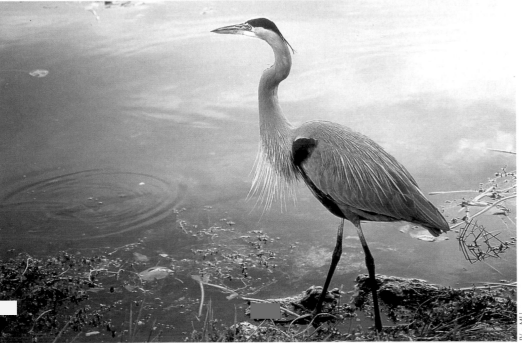

LOCATION INFORMATION

Writing or calling in advance of a visit is a good idea. None of the places in the book are static—they are always changing. Sometimes they are closed or portions are closed. Fax numbers should not be used to make camping reservations. Camping and stabling reservations should always be made in advance when possible, but some facilities do not take reservations. For fishing and hunting, check with site management and comply with applicable laws, regulations, and rules. In almost all cases, expect to pay fees for entrance and use. Fees vary. Rapid growth may affect zip codes, area codes, and even phone numbers. This list is updated with each edition, but it is possible that calling directory assistance may be necessary. Areas with primitive camping often have youth camps available for groups, but arrangements must be made in advance.

FOR ALL FLORIDA STATE PARKS, PRESERVES, AND RECREATION AREAS

Florida Department of Environmental Protection
Division of Parks and Recreation
3900 Commonwealth Ave
Tallahassee FL 32399-3000
850-488-9872

INDIVIDUAL LOCATIONS

Apalachicola National Forest (East)
Wakulla Ranger District
1773 Crawfordville Hwy
Crawfordville, FL 32327
850-926-3561
850-926-1904 (Fax)

Apalachicola National Forest (West)
PO Box 579, Bristol FL 32321
850-643-2282
850-643-2284 (Fax)
Boating, bicycle trails, camping (primitive), fishing, hiking, horse trails, hunting, short nature trails. Off road vehicles ask the ranger office.

Apalachicola Ravines and Bluffs Preserve
PO Box 876, Apalachicola FL 32329
850-653-3111
Hiking

Archbold Biological Station
PO Box 2057, Old State Road 8
Lake Placid FL 33862
863-465-2571
863-699-1927 (Fax)
Check in advance for activities. Short nature trail. Donation to the Scrub Fund will help buy endangered lands.

Bahia Honda State Recreation Area
36850 Overseas Hwy
Big Pine Key FL 33043
305-872-3897
305-292-6857 (Fax)
Fishing, nature trail, swimming.

Big Cypress National Preserve
HCR 61 Box 11, Ochopee FL 34141
941-695-2000
941-695-3493 (Fax)
Camping (primitive and hook-ups), fishing hiking, hunting. Check with management for restrictions.

Big Talbot Island State Park
12157 Heckscher Dr., Ft. George FL 32226
904-251-2323
904-251-2325 (Fax)
Fishing, hiking, swimming.

Biscayne National Park
PO Box 1369, Homestead FL 33090
305-230-7275
305-230-1190 (Fax)
Boating, canoe rentals, fishing, glass-bottom boat, snorkel trip, swimming. Boat owners can camp on islands when they wish. Other campers must make arrangements with the concession in advance.

Blackwater River State Forest
11650 Munson Hwy, Milton FL 32570
850-957-4201
850-957-4203 (Fax)
Bicycle trail, camping (primitive and hook-ups), fishing, hiking, hunting, horse trails (overnight stabling), nature trail.

Blowing Rocks Preserve
574 South Beach Rd
Hobe Sound FL 33455
561-744-6668
561-744-8680 (Fax)
Short nature walks, swimming.

Blue Spring State Park
2100 W French Ave, Orange City FL 32763
904-775-3663
904-775-7794 (Fax)
Diving, hiking, and swimming. Check with the park concerning diving and swimming restrictions. Boardwalk along spring run.

Canaveral National Seashore
308 Julia St, Titusville FL 32796
407-267-1110
407-264-2906 (Fax)
Boating, canoes allowed, fishing, hiking, horse trails, limited hunting (contact Chief Ranger), nature trails, off-road vehicles permitted, swimming.

Cedar Keys National Wildlife Refuge
16450 NW 31st Pl, Chiefland FL 32626
352-493-0238
352-493-1935 (Fax)
Bicycling, boating, fishing, hiking, hunting, swimming.

Chassahowitza National Wildlife Refuge
1502 Kings Bay Dr, Crystal River FL 34429
352-563-2088
352-795-7961 (Fax)
Boat rentals, fishing, swimming.

Collier-Seminole State Park
20200 Tamiami Trail E, Naples FL 34114
941-394-3397
941-394-5113 (Fax)
Mountain bicycle trails, camping (primitive and hook-ups), canoe trail with primitive camping, canoe rentals, concession boat tour, fishing, hiking trails, short nature walk.

Corkscrew Swamp
375 Sanctuary Rd, Naples FL 34120
941-348-9151
941-348-9155 (Fax)
Nature boardwalk only.

Crystal River National Wildlife Refuge
1502 Kings Bay Dr, Crystal River FL 34429
352-563-2088
352-795-7671 (Fax)
Boating, diving, fishing, swimming. Obey restrictions for manatee protection.

Dead Lakes State Recreation Area
PO Box 989, Wewahitchka FL 32465
850-639-2702
850-639-3806 (Fax)
Boating, fishing, nature trails, short nature walk on request.

Devil's Millhopper
4732 Millhopper Rd, Gainesville FL 32606
352-955-2008
904-462-7297 (Fax)
Nature trails.

Ding Darling National Wildlife Refuge
1 Wildlife Dr, Sanibel FL 33957
941-472-1100
941-472-4061 (Fax)
Canoe rentals, fishing, hiking by road, nature trails.

Everglades National Park
40001 SR 9336, Homestead FL 33034
305-242-7700
305-242-7711 (Fax)
So much is available, write for information or use the web site. www.nps.gov

Fakahatchee Strand State Preserve
PO Box 548, Copeland FL 33926
941-695-4593
941-685-4947 (Fax)
Fishing in canals, hiking, and swamp stomping for the brave and fit.

Falling Waters State Recreation Area
1130 State Park Rd, Chipley FL 32438
904-638-6130
904-473-0827 (Fax)
Camping (primitive and hook-ups), fishing, short trails.

Florida Caverns State Park
3345 Cavern Rd, Marianna FL 32446
850-482-1228
850-482-9114 (Fax)
Bicycle trails, canoe rentals, fishing, hiking, hook-ups, horse trails (overnight stabling).

Florida Panther National Wildlife Refuge
3860 Tollgate Blvd Suite 300
Naples FL 34114
Admission very restricted.
941-353-8442
941-353-8640 (Fax)

Gold Head Branch State Park
6239 SR 21, Keystone Heights FL 32656
352-473-4701
352-473-0827 (Fax)
Camping (primitive and hook-ups), canoe rentals, restricted boating, fishing, hinking, swimming, nature trails.

Grayton Beach State Recreation Area
357 Main Park Road
Santa Rosa Beach FL 32459
850-231-4210
850-231-9879 (Fax)
Boating on Western Lake, camping (primitive and hook-ups), canoe rentals, fishing, hiking, nature trail, swimming. A campfire program from Memorial Day to Labor Day.

Green Swamp
Land Resource Department
Southwest Florida Water
Management District
2379 Broad Street, Brooksville FL 34609
352-796-7211
352-754-6877 (Fax)
Fishing, hiking, hunting, very primitive camping. During hunting season, the gates are open. Out of hunting season, contact the Land Resource Department.

Gulf Islands National Seashore
1801 Gulf Breeze Parkway
Gulf Breeze FL 32561
850-934-2600
850-932-8654 (Fax)
Boating (ramp outside park), camping (primitive and hook-ups), fishing, hiking, limited hunting, nature trails, swimming.

Highlands Hammock State Park
5931 Hammock Road, Sebring FL 33872
863-386-6094
863-386-6095 (Fax)
Hiking, hook-ups, horse trails, nature trails.

Hillsborough River State Park
15402 US 301N, Thonotosassa FL 33592
813-987-6771
813-987-6773 (Fax)
Camping (primitive and hook-ups), canoe rentals, fishing, hiking, nature trails, swimming pool.

Homosassa Springs Wildlife Park
4150 S Suncoast Blvd, Homosassa FL 34446
352-628-5343
352-628-4243 (Fax)
Boat ride, classes, nature walk.

Ichetucknee Springs State Park
SR2 Box 108, Ft White FL 32038
904-497-2511 (Recorded Info)
904-497-3095 (Fax)
Canoe rentals, fishing (not during tubing season), hiking, nature trails, and swimming.

Jonathan Dickinson State Park
16540 SE Federal Hwy
Hobe Sound Fl 33455
561-744-9814
561-744-7604 (Fax)
Camping (primitive and hook-ups), canoe rental, fishing, hiking, horse trails, tour boat.

John Pennekamp Coral Reef State Park
PO Box 487, Key Largo FL 33037
305-451-1202
305-451-1410 (Fax)
Boat and canoe rentals, diving, fishing, glassbottom boat, hook-ups, two short nature trails, swimming.

Key Deer National Wildlife Refuge
PO Box 430510, Big Pine Key FL 33043
305-872-2239
305-872-3675 (Fax)
Watson Nature Trail.

Lake Kissimmee State Park
14248 Camp Mack Rd
Lake Wales FL 33853
941-696-1112
941-696-2656 (Fax)
Camping (primitive and hook-ups), canoe rentals, fishing hiking, nature trail.

Lake Woodruff National Wildlife Refuge
PO Box 488, DeLeon Springs FL 32028
Fishing, hiking.

Lignumvitae Key State Botanical Site
PO Box 1052, Islamorada FL 30336
305-664-4815
305-664-2629 (Fax)
Guided walk only.

Lower Suwannee National Wildlife Refuge
16450 NW 31st Pl, Chiefland FL 32626
352-493-0238
352-493-1935 (Fax)
Many places to canoe or kayak, fishing, hiking, hook-ups, hunting, nature trails.

Loxahatchee National Wildlife Refuge
10216 Lee Rd, Boynton Bch FL 33437
561-734-8303
561-369-7190 (Fax)
Canoe trail, fishing, hiking, limited hunting, nature trail.

Manatee Springs State Park
11650 NW 115th St, Chiefland FL 32626
352-493-6072
352-493-6089 (Fax)
Camping (facilities and hook-ups), canoe rental, diving, fishing, hiking, swimming.

Merritt Island National Wildlife Refuge
PO Box 6504, Titusville FL 32782
407-861-0662
407-861-1276 (Fax)
Fishing, hiking, limited hunting, nature trails.

Myakka River State Park
13207 SR 72, Sarasota FL 34241
941-361-6511
941-361-6501 (Fax)
Boat and canoe rentals, camping (primitive and hook-ups), fishing, hiking, log cabins, nature trail.

Ocala National Forest
Lake George District
17147 E Hwy 40, Silver Springs FL 34488
352-625-2520
352-625-7556 (Fax)

Ocala National Forest
Seminole District
40929 SR 19, Umatilla FL 32784
352-669-3153
352-669-2385 (Fax)
Boat rentals at Salt Springs, camping (primitive and hook-ups), canoe rentals and trails, fishing, hiking, hunting, horse trails (100 miles), nature trails.

Ochlockonee River State Park
PO Box 5, Sopchoppy FL 32358
850-962-2771
Camping (primitive and hook-ups), boat ramp, canoe put-ins, fishing, hiking, swimming.

O'leno State Park
Rt 2 Box 307, High Springs FL 32643
904-454-1853
904-454-2565 (Fax)
Camping (primitive and hook-ups), conoe rentals, fishing, hiking, horse trails plus overnight horse camping, swimming.

Osceola National Forest
PO Box 70, Olustee FL 32072
904-752-2577
904-752-7437 (Fax)
Camping (primitive and facilities), fishing, hiking, horse trails (four stalls), hunting, nature trails, swimming.

Paynes Prairie State Preserve
Rt 2 Box 41, Micanopy FL 32667
352-466-3397
352-466-4297 (Fax)
Boating (no gasoline motors) on Lake Wauberg, fishing, hiking, hook-ups, horse trails, nature trails.

Peacock Springs State Recreation Area
18081 185th Rd, Live Oak FL 32060
904-776-1040
904-776-1448 (Fax)
Diving, fishing, swimming.

Pine Log State Forest
715 W 15th St, Panama City FL 32401
850-872-4175
850-872-4879 (Fax)
Boating, camping (prmitive and hook-ups), fishing, hiking, swimming

San Felasco Hammock State Preserve
4732 Millhopper Rd, Gainesville FL 32606
904-462-7905
904-462-7297 (Fax)
Hiking, nature trails.

St. George Island State Park
1900 E Gulf Beach Ave
St George Island FL 32338
850-927-2111
Boating, camping (primitive and hook-ups), fishing, hiking, off road vehicle trail with permit, nature trail.

St. Joseph Peninsula State Park
8899 Cape San Blas Rd
Port St Joe FL 32456
850-227-1327
850-227-1488 (Fax)
Boating, camping (primitive and hook-ups), canoe rentals, fishing, hiking, nature trails.

St. Marks National Wildlife Refuge
Box 68, St. Marks FL 32355
850-925-6121
850-925-6930 (Fax)
Fishing, hiking, horse trails, hunting, nature trails, primitive camping.

St. Vincent National Wildlife Refuge
PO Box 447, Apalachicola FL 32329
850-663-8808
850-653-9893 (Fax)
No camping. Hiking. It is best to check in advance with the Refuge office.

Suwannee River State Park
2-185 CR 132, Live Oak FL 32060
904-362-2746
904-364-1614 (Fax)
Boating, beginning of lower and end of the upper Suwannee river and Withlacoochee canoe trails, fishing, hiking.

Ten Thousand Islands Aquatic Reserve
c/o Florida Panther Wildlife Refuge
3860 Tollgate Blvd Suite 300
Naples FL 34114
941-353-8442
941-353-8640 (Fax)
Boating, fishing.

Torreya State Park
HC 2 Box 70, Bristol FL 32321
850-643-2674
850-643-2987 (Fax)
Camping (primitive and hook-ups), hiking.

Tosohatchee State Reserve
3365 Taylor Creek Rd, Christmas FL 32708
407-568-5893
407-568-1704 (Fax)
Camping (primitive), fishing, hiking, horse trails, overnight camping with horse, hunting. Reservations required.

Wakulla Springs State Park
550 Wakulla Park Dr
Wakulla Springs FL 32305
850-922-3632
850-561-7251 (Fax)
Diving, boat tour, nature trail, swimming.

Wekiwa Springs State Park
1800 Wekiwa Cir, Apopka FL 32712
407-884-2009
407-884-2014 (Fax)
Bicycle trails, camping (primitive and hook-ups), canoe rental, fishing, hiking, horse trails (overnight camping with horse at Rock Springs Run), nature trails.

Withlacoochee State Forest
15019 Broad St, Brooksville FL 34601
352-754-6896
352-544- 2356 (Fax)
Boating, camping (primitive and hook-ups), fishing, hiking, hunting, motorcycle trail, nature trails. Spread-out and diverse. Request information in advance.

NATIVE AMERICAN PLACE NAMES

Many places in Florida are named for early forts (Ft. Myers) or prominent settlers (Flagler Beach). Some were named by the Spanish, such as *Boca Grande*, which means big mouth. Still others take their name from physical characteristics, like Clearwater, for its offshore freshwater springs.

Many places bear Native American names. Since two Seminole dialects are still spoken, the meaning of those names can be determined. The earlier tribes were destroyed by the Europeans and their diseases, leaving behind no written record, so these names are subject to some interpretation. The following are more or less generally accepted interpretations. Much linguistic debate still goes on about some of these names.

Alachua *Sinkhole*

Apalachicola
 Friendly people on the other side

Aucilla *Meaning is lost*

Caloosahatchee
 River of fierce people.

Chassahowitzka *Pumpkin place*

Chattahoochee *Marked rock*

Choctawhatchee
 River of the Choctaws

Colohatchee *River of white oak*

Econfina *Earth bridge*

Fahkahatchee *Clay or mud creek*

Homosassa *Where there are wild peppers, or smoking creek*

Ichetucknee *Beaver pond*

Kissimmee *Meaning is lost*

Loxahatchee *Turtle creek*

Miami *Meaning is lost*

Micanopy *A Seminole leader*

Mikasuki *A Creek/Seminole dialect*

Muskogee
 Another Creek/Seminole dialect

Ocala *From a Timucuan area, Ocali*

Ochlocknee *Yellow water*

Ocklawaha *Muddy*

Okaloosa *Black water*

Okeechobee *Big water*

Okefenokee *Trembling earth*

Olustee *Black fish*

Osceola *"Asi-yaholo," the true pronunciation, from "Shout given when taking the black drink," a Creek/Seminole ritual*

Palatka *Probably ferry crossing*

Panasoffkee *Deep ravine or valleys*

Seminole *Possibly from Cimmarones, a Spanish word for wild ones or runaways*

Sopchoppy *Not clearly known*

Steinhatchee *Dead man's creek*

Suwannee *Echo river*

Tallahassee *Old town*

Thonotosassa *A place with flint*

Tomoka *Probably from the way Europeans pronounced Timucua*

Waccasassa
 An area for cattle

Wacissa
 Another word with a lost meaning

Wakulla *Still another word with a lost meaning*

Wauchula *Best guesses: cow house or water house*

Wekiva *Water spring*

Withlacoochee *Big and little water*

Source: FLORIDA PLACE NAMES, Pineapple Press, by permission.

FLORIDA'S ECOSYSTEMS

The words "ecosystem" and "habitat" are often used interchangeably in scientific literature. In our ecologically aware era, the word ecosystem is often mentioned. It refers to the way plants and animals relate to each other and to their environment.

Coral Reefs: Corals are animals that produce limestone skeletons that accumulate and build toward the surface. There are three types of reefs: deepwater, shallow-water, and intertidal (between high and low tide).

Dry Prairies: Florida's dry prairies are grass dominated and lacking in trees. Dry prairies are like pine flatwoods, but without the tress. The phrase "wet prairie" is confusing, as it does not refer to a prairie at all, but to a type of marsh. Even a dry prairie can become wet in certain seasons.

Dunes: There is no desert in Florida. When one talks of sand dunes, they are discussing coastal dunes. The different dune areas are often described as upper beach, fore-dune, backdune, and inland. Different plants are associated with these parts of the dunes, and with the dunes in different regions in Florida.

Freshwater Marshes: Marshes are wetlands that differ from swamps because they are dominated by grasses, not trees. Swamps are also wetlands, but are dominated by trees.

Hardwood Forests: Temperate hardwood forests are dominated by trees other than pine. They are frequently called hammocks in Florida. In extreme South Florida and the Keys, they are tropical hardwood hammocks because many of the trees are tropical in origin.

High Pine (or Sandhill): High pine and sandhill are synonymous. They are high, well-drained areas, predominately covered with longleaf pine and drought-tolerant oaks, and as such are prime land for human development.

Inshore Marine Habitats: These are estuaries or inlets including oyster beds, tidal flats, and sea grass beds.

Lakes: Florida has around 7,800 lakes.

The five largest are: Okeechobee, George, Kissimmee, Apopka, and Istokpoga.

Mangroves: This type of ecosystem is dominated by mangroves, an imprecise term which applies to similar appearing trees that live at the edge of the sea. In Florida there are four unrelated species of "mangrove:" black mangrove, buttonwood, red mangrove, and white mangrove.

Maritime Forests: Inland vegetation on coastal uplands varies widely. Forests on the coastal dunes are called maritime, and can include palms, pine, oaks, and other trees and plants.

Pine Flatwoods: Woods dominated by pines on poorly drained soil.

Rivers: There are 23 major rivers in Florida that flow to the sea and 21 of those flow into the Gulf of Mexico. Only the St. Marys and St. Johns empty directly into the Atlantic.

Saltwater Marshes: Like freshwater marshes, these are dominated by grasses and herbaceous plants.

Springs: More than 300 major springs are found in Florida. About 80% of the water flows from 27 springs, or less than 10% of them. These are known as first magnitude springs because of their water output.

Scrub: Scrub is usually found on excessively dry and sandy soils. Scrub is identified by what grows on it. Since Florida rosemary, scrub oaks, and sand pine are often found in this habitat, they are useful as "markers" to help the untrained person recognize a scrub habitat.

South Florida Rockland: These are limestone areas of South Florida. Pine and hardwood grow on the rockland. Hardwoods are trees other than cypress, pine, red cedar, and white cedar. The hardwood grows in isolated hammocks.

Swamps: Swamps are wetlands dominated by trees. They are often named for the predominate tree. An example is a cypress swamp.

TABLE OF CONTENTS

COMMON AND SCIENTIFIC NAMES

The following are common and scientific names for most species mentioned in the preceding pages. Sometimes common names are capitalized and sometimes they are not. This varies by scientific discipline as well as editorial style. In this listing, the common names are capitalized. Within the book, it was felt that capitalizing them would be distracting.

BIRDS
American Bittern *Botaurus lentiginosus*
American Coot *Fulica americana*
American Flamingo *Phoenicopterus ruber*
American Kestrel *Falco sparverius*
American White Pelican *Pelecanus erythrorhynchos*
Bald Eagle *Haliaeetus leucocephalus*
Barred Owl *Strix varia*
Black-crowned Night Heron *Nyclicorex nycticorax*
Black Vulture *Coragyps atratus*
Brown Pelican *Pelecanus occidentalis*
Burrowing Owl *Athene cunicularia*
Cooper's Hawk *Accipiter cooperi*
Cattle Egret *Bubulcus ibis*
Common Moorhen *Gallinula chloropus*
Double-breasted Cormorant *Phalacrocorax auritus*
Eastern Screech Owl *Otus asio*
Everglade Kite (see snail kite)
Glossy Ibis *Plegadis falcinellus*
Great Blue Heron *Ardea herodias*
Great Egret *Egretta alba*
Least Bittern *Ixobrychus exilis*
Limpkin *Aramus guarauna*
Little Blue Heron *Egretta caerulea*
Magnificent Frigatebird *Fregata magnificens*
Northern Bobwhite *Colinus virginianus*
Osprey *Pandion haliaetus*
Peregrine Falcon *Falco peregrinus*
Pileated Woodpecker *Dryocopus pileatus*
Purple Gallinule *Porphyrula martinica*
Red-cockaded Woodpecker *Picoides borealis*
Red-headed Woodpecker *Melanerpes erythrocephalus*
Red-shouldered Hawk *Buteo lineatus*
Red-tailed Hawk *Buteo jamaicensis*
Reg-winged Blackbird *Agelaius phoeniceus*
Roseate Spoonbill *Ajaia ajaja*
Sandhill Crane *Grus canadensis*
Scrub Jay *Aphelocoma coerulescens*
Sharp-shinned Hawk *Accipiter striatus*
Snail Kite *Rostrhamus sociabilis*
Snowy Egret *Egretta thula*
Tricolored Heron *Egretta tricolor*
Turkey Vulture *Cathartes aura*
White Ibis *Eudocimus albus*
Wild Turkey *Meleagris gallopavo*
Wood Stork *Mycteria americana*
Yellow-crowned Night Heron *Nycticorax violacea*

MAMMALS
Beaver *Castor canadensis*
Bison *Bison bison*
Bobcat *Felis rufus*
Bottle-nosed Dolphin *Tursiops truncatus*
Coyote *Canis latrans*
Eastern Pipistrelle *Pipistrellus subflavus*
Florida Black Bear *Ursus americanus floridanus*
Florida Mouse *Podomys floridanus*
Florida Panther *Felis concolor coryi*
Fox Squirrel *Sciurus niger*
Gray Bat *Myotis grisescens*
Gray Fox *Urocyon cinereoargenteus*
Gray Squirrel *Sciurus carolinensis*
Jaguarundi *Herpailurus yaguarondi*
Key Deer *Odocoileus virginianus clavium*
Nine-banded Armadillo *Dasypus novemcinctus*
Racoon *Procyon lotor*
Red Fox *Vulpes vulpes*
Red Wolf *Canis rufus*
River Otter *Lutra canadensis*
Round-tailed Muskrat *Neofiber alleni*
Sambar Deer *Cervus unicolor niger*
Southeastern Bat *Myotis austroriparius*
Southern Flying Squirrel *Glaucomys volans*
Spinner Dolphin *Stenella longirostris*
Spotted Dolphin *Stella frontalis and attenuata*
Virginia Opposum *Didelphis virginiana*
Virginia White-tailed Deer *Odocoileus virginianus*
West Indian Manatee *Trichechus manatus*
Wild Hog *Sus scrofa*

REPTILES AND AMPHIBIANS
Alligator Snapping Turtle *Macroclemys temminckii*
American Alligator *Alligator mississippiensis*
American Crocodile *Crocodylus acutus*
Atlantic Green Turtle *Chelonia mydas*
Atlantic Hawksbill Turtle *Eretmochelys imbricata*
Bullfrog *Rana catesbiana*
Canebrake Rattlesnake *Crotalus horridus*
Cuban Brown Anole *Anolis sagrei sagrei*
Dusky Pygmy Rattlesnake *Sistrurus miliarius barbouri*
Eastern Coral Snake *Micrurus fulvius*
Eastern Diamondback Rattlesnake *Crotalus adamanteus*
Eastern Indigo Snake *Drymarchon corais couperi*
Everglades Racer *Coluber constrictor paludicola*
Florida Cottonmouth *Agkistrodon piscivorus conanti*
Florida Chorus Frog *Pseudacris nigrita verrucosa*
Florida Gopher Frog *Rana capito aesopus*
Florida Keys Mole Skink *Eumeces egregius egregius*
Florida Scrub Lizard *Sceloporus woodi*
Florida Snapping Turtle *Chelydra serpentina osceola*
Florida Softshell Turtle *Apalone ferox*
Florida Red-bellied Turtle *Pseudemys nelsoni*
Florida Watersnake *Nerodia fasciata pictiventris*
Georgia Blind Salamander *Haediotriton wallacei*
Gopher Tortoise *Gopherus polyphemus*
Green Anole *Anolis carolinensis*
Leatherback Turtle *Dermochelys coriacea*
Loggerhead Turtle *Caretta caretta*
Ornate Chorus Frog *Pseudacris ornata*
Pig Frog *Rana grylio*
Redbelly Water Snake *Nerodia erythrogaster erythrogaster*
Sand Skink *Neoseps reynoldsi*
Six-lined Racerunner *Cnemidophorus sexlineatus*
Southern Black Racer *Coluber constrictor priapus*
Southern Copperhead *Agkistrodon contortrix contortrix*
Southeastern Five-lined Skink *Eumeces inexpectatus*
Southern Leopard Frog *Rana sphenocephala*
Southern Ringneck Snake *Diadophis punctatus punctatus*
Southern Toad *Bufo terrestris*
Spiny Softshell Turtle *Apalone spinifera*
Red-eared Turtle *Trachemys scripta elegans*

PLANTS AND TREES
Atlantic White Cedar *Chamaecyparis thyoides*
Australian Pine *Casuarina glauca and C. litorea*
Bald Cypress *Taxodium distichum*
Blackgum *Nyssa biflora*
Black Mangrove *Avicennia germinans*
Black Titi *Cliftonia monophylla*
Black Tupelo *Nyssa sylvatica*
Bladderwort *Utricularia*
Blue Flag Iris *Iris virginica*
Bluff Oak *Quercus incana*
Butterwort *Pinguicula sp.*
Buttonbush *Cephalanthus occidentalis*
Buttonwood *Conocarpus erectus*
Cabbage Palm *Sabal palmetto*
Cedar Elm *Ulmus crassifolia*
Cinammon Fern *Osmunda cinnamomea*
Coco Plum *Chrysobalanus icaco*
Costal Plains Willow *Salix caroliniana*
Coontie *Zamia pumila*
Cordgrass *Spartina alterniflora*
Duckweed *Lemnaceae*
Florida Rosemary *Ceratiola ericoides*
Florida Yew *Taxus floridana*
Giant Water Dropwort *Oxypolis greenmanii*
Gumbo Limbo *Bursera simaruba*
Hooded Pitcher Plant *Sarracenia minor*
Live Oak *Quercus virginiana*
Lingnumvitae *Guaiacum sanctum*
Loblolly Bay *Gordonia lasianthus*
Longleaf Pine *Pinus palustris*
Mahogany *Swietenia mahagoni*
Paurotis palm *Acoelorrhaphe wrightii*
Pond Apple *Annona glabra*
Pond Cypress *Taxodium ascendens*
Pond Pine *Pinus serotina*
Red Mangrove *Rhizophora mangle*
Resurrection Fern *Polypodium polypodioides*
Royal Palm *Roystonea elata*
Sabal Palm *Sabal palmetto*
Sand Pine *Pinus clausa*
Saw Palmetto *Serenoa repens*
Sawgrass *Cladium jamaicense*
Sea Grape *Coccoloba uvifera*
Sea Oats *Uniola paniculata*
Slash Pine *Pinus elliotii*
Southern Magnolia *Magnolia grandiflora*
Spanish Moss *Tillandsia usneoides*
St. John's Wort *Hypericum sp.*
Strangler Fig *Ficus aurea*
Swamp Cyrilla (Titi) *Cyrilla racemiflora*
Torchwood *Amyris elmifera*
Torreya Tree *Torreya taxifolia*
Tupelo *Nyssa sp.*
Turkey Oak *Quercus laevis*
White Mangrove *Laguncularia racemosa*
Wild Coffee *Psychotria nervosa*
Wild Tamarind *Lysiloma latisliquum*
Wiregrass *Aristida stricta*